THE ART OF Greece and rome

Second Edition

In *The Art of Greece and Rome*, Susan Woodford lucidly traces the development of ancient art, capturing the excitement that inspired artists whose works have influenced all later Western art.

The Greeks challenged time-honoured styles, experimented, created problems and finally produced solutions considered classics ever since. The Romans adapted Greek achievements, added a talent for organisation on a large scale and soon produced impressive original works themselves.

Time, war and the hand of man have destroyed countless celebrated creations. But study of surviving architecture, sculpture, painting and mosaics combined with evidence from ancient literature provides brilliant glimpses of 'the glory that was Greece and the grandeur that was Rome'.

This edition includes a new chapter on art throughout the Roman empire and an Appendix dealing with aspects of art historical method, plus new illustrations and maps and an updated bibliography.

Dr Susan Woodford teaches Greek and Roman art for the University of London and is engaged in research in the British Museum. She has written extensively for learned journals and is the author of several books, including *The Parthenon, An Introduction to Greek Art, The Trojan War in Ancient Art, Images of Myths in Classical Antiquity* and one book dealing with later art history, *Looking at Pictures*.

THE ART OF GREECE AND ROME

Second Edition

Susan Woodford

PUBLISHED BY THE PRESS SYNDICATE OF THE UNIVERSITY OF CAMBRIDGE The Pitt Building, Trumpington Street, Cambridge, United Kingdom

CAMBRIDGE UNIVERSITY PRESS
The Edinburgh Building, Cambridge CB2 2RU, UK
40 West 20th Street, New York, NY 10011-4211, USA
477 Williamstown Road, Port Melbourne, VIC 3207, Australia
Ruiz de Alarcón 13, 28014 Madrid, Spain
Dock House, The Waterfront, Cape Town 8001, South Africa
http://www.cambridge.org

© Susan Woodford 1982, 2004

This book is in copyright. Subject to statutory exception and to the provisions of relevant collective licensing agreements, no reproduction of any part may take place without the written permission of Cambridge University Press.

First published 1982

Second edition 2004

Printed in the United Kingdom at the University Press, Cambridge

Typefaces Trajan, Weiss, and Adobe Garamond 11.25/13.5 pt. System $\text{ETEX } 2_{\mathcal{E}}$ [TB]

A catalogue record for this book is available from the British Library

Library of Congress Cataloging in Publication Data

Woodford, Susan

The Art of Greece and Rome / Susan Woodford. - 2nd ed.

n cm

Includes bibliographical references and index.

ISBN 0-521-83280-2 - ISBN 0-521-54037-2 (pb.)

1. Art, Classical. I. Title.

N5610.W6 2004 709'.38 – dc22

2003069663

ISBN 0 521 83280 2 hardback ISBN 0 521 54037 2 paperback For Léo

CONTENTS

	List of Illustrations	page XI
	Acknowledgements	XVII
	Maps	XIX
	Introduction	I
P.A	ART I. THE ARCHAIC AND CLASSICAL	
P]	ERIODS: PROGRESS AND PROBLEMS	4
Ι	Free-Standing Statues	4
	The Greeks	4
	Greeks and Egyptians: style and technique	7
	The perils of progress: archaic kouroi 650–490 BC	9
	New medium, new style: bronze-casting	
	in the early 5th century вс	12
	Greater boldness, more problems: early classical	
	statues	15
	The classic solution: the Spear-bearer of Polykleitos	18
	Style and taste: draped female figures	20
	Trends and developments in archaic and	
	classical statuary	22
2	Greek Temples and Their Decoration	23
	Four popular plans	23
	Two basic elevations: the Doric and Ionic orders	24
	Spaces and shapes to decorate	27
	Pediments and their problems	27
	Metopes: few but telling figures	32
	Friezes: difficulties of design	35
	The early and high classical styles contrasted	36

3	Painting and Painted Pottery	38
	Painting on walls and panels	38
	Painting on pottery: the beginning	39
	How Greek pottery was used	4
	New interests in the 7th century BC	42
	Vividness in storytelling: the black-figure technique	44
	The search for new effects: the red-figure technique	47
	Advances in wall painting: Polygnotos	52
	The illusion of space	54
	Written sources of information on the arts	50
P.A	ART II. THE FOURTH CENTURY BC AND	
Tl	HE HELLENISTIC PERIOD: INNOVATION	
A۱	ND RENOVATION	59
4	Sculpture	59
	The decline of the classical poleis and the rise of the	
	Hellenistic kingdoms	59
	New trends in sculpture in the 4th century BC	6
	The female nude: a new theme in Greek art	62
	New problems in the Hellenistic period: figures in	
	space	64
	Hellenistic variety: new subjects – foreigners and	
	groups	66
	New drama in old compositions	68
	Uses and abuses of the past	69
	The Hellenistic contribution	7
5	Painting	72
	Sources of information and their value	73
	The 4th century BC and its legacy	73
	Hellenistic achievements: new themes and	
	settings	70
6	e e	8
	The house: new luxury in private life	8
	The theatre: the actor becomes the principal	82
	The sanctuary: unification of architectural complexes	8

	RT III. THE ROMAN WORLD:	
	DOPTION AND TRANSFORMATION F THE GREEK LEGACY	89
7	Roman Statues and Reliefs	89
	The emergence of the Roman empire	89
	Portraiture: specificity of person	90
	Roman portraits and Greek forms	92
	Historical reliefs: specificity of event	93
	Reliefs for private individuals: sarcophagi	98
8	Roman Painting	IOI
	Greek inspiration for Roman painting	IOI
	An example of a thoroughly Roman painting	102
	Roman settings: the four Pompeian 'styles'	103
9	Roman Architecture: Adaptation and Evolution	109
	Houses and temples: dwellings for men and gods	109
	From theatre to amphitheatre	116
	Imperial thermae; the 'palaces of the people'	119
10	World Rulers	123
	World architecture for world rulers	123
	Unity and diversity	126
	Non-Roman ethnic traditions under Roman rule	130
	Art outside the classical tradition	133
	Epilogue	138
	Appendix: How We Know What We Think	
	We Know	139
	How Greek and Roman works of art and architecture	-37
	can be dated	139
	How works can be attributed to artists known	
	from literature	141
	How we think marble statues in complex poses may	
	have been made	141
	How we think the Romans made copies (or variants)	
	of Greek statues	143

CONTENTS

How we think the Romans used copies of Greek	
paintings	144
Glossary	146
Further Reading	152
Index	100

ILLUSTRATIONS

I	Kouros, New York	6
2	Bakenref	6
3	King Meryankhre Mentuhotep VI	6
4	Diagram of stone carving	7
5	Analysis of patterns on the New York kouros	8
6	Anavyssos kouros, front	IO
7	Anavyssos kouros, back	II
8	New York kouros, back	II
9	Aristodikos	II
Ю	Kritios boy	II
II	New York kouros, side	12
12	Aristodikos, side	12
13	Kritios boy, left side	12
14	Kritios boy, right side	12
15	Diagram of bronze-casting	13
16	Kritios boy, head	14
17	Zeus of Artemisium, head	14
18	Zeus of Artemisium, front	15
19	Zeus of Artemisium, side	16
20	Roman copy of Discus-thrower by Myron	17
21	Pompeian painting of a statue in a garden	17
22	Cartoon showing expectations aroused by the	
	Discus-thrower	17
23	Diagram of the composition of the Discus-thrower	18
24	Discus-thrower, side	18
25	Roman copy of the Spear-bearer by Polykleitos	19
26	Stele showing side view of the Spear-bearer	19
27	Spear-bearer, right side	20
28	Spear-bearer, left side	20
29	Goddess, Berlin	21
30	Kore, Acropolis Museum	21
31	Roman copy of a goddess	21
32	Roman copy of 'Venus Genetrix'	21

LIST OF ILLUSTRATIONS

33	Plan of a simple Greek temple with porch in front	23
34	Plan of a Greek temple with porches in front and back	23
35	Plan of a Greek temple with a peristyle	23
36	Plan of a Greek temple with a double peristyle	24
37	Plan of a typical Greek peripteral temple	24
38	Hephaisteion, Athens	25
39	The Doric order	26
40	The Ionic order	26
4 I	Base and bottom of the shaft of an Ionic column	27
42	Bottom of the shaft of a Doric column	27
43	Corinthian capital	27
44	Reconstruction drawing of the Corfu pediment	28
45	Reconstruction drawing of the east pediment at	
	Aegina	29
46	Reconstruction drawing of the east pediment of the	
	Temple of Zeus at Olympia	29
47	Drawing of the west pediment of the Parthenon	30, 31
48	Cattle-stealing metope from the Treasury of the	
	Sicyonians	33
49	Atlas metope from the Temple of Zeus at Olympia	33
50	Bull metope from the Temple of Zeus at Olympia	34
51	Lapith and centaur, metope from the Parthenon	34
52	Lapith and centaur, metope on the Parthenon	35
53	Procession from the frieze of the Parthenon	36
54	Procession from the frieze of the Parthenon	36
55	River god from the east pediment of the Temple of	
	Zeus at Olympia	37
56	River god from the west pediment of the Parthenon	37
57	Perseus metope from Thermon	38
58	Copy of painted wooden panel from Pitsa	39
59	Amphora showing mourners around a bier	40
60	Shapes of Greek vases	42, 43
61	Krater by Aristonothos	44
62	Black-figure krater handle by Kleitias showing Ajax	
	with the body of Achilles	45
63	Ajax with the body of Achilles without incision	46
64	Black-figure amphora by Exekias showing Ajax and	
	Achilles playing	47

65	Black-figure amphora showing Ajax and Achilles	
	playing	48
66	Red-figure amphora showing Ajax and Achilles	
	playing	49
67	Red-figure amphora by Euthymides showing revellers	50
68	Red-figure hydria shoulder showing the fall of Troy	52, 53
69	Red-figure krater showing Orpheus	54
70	Red-figure krater showing the influence of Polygnotos	55
71	White-ground lekythos showing the influence of	
	Parrhasios	55
72	Roman copy of the Knidian Aphrodite by Praxiteles	62
73	Drawing by Raphael, copy of 'Leda' by Leonardo	
	da Vinci	63
74	Aphrodite of Capua	64
75	Dancing faun	65
76	Dancing faun, drawing showing the twist of the body	65
77	Gaul killing his wife and himself	67
78	Zeus and Athena fighting giants, Pergamon altar	68, 69
79	Aphrodite from Melos	70
80	Orestes and Electra	71
81	Alexander mosaic	74
82	Pluto abducting Persephone, Macedonian	
	royal tombs	75
83	Mosaic showing a scene from a comedy	77
84	Mosaic showing doves drinking	77
85	Roman wall painting from Boscoreale	79
86	Roman wall painting showing scenes from the	
	Odyssey	79
87	Plans of Greek houses from the classical and	
	Hellenistic periods	82
88	The theatre at Epidauros	83
89	Reconstruction drawing of the theatre at Priene	84
90	Reconstruction drawing of the sanctuary of Asclepius	
	on Kos	85
91	Reconstruction drawing of the acropolis at Athens	86
92	Reconstruction drawing of the Sanctuary of Fortuna	
	at Praeneste	87
93	Augustus from Prima Porta	91

LIST OF ILLUSTRATIONS

94	Titus	92
95	Sabina as Venus	92
96	Commodus as Hercules	93
97	Procession from the Ara Pacis frieze	94
98	Procession from the Parthenon frieze	94
99	Spoils from Jerusalem, Arch of Titus	95
100	Siege scene, Column of Trajan	96
IOI	Victory writing on a shield, Column of Trajan	97
102	Massacre, Column of Marcus Aurelius	97
103	Achilles and Penthesilea, sarcophagus	99
104	Perseus and Andromeda, Roman wall painting	IOI
105	Perseus and Andromeda, Roman wall painting	IOI
106	Riot in the amphitheatre, Roman wall painting	102
107	Second Style room from Boscoreale, Roman	
	wall painting	104
108	Villa of the Mysteries, Roman wall painting	104
109	Third Style wall from Boscotrecase, Roman wall	·
	painting	106
IIO	Detail of 109	106
III	Fourth Style room from the House of the Vettii,	
	Roman wall paintings	106
II2	Fourth Style room from the House of the Vettii,	
	Roman wall paintings	107
113	Fourth Style decoration from Herculaneum, Roman	,
	wall painting	108
114	Plan of a Roman atrium house	109
115	Plan of a Roman atrium house with peristyle	109
116	View of the House of the Menander	IIO
117	Reconstruction drawing of an Etruscan-early Roman	
	type of temple	III
118	Maison Carrée, three-quarter view	112
119	Plan of the Maison Carrée	112
120	Maison Carrée, front view	113
121	The Pantheon, interior	114
122	Theatre of Marcellus, model	116
123	Theatre at Orange, interior	117
124	Roman coin showing the Colosseum	117
125	Colosseum, exterior	118

LIST OF ILLUSTRATIONS

126	Drawing of Colosseum without the veneer of orders	119
127	Plan of the Baths of Caracalla	120
128	Reconstruction drawing of the frigidarium of the	
	Baths of Caracalla	121
129	Roman aqueduct, Segovia	122
130	Theatre at Aspendos, interior	123
131	Amphitheatre at El Djem (Thysdrus), exterior	124
132	Plan of the Imperial Baths at Trier	125
133	Mosaic showing the discovery of Achilles, Pompeii	127
134	Mosaic showing the discovery of Achilles, Tunisia	128
135	Mosaic showing the discovery of Achilles, Zeugma	129
136	Egyptian mummy portrait	130
137	Sardis menorah (and reconstruction)	131
138	Grave stone of Philus from Cirencester	
	(and drawing)	132, 133
139	Battle scene from Adamklissi (and drawing)	134, 135
140	Trumpeters from Adamklissi (and drawing)	136, 137
141	Diagram of carving a statue from a model	142, 143

ACKNOWLEDGEMENTS

For permission to reproduce illustrations, the author and the publisher wish to thank the institutions mentioned in the captions. The following are also gratefully acknowledged:

12, 13, 14, 18, 19, 21, 24, 26, 27, 28, 41, 42, 58, 129, 130, 139, 140 Susan Woodford; 3, 51, 52, 53, 54, 56, 136 reproduced by courtesy of the Trustees of the British Museum; 4, 15, 33, 34, 35, 36, 37, 39, 40, 114, 115, 119, 126 drawn by Susan Bird, courtesy of the British Museum; 6, 9, 10, 29, 30, 48, 49, 50, 55, 71, 88, 98 Alison Frantz; 16, 38, 59, 44, 46, 62, 68, 70 Hirmer Fotoarchiv; 20, 25, 31, 32, 75, 77, 79, 93, 94, 96, 97, 99, 100, 103, 112, 122, 125 The Mansell Collection; 22 The Strange World of Mr. Mum by Phillips: copyright Hall Syndicate: Courtesy of Field Newspaper Syndicate; 43 Deutsches Archaeologisches Institut, Athens; 60 from G. M. A. Richter and L. F. Hall, Attic Red-Figured Vases (Yale University Press 1958); 65, 66 Photograph copyright 2003 Museum of Fine Arts, Boston; 81, 83, 84, 104, 111, 113 Fotografie della Società Scala, Florence; 67 C. H. Krüger-Moessner; 73 reproduced by gracious permission of Her Majesty Queen Elizabeth II; 74, 101, 102, 133 Deutsches Archaeologisches Institut, Rome; 76 Brian Lewis; 82 The Archaeological Society at Athens; 87a Professor J. Travlos; 87c from W. B. Dinsmoor, The Architecture of Ancient Greece (Batsford 1953); 89 from M. Schede Ruinen von Priene (Berlin 1934); 91 by Gorham Stevens, courtesy of Agora Excavations, American School of Classical Studies, Athens; 92 from H. Kähler, Das Fortunaheiligtum von Palestrina Praeneste (Saarbrucken 1958); 95 Leonard von Matt; 105 Editions d'Art Albert Skira; 106 Werner Forman Archive; 116 (F.U. 13040F); 124, 128 (F.U. 4267 F) Fototeca Unione, American Academy in Rome; 117 Professor Frank Brown from Memoirs of the American Academy in Rome, 26 (1960); 118, 120 Copyright Arch. Phot. Paris/SPADEM; 7, 8 from G. M. A. Richter, Kouroi, 1960; 57 from G. M. A. Richter Greek Art The Phaidon Picture Archive; 90 from J. Durm, Handbuch der Architektur (Leipzig 1910); 131 Roger Wood/CORBIS; 134 from Katherine M. D. Dunbabin *The Mosaics of Roman North Africa* (Oxford University Press 1978); 135 A Turizm Yayinlari, Istanbul; 137 Archaeological Exploration of Sardis/Harvard University; 138 Copyright Gloucester City Museum and Art Gallery; 127, 132, 138–40, 141, Maps 2, 3 Susan Bird; Map 1 Susan Bird (after Susan Woodford *An Introduction to Greek Art* Duckworth and Cornell University Press 1986); 64 Musei Vaticani.

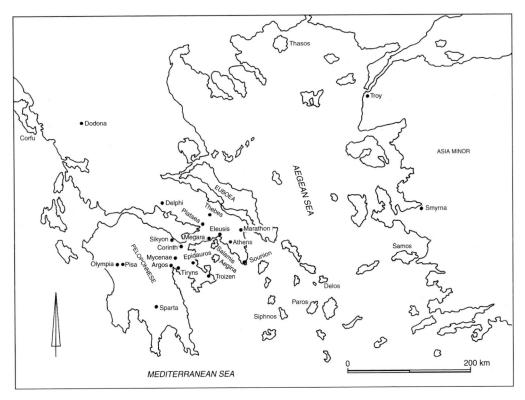

Map 1: Greece and the West Coast of Asia Minor.

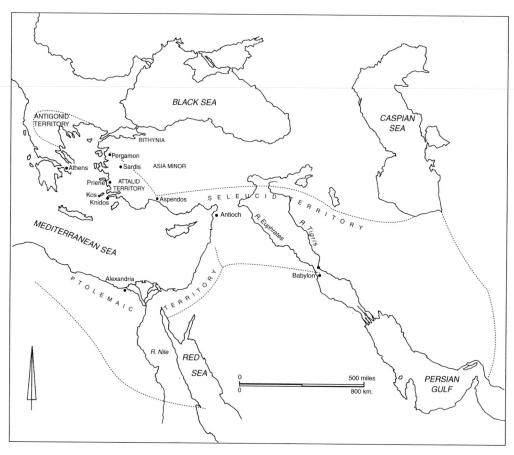

Map 2: The Hellenistic World.

Map 3: The Roman Empire.

INTRODUCTION

Helen, thy beauty is to me Like those Nicean barks of yore, That gently o'er a perfumed sea, The weary, wayworn wanderer bore To his own native shore.

On desperate seas long wont to roam, Thy hyacinth hair, thy classic face, Thy Naiad airs have brought me home To the glory that was Greece And the grandeur that was Rome.

> Ode to Helen Edgar Allan Poe

P oe's ode is addressed to the legendary beauty who, though married to King Menelaos of Sparta, was carried off by the Trojan prince, Paris. Menelaos thereupon summoned his allies and, having assembled a mighty army under the command of his brother Agamemnon, king of Mycenae, sailed to Troy and fought there for ten years until the city was sacked and Helen was recovered. This is a famous story and one that has often inspired poets, but its connection with the glory of Greece and the grandeur of Rome may not be immediately obvious.

The myth of Helen and the Trojan War seems to have had historical roots in the period around 1250 BC. People speaking an early form of Greek were then already living in Greece and had produced a flourishing civilisation that we call *Mycenaean*, naming it after the richest and most powerful of its centres. By the end of the 12th century BC, for reasons that are still obscure, this civilisation lay in ruins. Populous sites had become deserted, trade had ceased, skills were lost and crafts declined. A once wealthy civilisation had

become poor, a literate one illiterate. Meanwhile, new tribes of Greek-speaking people, the Dorians, began to move into Greece, and some of the earlier ones migrated eastward to the islands of the Aegean and the west coast of Asia Minor (Map 1). Hardly more than a memory survived of the desolation that followed the collapse of Mycenaean civilisation, but out of that memory legends were shaped, tales told and new poems created.

By the 8th century BC, the *Iliad* and the *Odyssey* had been composed. These two Homeric epics developed the story of the Trojan War and made it something essential for all later cultural developments. These poems were among the earliest manifestations of a new civilisation, the *Hellenic*, which had arisen out of the ashes of the old; the people who produced this civilisation, the successors of the Mycenaeans, were the ones who created 'the glory that was Greece'. Throughout their history they greatly valued the poetry of Homer; children learned his works by heart, and adults used them as models of behaviour.

In the four centuries from the time of Homer to that of Alexander the Great (356–323 BC), the Greeks evolved a culture that was to be immensely influential throughout the Western World. The conquests of Alexander carried Greek ideas to people far beyond the traditional centres in which Greeks had lived (Map 2). Such geographical extension drastically modified the character of Greek civilisation, and so this later phase is called *Hellenistic* rather than Hellenic. From the 3rd to the 1st century BC, Hellenistic culture was admired and imitated from the western borders of India to the southern slopes of the Alps.

The 'grandeur that was Rome' came into being rather differently. Rome was founded in the 8th century BC, a small settlement on the banks of the Tiber with no memories of a glorious past. As the city grew in power, the Romans encountered more civilised peoples and began to take an interest in art and literature, which hitherto had been of little importance to them. At first the Romans learned from the neighbouring Etruscans (who were masters of Rome for a time and left a lasting imprint on Roman religion and attitudes), but from the 3rd century BC they turned increasingly to the Hellenistic Greeks for instruction and inspiration. By adapting elements of Hellenistic culture and combining them with their

own well-developed organisational and military skills, the Romans were able to produce a magnificent culture of their own.

By the time Rome had reached its zenith, Greece had become a mere Roman province. But even then the myth of Helen and the Trojan War continued to play a vital part in Greek culture. The Romans, when they began to appreciate Greek values, sought to attach Greek legends to their own traditions by tracing their descent from those very Trojans whom the Greeks, in their art and literature, had depicted as noble and worthy adversaries.

The Roman empire gradually expanded, embracing virtually all the territory that had once been part of the Hellenistic world and also many lands to the north and the west (Map 3). Roman values, Roman building practices and Roman styles followed the Roman armies, and though some native traditions persisted, most people were attracted to the comfort and elegance that came with Roman civilisation.

Eventually the Roman empire fell into decline. The cities and sanctuaries of Greece, too, became little more than neglected ruins. Nevertheless, the art of Greece and Rome, though much of what has survived is only fragmentary, bears vivid testimony to the erstwhile greatness of these two cultures. The object of this book is to recapture the feeling of the time when the art was created and to explain its lasting power to enthral men's minds and captivate their imaginations.

PART I. THE ARCHAIC AND CLASSICAL PERIODS: PROGRESS AND PROBLEMS

I: FREE-STANDING STATUES

THE GREEKS

The beginnings of Greek civilisation after the decline of the Mycenaeans were not very glorious. By about 1000 BC, people speaking various Greek dialects were living around the Aegean Sea. Principal among them were the Dorians, who lived mostly on mainland Greece, and the Ionians, who populated many of the islands and the west coast of Asia Minor (Map 1). They gathered together in small, widely separated communities, many of which eventually developed into *poleis* ('city-states', as they are often, somewhat imprecisely, called; singular *polis*).

The earliest communities were poor, illiterate, and isolated from one another as well as from the rest of the world. Slowly they began to prosper and develop. By the middle of the 8th century BC, when the Homeric poems were being composed, craftsmen could already produce huge funerary monuments of pottery covered with precise and elegant decoration (Fig. 59). Soon an increase in population encouraged the now overcrowded Greeks to send out colonies, east to the area around the Black Sea and west to Sicily and southern Italy. The poleis eventually also began to trade more widely and so came into contact with the peoples and the cultures of Egypt and the Near East. These ancient, literate and brilliant civilisations, with their rich and accomplished art forms, awed and astonished the Greeks. Thoroughly impressed and eager to learn, many had by the middle of the 7th century BC acquired the two skills which enabled them to produce the literature and sculpture that later made them famous: they learned how to write and how to carve stone.

Each polis was fiercely independent and each developed a character of its own. Corinth, on the isthmus, was rich and luxurious, a great trading centre; Sparta became renowned for its military prowess; Argos produced a succession of outstanding bronze-casters; Athens, an Ionian polis on the predominantly Dorian mainland, encouraged individual achievements and attracted gifted foreigners,

so that eventually the finest poetry, drama and art were created there.

These independent poleis were linked by a shared language and a common religion. At the famous panhellenic (all-Greek) sanctuaries like Delphi and Olympia, the Greeks from different poleis would congregate to hold competitions in athletics, poetry and music in honour of the gods. Most of their other encounters were acrimonious. The poleis were constantly at war with one another.

It took a great threat to unite them, even temporarily. That threat came in the early 5th century BC with the Persian Wars. The Persian empire had gradually absorbed the Greek poleis on the coast of Asia Minor during the course of the 6th century BC. In 499 BC, these poleis unsuccessfully rebelled against their Persian overlords and drew Greek poleis from the mainland into their rebellion. The Persians quelled the revolt and sent out a punitive mission. When, in 490 BC, this came to grief on the plains of Marathon, defeated primarily by the Athenian army, the Persian king resolved on a war of total conquest.

The Greeks united to face the common enemy. The Athenians, though their city was sacked, took to their ships and fought bravely in the naval battle at Salamis in 480 BC, and the Spartans distinguished themselves in the final battle on Greek soil at Plataea in 479 BC. The great Persian invasion had been defeated.

Athens had been an important and cultured polis before the Persian Wars, but it was after their conclusion that it reached its height. The fifty or so years between the end of the Persian Wars (479 BC) and the beginning of the Peloponnesian War (431 BC) were for Athens a golden age of art, literature and political power. It continued to produce great works right up to the end of the century, but the Peloponnesian War, in which it and its empire fought against the Spartans and their allies, eventually sapped most of its strength and almost all of its creativity. Athens was defeated by the Spartans in 404 BC, but the works it created during the 5th century BC were so extraordinary in their beauty that they have been considered classics ever since.

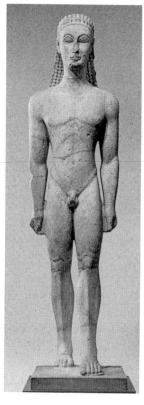

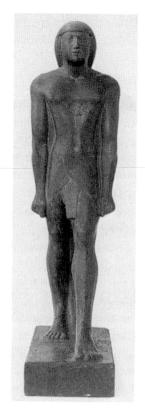

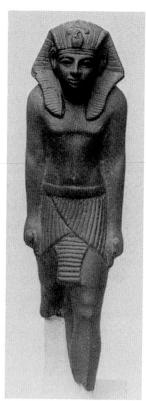

from left to right

1. Kouros, late 7th century

BC, height 184 cm,

Metropolitan Museum of

Art, New York, Fletcher

Fund, 1032.

- 2. Bakenref (Egyptian), mid-7th century BC, height 50 cm, courtesy Museum of Fine Arts, Boston, William E. Nickerson Fund.
- 3. King Meryankhre Mentuhotep VI (Egyptian), mid 17th century BC, height 23 cm, British Museum, London.

Archaic is the name given to the period from about the middle of the 7th century BC (around 650), when the Greeks were developing techniques and ideas stimulated by contact with the older civilisations of Egypt and the Near East, until the time of the Persian Wars in the early part of the 5th century BC (490–479). Classical is the name given to the period from the Persian Wars till the end of the Peloponnesian War (404 BC).

The term *classical* is commonly used in two further senses. It often simply denotes excellence, so that something is called 'a classic' if it is an outstanding example of its type; or the term is used historically, so that the Greek and Roman civilisations together are known collectively as 'classical antiquity' in order to distinguish them from the remoter antiquity of the civilisations of Egypt and the Near East. In this book 'classical' is used restrictively to describe the artistic style developed in the 5th century BC.

The archaic and classical periods were for the Greeks immensely exciting times to live in; thinkers and practical men were constantly

discovering and inventing new things. It was also a critical time for the development of art, as we shall see.

GREEKS AND EGYPTIANS: STYLE AND TECHNIQUE

Sometime after the middle of the 7th century BC, the Greeks began to carve large-scale figures of men out of marble (Fig. 1). They must have been impressed by statues made in other hard stones that they saw in Egypt, since the inspiration for the type of standing figure they made clearly comes from Egypt (compare Fig. 1 with Figs. 2 and 3). There was also something else, more important than inspiration, which came from Egypt: technique.

Carving a life-size figure out of stone is not a simple matter, and any unsystematic attempt quickly leads to disaster. The Greeks must have been aware of this, but they also knew that the Egyptians, many centuries earlier, had devised a method for carving stone figures. The Egyptians would draw the outlines of the figures they wanted on three (or four) faces of a stone block – front view on the front, profile on the sides. Then they would chip away inwards gradually from the front and the sides, removing more and more stone until they reached the depth that corresponded to the figure that had been drawn (Fig. 4). The drawings had to be made according to a fixed scheme of proportions (for instance, one unit up to the ankle, six units up to the knee and so on) so that when the work was finished the front and side views would agree with one another.

The Greeks adopted the Egyptian method of working and, to a large extent, also the Egyptian system of proportions. That is why early Greek statues look so much like Egyptian ones (Figs. 1–3).

The similarities in pose and technique are obvious; the differences in style and function are more subtle, but extremely important. The Egyptian sculptor made a rather convincingly naturalistic figure of a man; the Greek statue is more abstract. Evidently, the Greeks believed that a statue of this kind should not only look like a man but should also be a beautiful object in itself. They made it into a thing of beauty by imposing three elements of design on

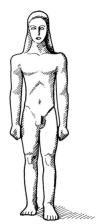

4. Diagram showing the archaic Greek method of stone carving.

the representation of the human form: symmetry, exact repetition of shapes, and use of some shapes on different scales.

The Greek sculptor, like his Egyptian counterpart, appreciated the natural symmetry of the human body with its pairs of eyes, ears, arms and legs, and stressed the symmetry by keeping the figure upright, facing straight forward, standing with its weight equally distributed on its two legs. He avoided any pose containing twists, turns or bends since these would have spoiled the symmetry.

Symmetry about a vertical axis was thus easily achieved. But symmetry about a horizontal axis was quite another matter. The human form, with a single head at one end and a pair of legs at the other, must have seemed unpromising material to organise in this way. Nevertheless, the Greek artist dealt with the problem by inventing his own, rather limited, horizontal axes. He imagined a horizontal axis running across the body at the level of the navel and then produced a symmetrical design on either side of it (Fig. 5, red) — the upright V of the heavily accented muscle separating the torso from the legs and the balancing inverted V of the lower boundary of the thorax. He imagined another horizontal line midway between the collar-bones and the pectoral muscles. He then balanced the shallow W of the pectorals below it with the inverted shallow W of the collar-bones above (Fig. 5, blue). (The symmetry is easier to perceive if you turn the book sideways.)

The sculptor repeated certain shapes exactly, in order to produce a decorative pattern. He made the line of the eyebrows follow the line of the upper lids (Fig. 5, brown) and composed the hair of bead-like knobs, each of which is the same as its neighbours (Fig. 5, brown). This is particularly effective from the back, where the play of light and shadow on the richly carved hair contrasts with the smooth surface of the body (Fig. 8).

Use of the same shape on different scales is a third aesthetic device employed by the sculptor. Notice how the shallow W of the pectorals is echoed on a smaller scale in the shallow Ws over the knee-caps (Fig. 5, yellow) and how the protruding V of the torsoleg division is echoed in the smaller, recessed Vs of the elbows (Fig. 5, green).

A great deal of thought about design has obviously gone into the making of a figure that at first glance might appear rather more

5. Kouros (same as Fig. 1). Analysis of the sculptor's efforts at pattern making.

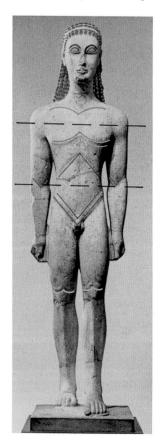

primitive than a contemporary Egyptian statue (Fig. 2). The Greek sculptor has sacrificed the smooth naturalism of his Egyptian model for the sake of creating a more aesthetically satisfying work. Greek artists were always concerned with striking a balance between beautiful designs and natural appearances, though sometimes the balance was tipped toward the abstract and formal, as here, and at other times toward the convincingly real.

The Greek statue we have been looking at (Fig. 1) was made near the end of the 7th century BC. It is one of the earliest examples of a type made throughout the archaic period (from about 650 to 490 BC). This type of statue – a nude male figure standing facing front with the weight evenly distributed on both legs – is called a *kouros* (plural: *kouroi*), meaning 'young man'.

THE PERILS OF PROGRESS: ARCHAIC KOUROI 650-490 BC

The Greeks made kouroi to serve one of three functions. A kouros could be the representation of a god; it could serve as a beautiful object offered as a dedication to a god; or it could be a memorial of a man, sometimes placed upon his tomb. There was nothing in any of these three functions that dictated the form of the statue and nothing to prevent artists from changing that form as they saw fit. This was very different from the practice in Egypt, where statues were often carved to serve a quasi-magical function, for instance, to be available as alternative homes for the *ka* (the spirit of a man) should his mummified body be accidentally destroyed. Magic is by its nature conservative and resistant to change. That is one of the reasons why a statue made around the middle of the 7th century BC in Egypt (Fig. 2) looks so much like a statue made more than a thousand years earlier (Fig. 3) around 1650 BC.

Change for its own sake, or 'progress', seems to us the natural order of things, but in antiquity it seemed daring, usually undesirable and often downright dangerous. Exact repetition of a model assured the sculptor of the successful outcome of his work. Changing even one element could lead to unlooked-for and often unfortunate consequences.

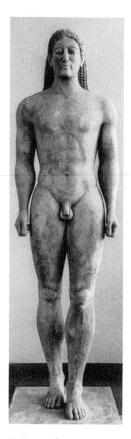

6. Kouros from Anavyssos, c. 530 BC, height 194 cm, National Archaeological Museum, Athens.

The Greeks, who were adventurous and willing to take risks, found all this out for themselves.

There were, of course, technical limitations on how much they could change at any one time, since the marble still had to be cut from the block in the same way, and any statue had to be designed so that it would not fall over or break. Within these limits, however, Greek sculptors started to make changes and to produce, little by little, increasingly naturalistic kouroi.

Within a hundred years, the kouros found at Anavyssos (near Athens) had been created (Fig. 6). This grave marker is a splendid figure, full of vibrant life, and shows a tremendous advance in the direction of naturalism. It is even more natural in appearance than the Egyptian statues (Figs. 2 and 3).

But the new realism of the Anavyssos kouros proved a mixed blessing. It was achieved by modifying the proportions of the figure and giving a more rounded treatment to the lines that had simply been engraved into the surface before. However, the hair – always difficult to render convincingly in stone – is carved not very differently from the hair of the early kouros. Here is a good example of the sort of problem that emerges once artists start making changes. The stylised, decorative, bead-like hair looked appropriate on the early kouros (Fig. 8) because it fitted in with the whole stylised decorative character of the statue. Not so on the later kouros (Fig. 7). There the swelling, natural forms of the body clash with the artificial, stiff, bead-like hair.

This clash of styles was not one that could be foreseen by the sculptor. It simply emerged when he altered some of the traditional elements. How such unanticipated problems could take a sculptor by surprise can be seen from a third kouros (Fig. 9) made around 500 BC, that is, about a generation later than the statue in Figure 6.

The statue representing Aristodikos – it also served as a grave marker – is still more naturalistic. It is so natural that it almost makes the Anavyssos kouros (Fig. 6) look like an inflated balloon by contrast. The problem with the hair has been solved by a new fashion; the hair is tied up in plaits (or braids) wound round the head rather than flowing loose down the back. And yet, despite the convincing anatomical forms – or perhaps just because of them – there seems something wrong with the statue of Aristodikos.

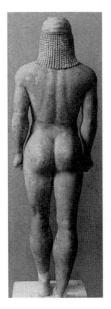

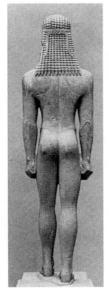

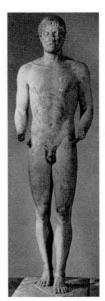

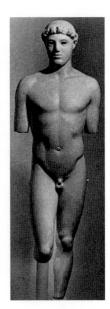

from left to right
7. Kouros from Anavyssos
(same as Fig. 6), back.

8. Kouros (same as Fig. 1),

9. Kouros (Aristodikos), *c.* 500 BC, height 195 cm, National Archaeological Museum, Athens.

10. Kritios boy, *с.* 480 вс, height 86 cm, Acropolis Museum, Athens.

Why, one wonders, does he stand so unnaturally? Why is he so stiff?

The pose is, of course, merely the consequence of the Greeks' having learned how to make statues from the Egyptians; this was the pose that the drawings on the block produced. The outlines used for this latest of the kouroi were not basically different from those used for the earliest (Figs. 1, 6 and 9 for front views, Figs. 7 and 8 for back views, and Figs. 11 and 12 for side views). In the earlier kouroi, the pose presented no problem; it is only when the figure has otherwise become so natural that we begin to question it. A gain in one direction entailed a loss in another.

The pattern that we recognise when we look at the three kouroi – change, emergence of a problem, solution of that problem and emergence of another – is a fundamental one for the whole development of Greek art. And the failures are as important to notice as the successes if we are to appreciate the daring of the Greek artists. They could have endlessly repeated the same proven formulae, as the Egyptians did, and run no risks; but their restlessness and sense of adventure spurred them on from one problem to another. Each problem led to a solution on a higher level of complexity until finally the Greeks produced solutions that carried such conviction that they left an impression on all later western art and eventually reached the far corners of the world.

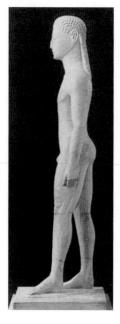

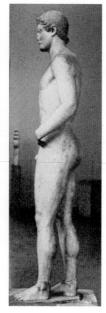

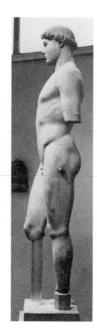

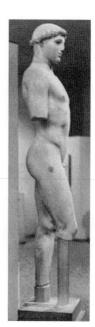

from left to right
11. Kouros (same as Fig. 1), side.

12. Kouros (Aristodikos) (same as Fig. 9), side.

13. Kritios boy (same as Fig. 10), left side.

14. Kritios boy (same as Fig. 10), right side.

NEW MEDIUM, NEW STYLE: BRONZE-CASTING IN THE EARLY 5TH CENTURY BC

The new problem emerging from the accomplished naturalism of the Aristodikos, the last of the kouroi (Fig. 9), namely, that the pose began to look stiff and rigid, could be solved in only one way: by changing the pose. The sculptor of the statue called the 'Kritios boy' (Fig. 10), made shortly before the Persian sack of Athens in 480 BC, has done just that. Instead of looking straight ahead, the boy turns his head slightly. Instead of standing evenly on both legs, he has shifted his weight onto his back leg, slightly raising the hip on that side.

The physical changes are actually rather small, but the consequences are enormous. The statue has come to life.

The technical challenge was great. The outlines drawn on the block for the earliest and the latest of the kouroi (see Figs. 1, 6–9, and 11 and 12) were not fundamentally different, and sculptors could use the same basic scheme, modifying only the proportions and details of finish, for more than a century. The sculptor of the Kritios boy, by contrast, had to make four radically new drawings (Figs. 10, 13 and 14).

Nobody had ever carved a statue in stone like this before.

How could the sculptor be sure that the outlines would fit together properly in such a new and complex pose? How could he know that the statue would look right when it was finished? Experimenting with a new pose was risky in the extreme. So much could go wrong.

It would, however, have been considerably easier to experiment with a new pose if the statue were to be cast in bronze rather than carved out of marble. To make a bronze statue, the artist would first make a model in clay (Fig. 15, black). He could walk round the model as he worked and change it as he went along, adding curves and adjusting contours in a way that would be impossible for a sculptor using marble. When the model was complete, the artist would cover it with a thin, even coating of wax (Fig. 15, vellow). The surface of the wax showed what the finished surface of the bronze statue would look like. Next, the artist surrounded the model with a mould (Fig. 15, blue), made mostly out of clay, thick and strong enough to withstand the pressure of molten metal. It fitted neatly around the wax and was held in place by iron rods that ran through to the core of the clay model. The wax was then melted out, leaving a gap between the clay model core and the outer mould (Fig. 15, white). Molten bronze (an alloy of copper and tin) was poured into the gap to fill the space originally occupied by the wax (Fig. 15, orange). After the bronze had cooled and solidified, the mould was chipped away and the completed bronze figure was smoothed and finished. (The 'lost wax' method of bronze-casting is often a great deal more complicated than this, as air vents are necessary and statues are seldom cast all in one piece, but this description and the diagram convey the essence of the process.)

Marble is a heavy material, with little tensile strength, that easily breaks under its own weight if extended unsupported over too great a span (for instance, the extended arms in Figure 18 would be in danger of breaking off if the statue were made of marble). A sculptor has to be extremely careful that all parts of a marble statue have adequate supports. Quite a different range of poses is therefore possible in bronze.

The Kritios boy (Figs. 10, 13 and 14) had been made in Athens a little before 480 BC, a critical year for the Athenians, since it was in 480 BC that the Persians sacked their city. This was one of the last episodes in the war between the Greeks and the Persians, for

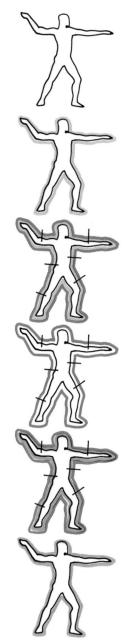

15. Diagram showing the 'lost wax' method of bronze-casting used by archaic and classical Greek bronze-casters.

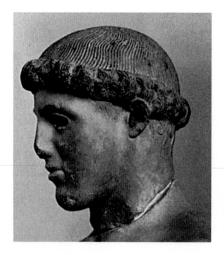

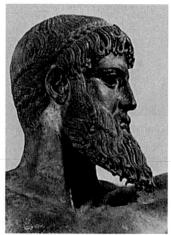

above
16. Kritios boy (same as Fig. 10), head (marble).

above right
17. Zeus of Artemisium
(same as Fig. 18), head
(bronze).

the next year the Greeks finally defeated their common enemy and drove the Persians out of Greece.

The Athenians then returned to their city and began to rebuild it. Most of their sculptures were beyond repair; the pieces were either used as building materials or simply piously buried. The Kritios boy was buried, only to be rediscovered, the head and the body separated, in the 19th century by archaeologists digging on the acropolis of Athens. Bronze statues had been either carried off or melted down. The stone base for one such lost bronze statue shows that it must have stood with the weight on one leg and the other relaxed, like the Kritios boy. Thus we know that a bronze statue in the new relaxed pose existed at about the time the Kritios boy was made.

It is easy enough to see how a statue like the Kritios boy might have been created in bronze, but why should a sculptor try something so new and difficult in marble? Perhaps he was struck by the liveliness of a bronze statue in the new relaxed pose. Would he not have felt disappointed when he returned to work on a kouros, even one as fine as the Aristodikos (Figs. 9 and 12), so very life-like and yet lacking the breath of life? Every careful new detail served only to make the statue look stiffer. Nothing but a change of pose could help. He decided to risk it, to make new drawings on all four sides of his block. It would take almost a year of hard work before he would know if his attempt had succeeded. Perhaps he actually took the bronze statue as a model and as a guide for his drawings. Details from the Kritios boy's head (Fig. 16) suggest that the sculptor had been looking at a bronze statue. The hair is represented by means of shallow scratched lines. Notice especially the wisps on the neck. This treatment is characteristic of bronze technique (see Fig. 17), for

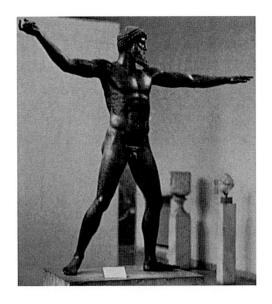

18. Zeus of Artemisium, second quarter of the 5th century BC, height 209 cm, National Archaeological Museum, Athens.

even slight scratches show up clearly on the smooth, shiny surface of a bronze. Marble does not reflect light so sharply; on the contrary, it absorbs it, so that much bolder carving is required to throw a shadow. That is of course why archaic sculptors represented hair by means of deeply cut, bead-like knobs. The use of inset eyes is also typical of bronze work (see Fig. 17); eyes on marble statues were usually painted.

In the end, as we can see, this sculptor's attempt did succeed; we do not know how many others failed.

GREATER BOLDNESS, MORE PROBLEMS: EARLY CLASSICAL STATUES

The Greeks had created, then, an entirely new kind of life-like statue. Nothing like it had ever been seen before. It made people look at statues in quite a new way, apply new standards and ask new questions, like 'What is this statue doing? Is he moving or is he still?'

Such questions probably never occurred to most sculptors making kouroi during the archaic period, but for artists working in the early classical period (the second quarter of the 5th century BC), they were vital issues.

The answer for the Kritios boy was clear; he stood unambiguously at rest. Other sculptors sought to explore the opposite extreme: emphatic movement. That is what the sculptor of the bronze Zeus (or Poseidon) found in the sea off Cape Artemisium did (Fig. 18).

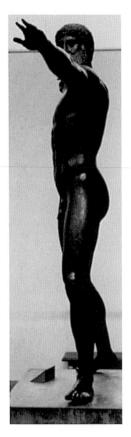

19. Zeus of Artemisium (same as Fig. 18), side.

The god is portrayed in the midst of vigorous action, at the very moment of hurling a thunderbolt (or trident) at an unseen enemy.

This fine bronze gives us a good idea of the extremely high quality that bronze sculptors could achieve at this time. The free, open pose also illustrates why the greatest sculptors of the 5th century BC preferred working in bronze to working in marble.

Questions of character or age were not asked when archaic sculptors carved kouroi; in these respects, their statues all looked much the same. By contrast, artists in the early classical period were deeply concerned about the characterisation of the men or gods they represented and used every device in their power to differentiate them in terms of age and personality. One has only to compare the youthful, tender, almost shy head of the Kritios boy (Fig. 16) with the magnificent mature and forceful head of the Zeus of Artemisium (Fig. 17) to appreciate this. It is not just a matter of adding a beard – archaic artists would sometimes do that to indicate an older man – but rather a profound and thoughtful distinction that is drawn between early adolescence and full maturity. (Both, of course, looked very much more convincing when they still had their coloured, inset eyes in place.)

We have seen that doing something new can easily unbalance the coherence of a work of art and that unforeseen problems are likely to emerge. This has happened with the Zeus of Artemisium. A novel sense of movement has been brilliantly captured, but at the same time two new problems have appeared, neither of which is solved.

First, though the torso should be dramatically affected by the vigorous activity of the limbs, it is as still as it would have been in a quietly standing figure like the Kritios boy. Second, though the Zeus of Artemisium is splendid from the front and the back, it is pathetically unintelligible from the sides (Fig. 19), which was not the case with the Kritios boy (Figs. 13 and 14) or even the kouroi (Figs. 11 and 12).

Made at the same time as the Zeus of Artemisium, in the second quarter of the 5th century BC, but very much more celebrated, was the Discus-thrower by the bronze-caster Myron. So famous was it that centuries later the Romans ordered copies to be made (Fig. 20). Instead of having expensive bronzes cast, the Romans chose to have copies made in marble, which was much cheaper.

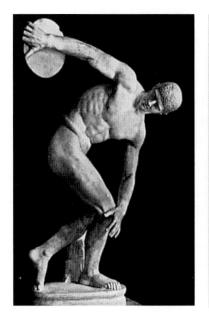

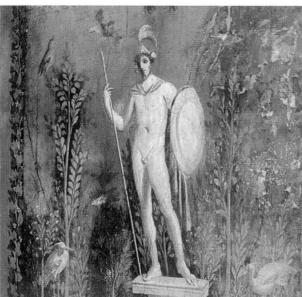

Such a delicately poised statue in marble could not stand up without supports, and so a marble tree-trunk behind the athlete was used to help hold up the top-heavy mass of stone and to keep it from cracking at the ankles. This might not originally have looked as disfiguring as it does now, since all marble statues were painted (Fig. 21), and the supporting tree-trunk would have been painted in so discreet a colour that it would hardly be noticeable. Pupils of the eyes were painted, too, which made the statues look lively and responsive – the blank stares we meet in museums are the result of the disappearance of the paint with time. Hair was also painted, lips were tinted, clothing was decorated. We can get some impression of an ancient marble statue with its original paint intact from a Pompeian painting of a statue in a garden (Fig. 21).

The original bronze Discus-thrower by Myron has disappeared (most ancient bronzes were melted down at some time, either by accident or on purpose), so we are lucky to have the Roman copies, for, although they do not convey the full beauty of the original, they give some important clues about its design.

The moment represented was chosen with genius. The Discusthrower is caught at the top of his backswing, just before he unwinds to throw the discus. It is an instant of stillness, and yet in our minds we are impelled to complete the action, as a 20th-century cartoonist suggests (Fig. 22). But though the pose is momentary, there is nothing unstable about it.

above left

20. Roman copy of the Discus-thrower by Myron, original made *c.* 450 BC, height 125 cm, Palazzo Massimo alle Terme (Museo Nazionale Romano), Rome.

above right

21. Pompeian painting of a statue in a garden, c. AD 70, height of pedestal and figure c. 210 cm, House of the Marine Venus, Pompeii.

below

22. Cartoon showing the psychological expectations aroused by the Discus-thrower.

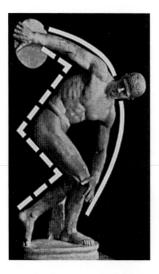

23. Roman copy of the Discus-thrower by Myron (same as Fig. 20). Analysis of design.

24. Roman copy of the Discus-thrower by Myron (same as Fig. 20), side.

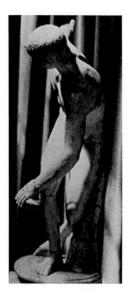

The Greeks were concerned not only to make their statues resemble men but also to make them objects of aesthetic delight. In the archaic period, symmetry and repetition of shapes were used to produce beautiful effects (Fig. 5). These were now out of fashion. In fact, they were systematically rejected in the design of the Discusthrower (Fig. 23). Notice how consistently symmetry is avoided. The right side of the statue is dominated by the sweep of a continuous, almost unbroken curve (Fig. 23, solid white), the left by a jagged zigzag (Fig. 23, broken white); the right side is closed, the left open; the right side is smooth, the left angular. The simplicity of the main forms, the great arc and the four straight lines meeting almost at right angles, bring harmony to the agitated figure. One sees the torso from the front and the legs from the side so that the most characteristic features of each are presented simultaneously. Both representation and design are marvellously clear.

But what of the problems that emerged from the active pose of the Zeus of Artemisium? Alas, they are still there, perhaps even in aggravated form. The torso is so little expressive of the actual action of the limbs that in the 18th century another copy of the Discus-thrower torso was taken to be part of a dying warrior and restored as such; and the side view, showing chest and legs each in their least characteristic aspects, is almost unrecognisable as a human figure (Fig. 24).

It was up to artists of the next generation, in the *high classical* period (about 450–420 BC), to try to solve these problems.

THE CLASSIC SOLUTION: THE SPEAR-BEARER OF POLYKLEITOS

The classic solution was formulated by Polykleitos, an Argive bronze-caster. He made a statue of a man carrying a spear and wrote a book (now lost) explaining the principles on which it was based. He was much admired for having embodied the rules of art within a work of art. The work, unfortunately, no longer exists. Once again we have to try to deduce from Roman copies in marble what made it so celebrated (Figs. 25, 27 and 28).

The Spear-bearer is shown in the midst of a step; a momentary pause combines stability with the sense of potential movement. The

action is far less vigorous than that of Myron's Discus-thrower, but the torso is eloquently responsive to it. The Spear-bearer held the spear in his left hand (to our right); his left shoulder is therefore tensed and slightly raised. His left leg bears no weight and the hip drops; the torso on this side is extended. The Spear-bearer's right arm hangs relaxed; the shoulder is dropped. His right leg supports his weight; the hip is raised. The torso between hip and armpit is contracted.

The contrast of contracted torso on one side and extended torso on the other gives the body a look of dynamic equilibrium, very different from the static symmetry of the kouroi, whose right and left sides are essentially mirror-images of each other. The alternation of tensed and relaxed limbs, combined with the responsive torso, is called *contrapposto*. It is a device that is used over and over again throughout the history of art, so effective is it in imparting a sense of vitality to figures made of stone or bronze or paint.

The turn of the Spear-bearer's head to his right gives the final touch to the statue; it describes a gentle reversed S curve, one that was much appreciated in the Gothic period and used to give grace to statues of the Madonna. The turn of the head to the right adds interest to the side view, a point that was appreciated by a later sculptor making a relief (Fig. 26), who adopted the side view of the Spear-bearer for his own purposes.

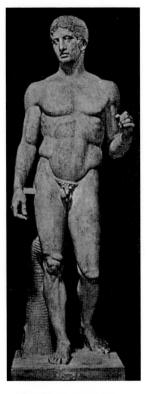

25. Roman copy of the Spear-bearer by Polykleitos, original made c. 440 BC, height 199 cm, Museo Nazionale, Naples.

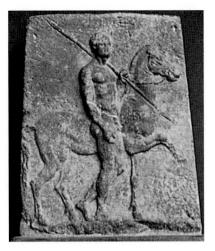

26. Stele found at Argos showing a side view of the Spear-bearer, 4th century BC, height 61 cm, National Archaeological Museum, Athens.

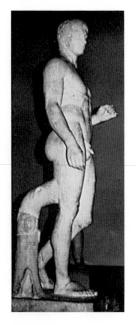

27. Roman copy of the Spear-bearer by Polykleitos (same as Fig. 25), right side.

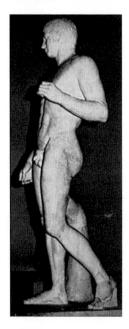

28. Roman copy of the Spear-bearer by Polykleitos (same as Fig. 25), left side.

The two side views have very different qualities, but each is harmonious and lucid in itself. The right side (Fig. 27) is tranquil, with the verticality of the straight weight-bearing leg continued in the vertical relaxed arm. The left side, by contrast (Fig. 28), is angular, the sharp elbow of the bent arm responding to the sharp bend of the relaxed left leg.

A great deal of art has gone into the making of a statue that looks artless. The perfect harmony that was attained in this work brought no new and unanticipated problems in its wake. This was the classic solution, one that was to be appreciated down through the ages.

STYLE AND TASTE: DRAPED FEMALE FIGURES

Though the Greeks in the archaic and classical periods liked to portray men in the nude, they preferred sculpted women to be clothed. The clothing actually worn by Greek women was loose and could be draped in a number of ways according to the wearer's choice. The artists also had considerable freedom in choosing how they would depict drapery. Drapery in all periods has provided much scope for expression, enabling artists to suggest calm serenity or agitated movement in accordance with the mood of the scene portrayed and the taste of their times.

Changes in taste often seem to have an inner rhythm of their own, almost independent of other factors. At one time simplicity is highly valued; at another, richness and elaboration are preferred. There is often a sharp reaction from one to the other. We see such changes of taste at work in modern fashions. They also influenced ancient art.

Although a statue of a clothed woman is entirely made of stone, some parts of it are supposed to look like a living person and other parts to look like inanimate but pliable fabric. A sculptor in the second quarter of the 6th century BC (575–550) was able to impart a life-like quality to the face, arms and feet of his figure (Fig. 29), but he left the clothing as a sort of dead area, with nothing more than its orderly appearance to recommend it. The many parallel vertical folds carved into the stone neither portray the soft natural fall of cloth nor suggest the presence of a living woman's body beneath it.

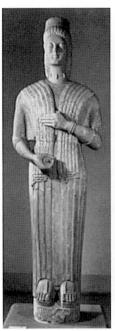

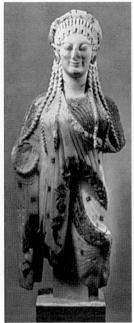

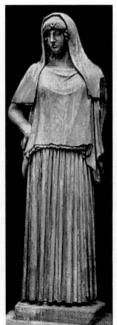

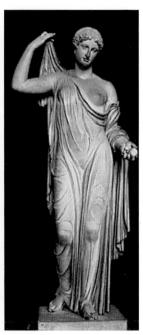

Artists had made great progress by the last quarter of the 6th century BC (around 525). They could now suggest the existence of a pair of swelling breasts, a slim waist and well-rounded thigh beneath an elaborate play of folds (Fig. 30). Two different kinds of cloth are even distinguished: a soft, thin, crinkly undergarment (painted a dark colour) and a heavy woollen cloak that is draped diagonally.

By the first half of the 5th century BC (around 460), a sculptor was able to make a statue look like a woman wearing clothing. Even a Roman copy (Fig. 31) shows how well body and drapery are integrated and how naturally they are both treated. Although little can be seen of the body, the irregular fall of the vertical folds of the skirt and the slight displacement of the material over the bosom convincingly suggest a body beneath.

The artist who created the so-called Venus Genetrix (known only through Roman copies) in the late 5th century BC has made the drapery so thin and clinging that the goddess's body is revealed almost as completely as it would be in a nude representation (Fig. 32). One breast, in fact, *is* bare.

In less than two centuries, then, sculptors had developed techniques and formulae that enabled them to show draped female figures as living women wearing garments made of soft cloth. The progress of naturalistic representational skill is very marked.

from left to right 29. Goddess, c. 575–550 BC, height 193 cm, Antikensammlung, Staatliche Museen zu Berlin, Preussischer Kulturbesitz, Berlin.

30. Maiden (Kore 675), c. 530–515 BC, height 56 cm, Acropolis Museum, Athens.

31. Goddess, Roman copy of an original from 470–460 BC, height 190 cm, Museo Capitolini, Centrale Montemartini, Rome.

32. 'Venus Genetrix', Roman copy of an original from *c.* 430–400 BC, Louvre, Paris. So too are the changes in taste. In the first half of the 6th century BC, drapery is austerely simple (Fig. 29). By the end of the century, it is usually shown as complicated and ornate, with strong diagonal accents, a multitude of folds going in different directions and a vivid suggestion of the body beneath (Fig. 30). In the early 5th century BC, there is a reaction and a return to a more severe style of drapery, one that covers and conceals and falls in heavy vertical folds (Fig. 31). By the end of the century, however, something more complex and decorative is once more in demand (Fig. 32). A strong diagonal accent is again introduced in the drapery that slips off the shoulder – in terms of design, it is much like that of the cloth draped under the breast in Figure 30 – and several lively folds counteract the naturally simple vertical fall of the cloth; now too the body is again revealed. These swings in taste are virtually independent of the continuous progress in naturalistic representation.

TRENDS AND DEVELOPMENTS IN ARCHAIC AND CLASSICAL STATUARY

Within a period of about two hundred years we have seen a remarkable development in Greek sculpture from the earliest kouroi (Fig. 1) to the classical perfection of the Spear-bearer (Fig. 25). Acquiring the ability to imitate natural appearances was but one element in this complex evolution. Artists also had to find solutions to the unexpected problems that emerged and to create works that embodied certain formal principles of design — through careful symmetrical patterning in the archaic period or by means of dynamic contrasts in the classical period. Finally, artists had to appreciate changes in taste: the way in which periods of delight in or rejection of the elaborate treatment of drapery alternated with one another.

Nature, design, fashion – all made demands on the sculptor. The factors that influenced the development of Greek art are many and complex. It would be unfair to the artists and to their achievements to simplify the situation in which they found themselves and the multitude of conditions they struggled so valiantly to satisfy.

2: GREEK TEMPLES AND THEIR DECORATION

FOUR POPULAR PLANS

The temple seems to us the most characteristic of all Greek buildings, and it would be natural to conclude that the Greeks regarded such buildings as requirements for the worship of their gods and goddesses. In fact, nothing more than an open-air altar was really necessary. However, once the Greeks began to make statues of their deities, they had to provide a shelter to protect them, and it was to serve this function that a temple was constructed. It was not built to accommodate a congregation, since religious ceremonies and rituals still took place at an altar outside the front (usually the east end) of the temple, and few people ever went inside.

A temple, whether made of wood or stone, could be very simple. A single room entered through a porch would suffice (Fig. 33). The room in which the statue of the god was kept was called a *naos* (the Romans called it a *cella*, and this term is sometimes also used of Greek temples). The porch was called a *pronaos* (literally 'in front of the naos').

When a temple could easily be seen from more than one side, the Greeks disliked having the front and the back look different, so they added another porch at the rear (Fig. 34). There was usually no way into the temple from the back porch (called the *opisthodomos*); its only purpose was to give the temple a more symmetrical appearance.

This was how smaller temples were designed. Larger temples were built to stand free in a clear space so that they would be visible from many points of view, and the Greeks tried to make all four sides of such temples look equally impressive by surrounding the core of the temple with a colonnade (Figs. 35, 37 and 38). This encircling colonnade was called a *peristyle* (from the Greek words *peri* 'around' and *stylos* 'column'), and it would usually surround the naos along with its pronaos in front and the balancing opisthodomos behind (Fig. 37).

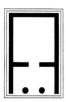

33. Plan of a simple temple consisting of just naos and pronaos.

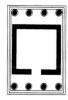

34. Plan of a temple with porches in front and at the back.

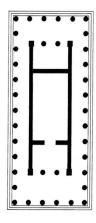

35. Plan of a temple with a peristyle.

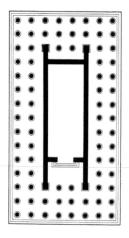

36. Plan of a temple with a double peristyle (dipteral).

The temple was generally built on a platform consisting of three steps. The top step was called the *stylobate*, and on it stood the columns of the peristyle and the walls of the naos (Fig. 38). Since a temple was part of a sanctuary, the entrance to the sanctuary would usually determine the angle from which the temple would first be seen. In most cases, the approach gave on to a corner of the temple (see Fig. 91). From this angle (Fig. 38), the temple could immediately be perceived as a three-dimensional volume rather than as a flat façade, and its principal dimensions (length, width and height) could all be taken in at a glance. In its clarity, its independence and its four equally satisfactory views, the peristyle temple is a characteristically Greek invention.

Some very rich poleis ostentatiously built temples with *two* sets of colonnades surrounding them. Such huge and costly structures must have looked very magnificent (Fig. 36).

The Greeks varied and modified their four fundamental plans for temples, making alterations in the proportions and the spacing of the elements from the time when they started building temples until the time when, with the triumph of Christianity, they stopped. Yet they kept the basic forms as constant as the pose of the kouros was kept throughout the archaic period. The Greeks liked to develop their ideas within a stable framework.

37. Plan of a typical peripteral temple.

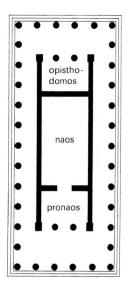

TWO BASIC ELEVATIONS: THE DORIC AND IONIC ORDERS

Greek temples were constructed on the simple post-and-lintel principle. Vertical posts (or columns or walls) supported horizontal lintels (or entablatures or ceilings). The earliest temples were built of wood and mud-brick on stone foundations. By the end of the 7th century BC, stone, which was both more expensive and more durable, began to be the preferred material for the building itself. The only temples of which substantial remains survive are those that were built of stone. In these, wall blocks were laid dry without any mortar. Coarse limestones were regularly coated with plaster to give them the appearance of an even surface. Marble was finely smoothed and so meticulously finished that the joins between one block and

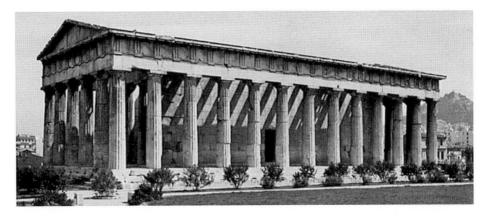

another are barely perceptible. Adjacent blocks were held in position chiefly by gravity, but some iron clamps sheathed in lead were also used to keep them in place. These would not have been visible once the temple was completed. Columns were erected similarly, with wooden pins used to help centre one drum upon another, and the joins were either so finely finished that they became virtually invisible or the whole was covered with a thin layer of plaster. In the final stages of building, the columns were *fluted*, that is, vertical channels were carved in the shafts.

The columns supported a horizontal *entablature* comprising an *architrave* (a band of rectangular blocks laid directly above the columns) surmounted by a *frieze* and topped by a cornice. Both columns and entablatures were designed so that they belonged to either the *Doric* or to the *Ionic order*. In each order, the proportions of all the elements and the scheme of decoration were co-ordinated with one another; mixing the two was rare before the Hellenistic period.

The Doric order (Fig. 39) was strong, simple and massive. The column *shafts* were sturdy (their height was only four to six times their lower diameters) and rested directly on the stylobate (Figs. 38 and 42). The *capitals* surmounting the shafts were simple, cushion-like swellings topped by an undecorated square abacus, which supported a plain, undivided architrave. This in turn supported the frieze, which was divided into alternating *triglyphs* (vertically grooved rectangles whose appearance was reminiscent of beam ends) and *metopes* (rectangles which could be plain, painted or sculpted in relief). There was one triglyph over each column and one between each pair of columns so that the measured rhythm of the columns was exactly doubled in the rhythm of the frieze above (Fig. 38).

38. View of a peripteral Greek temple from the corner, third quarter of the 5th century BC, Hephaisteion, Athens.

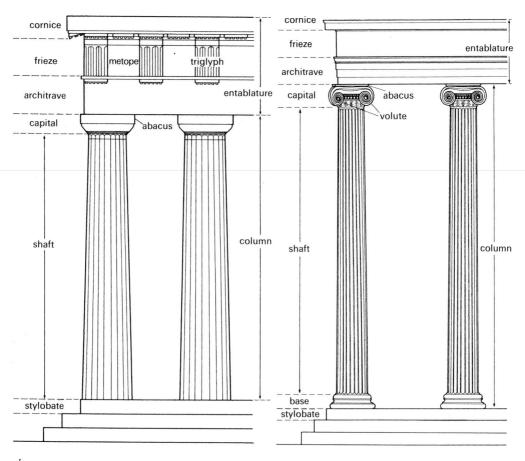

above 39. The Doric order.

above right 40. The Ionic order. The Ionic order (Fig. 40) was more delicate and ornate. The column shafts were slender (ranging in height from eight to ten times their lower diameters) and rested on elaborate *bases* that consisted of at least two convex parts and one concave (Figs. 40 and 41). Ionic capitals curve over to the right and left and end in *volutes* and are surmounted by a thin, carved abacus, on which rests the architrave, often divided into three horizontal bands. The triple division subtly reflects the three steps on which the temple usually stands. The frieze above is undivided and may sometimes be decorated by a continuous band of relief carvings. The cornice at the top is normally richer than the Doric cornice and may carry several bands of pattern cut in relief.

The basic forms of the two orders were constant, but within limits the elements and the proportions could be modified. The Ionic order was generally treated more freely than the Doric. For instance, in the Ionic order as it first developed in the eastern Aegean and the coast of Asia Minor – and often later as well – *dentils* (small

tooth-like carvings) were used at frieze level instead of a continuous frieze. And yet each order always preserved a special character of its own, so pervasive that it can be perceived even in details. Thus Figure 42 conveys the strength and simplicity of the Doric order, while Figure 41 reveals the grace and delicacy of the Ionic. (Both show the very bottom of a column – the shaft of the Doric and the base of the Ionic – where it rests on the stylobate.)

At the end of the 5th century BC, the Corinthian capital was invented (Fig. 43). It soon became popular and was much used in the Roman period as an alternative to the Ionic capital within a somewhat enriched version of the Ionic order.

All temples were covered by a pitched roof, which left triangular gables at the front and back; these are called *pediments* (Fig. 38). Decorative acroteria, which, unfortunately, have seldom survived, graced the three angles of the gables and softened the severe geometry of the temple's roof.

SPACES AND SHAPES TO DECORATE

Three areas on Greek temples invited sculpted (or painted) decoration: the triangular pediments on temples of either order (although those in the Ionic order were only seldom filled), the rectangular metopes on Doric temples, and the long, narrow, continuous friezes on Ionic temples.

None of these would have presented any problems if the Greeks had been content to fill them with floral or abstract patterns, as was sometimes done later by the Romans and 18th-century neoclassical decorators. But the Greeks were not satisfied with anything so simple. They wished instead to represent people, or monsters, and if possible to represent them enacting a story. Consider the problems that then arose.

PEDIMENTS AND THEIR PROBLEMS

A pediment is a long, low triangle. It is not easy to arrange figures within it so that they will fill it harmoniously, tell a story and tell it

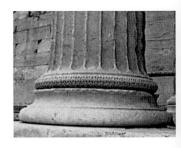

41. Base and bottom of the shaft of an Ionic column, late 5th century BC, Erechtheion, Athens.

42. Bottom of the shaft of a Doric column, mid 5th century BC, Propylaea, Athens.

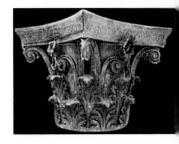

43. Corinthian capital, 4th century BC, Epidauros Museum.

44. Reconstruction drawing of the west pediment of the Temple of Artemis on Corfu, first quarter of the 6th century BC (c. 580).

coherently. This is obvious from the difficulties encountered by the artist who carved huge figures in relief to decorate the pediment of the Temple of Artemis in Corfu in the early years of the 6th century BC (around 580) (Fig. 44). The high centre of the triangle is filled by a huge Gorgon, whose terrifying features would have been considered effective in warding off evil spirits from the temple. But her role was more than that of a mere guardian. The Gorgon was Medusa, whose fate was to be decapitated by the hero Perseus. At the moment of her death, she gave birth to two children, Pegasus the winged horse and Chrysaor the hero, who sprang from her neck as her head was severed from it. Medusa, in her bent-knee pose, is meant to be shown running away from Perseus; the unhappy outcome of her flight is suggested by the presence of her two children, Pegasus on the left, Chrysaor on the right.

The Gorgon is flanked on either side by crouching panthers. They do not have her double function of simultaneously protecting the temple and suggesting a story; they are just guardians of the temple whose reclining posture enables them to fit comfortably into the awkward shape of the pediment.

Tucked into the corners are several tiny figures. These are purely narrative. Those on the left come from the story of the fall of Troy: King Priam, seated, is about to be killed by the Greek attacking him, a dead Trojan lies behind him. The figures on the right are participants in the battle of the gods and giants. The great god Zeus, wielding his thunderbolt, has brought a giant to his knees. Another giant lies supine in the corner.

Decoratively the pediment is superb; narratively it is incoherent. Three completely unrelated stories are told, and they are told on totally unrelated scales. This may not have been disturbing to someone looking at the pediment at the time it was made. He might have been pleased simply to recognise the three stories and to enjoy each one in itself. He probably would not have thought of the pediment space as a single field in which a unified image of reality ought to appear. But demand for convincing and coherent representations,

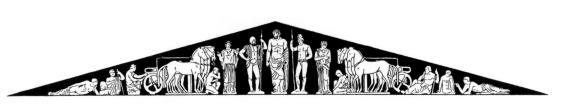

even within such an awkward triangular frame, did eventually arise. This happened as a result of the way the Greeks looked at art and of their notion, revolutionary at the time, that art should be the mirror of nature.

We have seen that when the Greeks looked at the statue of a man, they (unlike earlier peoples) thought of it more as a man than as a statue. They therefore demanded that it should resemble a man, and it was to meet this demand that increasingly naturalistic images were produced. The Greeks thought about pediments similarly. At first they were satisfied with a pleasant design and a multitude of stories, but in time they came to think of the pediment shelf as a sort of stage on which a plausible vision of a real situation should appear. Thus they desired artists to fill the space of a pediment with a single story, intelligibly told by figures all conceived on a single scale. This presented a difficult problem, but within a century a satisfactory solution had been devised.

The designer of the east pediment at Aegina, carved around 490 BC, chose to depict a mythological battle (Fig. 45). It was a good choice. The mighty goddess Athena stands in the centre, her head reaching to the apex of the pediment. On either side mortal heroes, who are naturally smaller than she, fight and fall, the incidents of war being so arranged that those nearest the middle stand while those further away stagger, lunge, crouch or lie in conformity with the slope of the pediment. The same scale was used for all the figures (now carved fully in the round); the violent theme gives plausibility to their different heights.

The next generation saw a *tour de force* in pedimental design: the east pediment of the Temple of Zeus at Olympia (465–457 BC) (Fig. 46). There is no violent action, and yet within a quiet scene a

top

45. Reconstruction drawing of the east pediment of the Temple of Aphaia on Aegina, first quarter of the 5th century BC (*c.* 490–480).

below

46. Reconstruction drawing of the east pediment of the Temple of Zeus at Olympia, second quarter of the 5th century BC (*c*. 465–457).

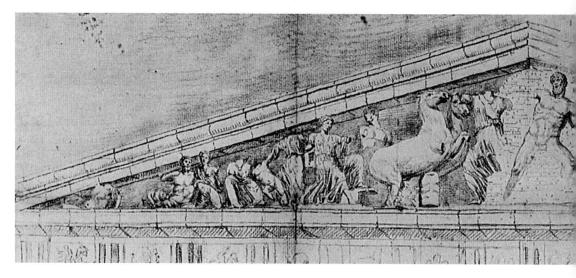

47. Seventeenth-century drawing of the west pediment of the Parthenon in Athens, third quarter of the 5th century BC (438–432), drawing in the Bibliothèque Nationale, Paris.

story is compellingly told with figures of uniform scale, the whole pediment being harmoniously filled.

In the centre stands Zeus, again a god who is taller than mere men. On his right (our left) stands Oinomaos, king of Elis. He is offering his daughter as bride to any man who can carry her off in his chariot and reach the Isthmus of Corinth before Oinomaos overtakes and kills him. Oinomaos has divine horses, and twelve suitors have already perished. A young man, modest in demeanour, stands to the right listening. He is Pelops, destined to defeat the old king and marry the girl. The prospective bride and her mother flank the men. Next come the chariot teams; the horses' heads, since they are higher than their rumps, are symmetrically turned towards the centre. Behind them on one side squats a charioteer holding the reins of the chariot, and on the other a seer, dismayed, is seated peering into the future, where he witnesses the terrible disaster in store for Oinomaos. Servants and other subordinate characters sit near the corners, which are neatly filled with reclining river gods, their legs extending into the furthest angles (Fig. 55).

The scene is tense, unified and effective. The subtle difference in the characterisations of the arrogant Oinomaos and the modest Pelops, the intense involvement of the principal characters and the detachment of the servants — one boy passing the time absent-mindedly playing with his toes — are all part of the early classical exploration of personality and mood which we also saw in the Kritios boy (Figs. 10 and 16) and the Zeus of Artemisium (Figs. 17 and 18).

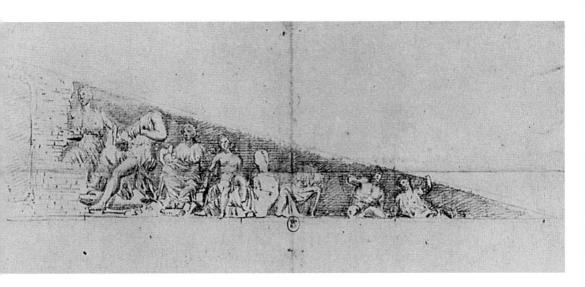

The pediments of the Parthenon in Athens (Fig. 47), carved a generation later (438–432 BC), are even more ambitious. The temple was unusually broad and so the pediments had to be extraordinarily wide, a change in scale that intensified the problems inherent in pediment design. While the pediments at Olympia were comfortably filled with about fifteen figures, well over twenty were required to fill each pediment of the Parthenon. Since these were placed higher up from the ground than usual, they were deeply carved so that they would catch the light and remain intelligible at a distance. Though they are boldly designed, these figures are finished with great refinement (Fig. 56), and even the backs, which would not have been visible once they were in place, have been completed with scrupulous care.

The west pediment showed the contest of the goddess Athena and the god Poseidon for the patronage of Athens (Fig. 47). The two huge deities occupied the centre, pulling away from each other. Teams of horses probably reared up on either side. We have to rely on a 17th-century drawing for our information about the design, as most of the sculpture still visible then has since been destroyed. From the violent thrusts and counterthrusts in the middle of the pediment, waves of excitement eddy out, finally coming to rest in the calm and unconcerned reclining figures of the river gods at the corners.

The river god (Fig. 56) that once occupied the left corner of the west pediment and can now be found in the British Museum illustrates the combination of grandeur and subtlety that distinguishes the pedimental sculpture of the Parthenon. Muscles flex, flow and

ripple, while the relaxed belly gently sags forward. Anatomy is portrayed naturalistically but without finicky detail. The softness of flesh, the strength of muscle, the hardness of bone are all suggested but not exhaustively explored.

The sense of drama and excitement in this pediment is marvel-lously conveyed (Fig. 47), but beyond the striking central composition, things seem to fall to pieces almost as they did in the Corfu pediment (Fig. 44). The gods and goddesses at the sides witnessing the spectacular event taking place in their midst are very shrunken in scale. Notice how tiny the river god in the corner is compared with Poseidon in the centre. As far as design is concerned, the artist has overreached himself and has tried to accommodate too many figures. The dazzling brilliance of the carving of the few surviving figures has, however, tended to divert attention from the imperfections of the composition.

METOPES: FEW BUT TELLING FIGURES

Metopes, being nearly square, are easier to decorate and fill than pediments. If, however, the artist wants the story presented in a metope to be intelligible at a distance, he must carefully choose the moment to be illustrated and use no more than three or four figures.

The sculptor of a metope on the Treasury of the Sicyonians at Delphi, carved around 560 BC, has produced a fine piece of decoration (Fig. 48). (A treasury was a small building erected in a panhellenic sanctuary to hold the dedications and offerings made by the polis that built it.) The metope now shows three heroes – originally there was one more – marching off to the right, proudly accompanying the oxen they have stolen in a heroic cattle raid. They occupy the full height of the metope, a triad of parallel vertical figures. They hold their sloping spears at the same angle and walk in step with the cattle, whose legs, meticulously aligned, recede into the background of the relief. A fine pattern emerges, elegantly composed of repeated shapes in the archaic manner (cf. Fig. 5).

The metopes on the outside of the Temple of Zeus at Olympia (465–457 BC) were left plain, but the twelve metopes over the

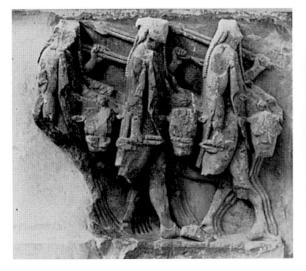

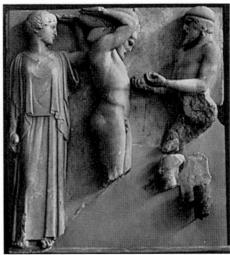

porches, six over the front porch and six over the back, were carved in relief. They illustrated the twelve labours of Herakles, one labour to each metope.

One labour required Herakles to fetch the apples of immortality from the garden of the Hesperides. Herakles persuaded Atlas to bring the apples to him while he held up the heavens in Atlas' place (Fig. 49). The metope shows Atlas, rejoicing in his unusual freedom of movement, striding to the left holding the apples in his outstretched hands. Herakles faces him, oppressed by the burden that rests heavily on his shoulders. The goddess Athena, his patroness, stands on the far left, one hand raised in an easy gesture of aid to the hero.

Something subtler than the parallel lines and repeated patterns on the metope from the Sicyonian treasury (Fig. 48) relates the three figures on the Olympia metope (Fig. 49). Atlas, the only figure shown in action, moves in from the right. His chest is shown in three-quarter front view; his extended forearms make a strong horizontal contrast with the predominant verticals of the design and draw our attention to the apples in his hands. Profile to profile he faces Herakles, who is shown in side view. Athena, fully frontal, majestic and still, brings the movement to an end. Athena's sympathy with Herakles is delicately indicated not only by her upraised hand but also by the turn of her head – in profile, like Herakles, confronting Atlas.

The master of the Olympia metopes could also portray conflict superbly. He showed Herakles fighting the monstrous Cretan bull

above left 48. Cattle-stealing metope from the Treasury of the Sicyonians, c. 560–550 BC, height 58 cm, Delphi Museum.

above right
49. Atlas bringing
Herakles the apples of the
Hesperides, metope from
the Temple of Zeus at
Olympia, c. 460 BC,
height 160 cm, Olympia
Museum.

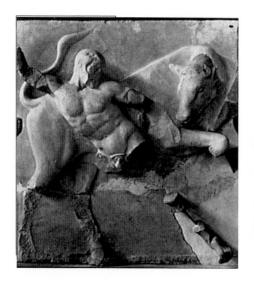

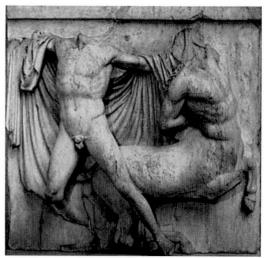

above 50. Herakles and the Cretan bull, metope from the Temple of Zeus at Olympia, c. 460 BC, height 160 cm, Louvre, Paris.

above right 51. Lapith and centaur, metope from the Parthenon in Athens, 447–442 BC, height 134 cm, British Museum, London. (Fig. 50) as a composition based on two crossing diagonals, so that both figures could appear especially large in relation to those on the other metopes. In a splendid invention designed to convey the intensity of the struggle, he makes the hero wrench the head of the gigantic bull round to confront him face to face.

The dynamism of this explosive composition was much appreciated in later times. The same structure underlies the conflict of the central figures in the west pediment of the Parthenon (Fig. 47), and it is also used for one of the most striking metopes on the Parthenon (Fig. 51).

The Parthenon was exceptionally richly decorated with architectural sculpture. Not only were the unusually wide pediments crammed with figures, but all ninety-two of the metopes on the outside of the temple were carved (447–442 BC). Those on the south, almost the only ones reasonably well preserved, represented the conflict of the Lapiths (mythical people supposedly living in the north of Greece) with the centaurs (monsters that were part man and part horse). In one metope (Fig. 51), man and monster pull energetically away from each other; the tense struggle is visually accentuated by the play of light and shadow on the deep folds of the cloak that falls behind the Lapith and over his arms. The Lapith's body is rendered by such a subtle wealth of anatomical detail and by transitions of so great a delicacy and softness as to make the Olympia metopes, with their grand simplifications, look by contrast ruggedly severe.

The metope at the western end of the south side of the Parthenon is magnificent (Fig. 52). It shows a centaur rearing up to strike a

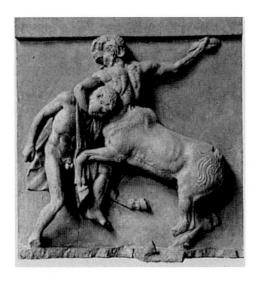

52. Lapith and centaur, metope at the western end of the south side of the Parthenon (from a cast), 447–442 BC, height 134

Lapith, who counters the attack by thrusting a spit (or some other implement which was originally added in bronze and is now lost) into the centaur's flank. The designer took special care to suit the composition of this metope to its position on the building, for it was the last on the left of a series. The vigorous curve of the Lapith's body is thus not only a response to the action within the metope but also provides a splendid termination for the entire sequence of scenes.

From the schematic, handsomely patterned design of the archaic metope on the Treasury of the Sicyonians (Fig. 48), the Greeks gradually evolved the dynamic, classical balance of the finest metopes of the Parthenon (Figs. 51 and 52).

FRIEZES: DIFFICULTIES OF DESIGN

Friezes presented more problems of design than metopes. A frieze was an immensely long, narrow ribbon for which it was not easy to find a satisfactory subject. The elaborate decoration of the Parthenon included a frieze, which was an unusual Ionic feature in this predominantly Doric temple. It was carved between 442 and 438 BC (Figs. 53, 54 and 98). The theme chosen was a procession in honour of the goddess Athena. It is designed so that the participants in the sculpted frieze appear to accompany the observer walking along beside the temple in the same direction. On each of three sides, the procession moves in one direction for the whole length of the side (Fig. 53). At the front, the two branches of the procession converge

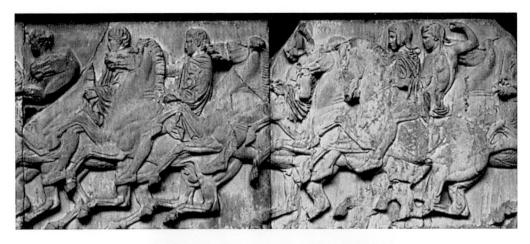

above 53. Part of the procession on the Parthenon frieze, 442–438 BC, height 106 cm, British Museum, London.

right
54. Part of the procession
on the Parthenon frieze,
442–438 BC, height 106
cm, British Museum,
London.

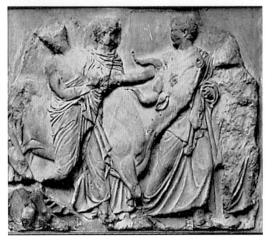

towards the centre, producing a natural point of rest for the eye. The flow of the figures is unified but not monotonous. Sometimes the procession is dense and the figures move along quickly (Fig. 53), at other times the pace is measured (Fig. 54) or even stately (Fig. 98).

THE EARLY AND HIGH CLASSICAL STYLES CONTRASTED

The exquisite carving of the frieze of the Parthenon is revealed by a detail of some youths bringing a heifer to sacrifice (Fig. 54). The austere simplicity of the Olympia metope (Fig. 50) looks almost harsh in comparison with the richly expressive carving on the Parthenon

55. River god from the corner of the east pediment of the Temple of Zeus at Olympia, *c.* 460 BC, length 230 cm, Olympia Museum.

56. River god from the west pediment of the Parthenon in Athens, 438–432 BC, length 156 cm, British Museum, London.

frieze. Notice how differently the heifer is rendered from the Cretan bull. The same contrast can be seen in a comparison between a river god from the east pediment at Olympia (Fig. 55) and a river god from the west pediment of the Parthenon (Fig. 56).

An observer living in ancient times who could have compared the original early-classical Discus-thrower (Fig. 20) with the original high-classical Spear-bearer (Fig. 25) would have noticed a similar contrast. The two works must have differed not only in design but also in style and treatment of surface. The severe simplicity of Myron's conception affected every aspect of his statue; the delicate balance of forms in the stance of the Spear-bearer was symptomatic of the method of working used by Polykleitos, who was particularly celebrated for the refinement of his finish. If we combine in our minds the design of the Discus-thrower with the austere vitality of the Olympia sculptures, and the poise of the Spear-bearer with the delicacy of surface of the Parthenon sculptures, we will come close to appreciating why the achievements of the early-classical and the high-classical periods are so much admired.

3: PAINTING AND PAINTED POTTERY

PAINTING ON WALLS AND PANELS

The Greeks, like us, thought of painting primarily in terms of paintings on walls and panels. Large paintings on flat surfaces were often used to decorate architecture; metopes, for instance, would sometimes be painted rather than carved in relief. Figure 57 shows a 7th-century BC example. The metope is about a metre square and depicts the hero Perseus, who, having beheaded the fierce Gorgon and put her terrifying head in a bag (the eyes can be seen peering out), runs off to the right. The pin-wheel form of the figure in flight is well conceived to fill the whole surface of the metope in a decorative and lively way. The metope is made of terracotta and painted in shades of black, purplish-red and orange, colours that were suitable for firing. There is no effort to show the figure realistically in space; this is just a fine pattern, recognisable as a running man, arranged to make a handsome decoration.

This is practically the only well-preserved example we have of large-scale painting from this period.

57. Perseus fleeing with the Gorgon's head, painted metope from the Temple of Apollo at Thermon, second half of the 7th century BC, watercolour reconstruction (original in the National Archaeological Museum, Athens).

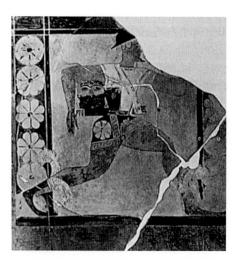

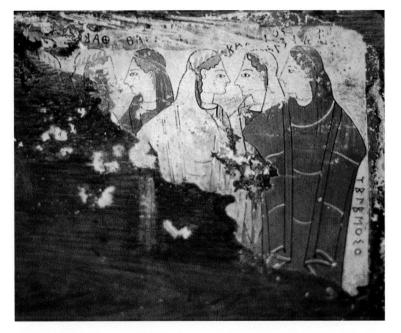

58. Painted wooden panel from Pitsa near Corinth, second half of the 6th century BC, height 14.5 cm (copy), original in the National Archaeological Museum, Athens.

The Greeks also painted on wooden panels. In Figure 58, several women are shown chatting, their delicate profiles outlined in red. Reds and blues are freely used for their clothing. This is an exquisite piece of drawing. It is still very flat, but the overlapping of one figure on top of another suggests the existence of the figures in space. The panel was painted in the later 6th century BC. Wood decays in the Greek climate, and this panel and the others found with it near Corinth are virtually the only Greek paintings on wood to survive to the present day.

If we had to learn about Greek painting from examples such as these, we would have very little to go on. Fortunately we have another source of information: pottery. In most civilisations, pottery decoration is a minor art, sometimes attractive but usually unimportant. Not so with the Greeks – at least not until the dawn of the classical period.

PAINTING ON POTTERY: THE BEGINNING

Decorating a pot is a very different matter from painting a picture on a flat surface. The outer surfaces of the pot are rounded, and parts curve away from the viewer. The profile can be strangely irregular;

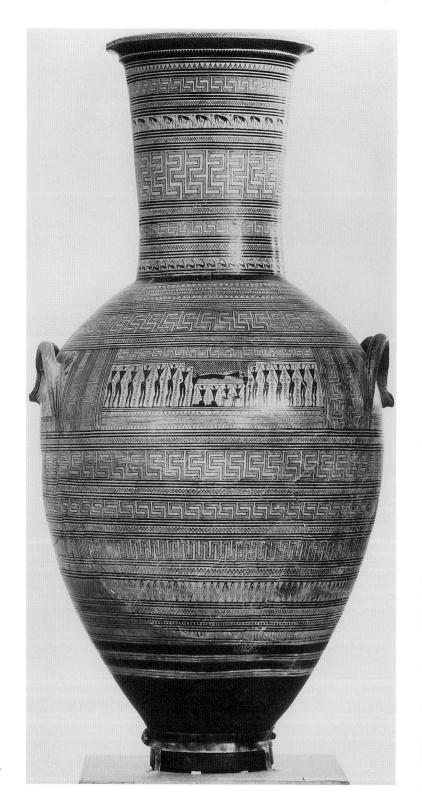

59. Amphora showing mourners around a bier, mid 8th century BC, height 155 cm, National Archaeological Museum, Athens.

the outline of a pot (for instance, Fig. 59) can sometimes even look like an inverted keyhole. This would make an oddly shaped frame for an ordinary picture. Of course, the Greeks did not use the contour of a pot as a frame for a picture but skilfully adjusted their designs to the vessels they were ornamenting.

Even as early as the 8th century BC, while the Homeric epics were being formulated, grand and impressive pieces of pottery could be created. Though the pot shown in Figure 59 is huge, about a metre and a half high, the elements that decorate it are small. They cover the entire surface with a network of light and dark, subtly varied to emphasise the different structural parts of the vessel: offset lip, cylindrical neck, expanding shoulder, wide belly and tapering foot. Strong triads of horizontal lines divide the surface into bands. All the patterns within the bands (except for the three that are decorated with living creatures, namely, the grazing deer and reclining goats on the neck and the men on the belly) are designed to be either vertical or horizontal. In this way the decoration is made to enhance the stable and monumental appearance of the vessel and to contrast piquantly with its curving contour.

Human figures appear only in one small but important section: the panel between the two handles. They are slim, elegant stick figures painted in flat silhouette. The scene represents mourners around a bier. The whole gigantic piece of pottery was used as a grave marker, and the sombre, controlled, meticulous decoration accords well with this function.

Pottery had been briefly elevated to the status of a monumental art, but from the end of the 7th century BC, stone slabs (*stelai*, singular: *stele*), either painted or carved in relief – or even statues in the round, like kouroi – were used as grave markers, and pottery went back to functioning as the useful craft it had always been.

HOW GREEK POTTERY WAS USED

The Greeks made pots with painted decoration to serve four main purposes (Fig. 60):

1. As containers and storage jars of ample capacity in which wine, water, olive oil or dry goods were kept. A pot with two handles is called

kylix

an *amphora*, one with three handles (two at the sides for lifting and one at the back for pouring) used for water is called a *hydria*.

- 2. As equipment for drinking parties. The Greeks drank their wine diluted with water; they therefore needed a wide-mouthed mixing bowl called a *krater* into which they could pour the two liquids and a jug called an *oinochoe* to dip it out so that it could be poured into a delicate cup (*kylix*) or a more humble mug (*skyphos*).
- 3. As vessels used in connection with personal adornment. Olive oil was very important in Greek life, not only for cooking, but also for lighting, for cleaning the body and as a base for perfumes. A *lekythos* could hold as much as a litre or two of olive oil and had a narrow neck to restrict the flow. An *alabastron* was a small flask with a very constricted neck from which a lady could shake a few drops of perfume. Still smaller and rather rounder was an *aryballos*, a vessel equipped with a thong for carrying or hanging, which held the olive oil men used to rub down with after exercise.
- 4. As special vessels for use in rituals. For instance, the loutrophoros was used to carry the water for a bride's ritual bath before her wedding. Sometimes a stone model of a loutrophoros was placed on the grave of an unmarried person. Olive oil was often presented to the dead in a lekythos covered with a white slip and fugitive paint added after firing, which would have been unsuitably delicate for everyday use. Such white-ground lekythoi were occasionally made with false necks so that only a small part at the top had to be filled to give the impression that the whole vessel was full, a clever bit of economising.

In the 18th century, when the modern study of ancient pottery began, all these vessels were called 'vases'. This conventional designation has persisted ever since, despite the fact that Greek pottery was clearly made to serve purely utilitarian functions, was only incidentally used as decoration and almost never held cut flowers.

NEW INTERESTS IN THE 7TH CENTURY BC

By the 7th century BC, human figures and their activities had become the most important part of vase painting for artists in several

areas of Greece. Homer's poems were by then very popular, and the vase painter longed to follow the poet's example and himself become a storyteller (Fig. 61). He therefore simplified the traditional patterned decoration and banished most of it to the bottom of the vase, thus clearing the principal area of his krater for the presentation of an exciting tale. From this time on, vase painters, like the artists who later carved architectural sculptures, strove to show men (and monsters) in action. Greek mythology was rich in tales of adventure - Homer recounted some of them in the *Iliad* and the Odyssey - and they provided an unending source of inspiration for artists.

The painted scene shows Odysseus and his men, after having made the Cyclops drunk, driving a great stake into his single eye. The men are drawn in flat silhouette, except for their faces which are drawn in outline. The Cyclops, who looks a bit small for a giant, sits on the ground to the right.

The artist had to try to satisfy two rather contradictory conditions: to decorate his vase with an effective pattern and to make his story clearly intelligible. He has succeeded in telling the story with great liveliness and has, at the same time, made the repeated forms of the men working in unison into a pleasing pattern. And yet this bold decoration seems less perfectly suited to the shape of the vessel than that used on the earlier monumental vase (Fig. 59).

We happen to know who made this vase (Fig. 61), for Aristonothos was one of the first potters to put his name on his work. From now on potters and painters somewhat irregularly signed their work. Many of the best artists, however, never signed, and even good artists with known signatures often left their finest work unsigned.

lekythos

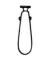

arvballos

alabastron

61. Krater by Aristonothos showing Odysseus and his friends blinding the Cyclops, mid 7th century BC, height 36 cm, Museo dei Conservatori, Rome.

VIVIDNESS IN STORYTELLING: THE BLACK-FIGURE TECHNIQUE

Storytelling eventually came to be the overwhelming concern of the painters who decorated vases. It captivated and enthralled them; other considerations became largely subordinate. It provided a powerful impetus toward naturalism, for painters were constantly looking for ways to make their stories livelier and more convincing. They felt that the vividness of Homeric poetry was a challenge to them and tried to rival it; they, too, wished to make stories come alive for their audiences.

It was difficult for painters to achieve this new goal while working just with silhouettes. Most stories required figures to interact and overlap, but the overlapping of silhouettes could only lead to confusion. Some painters, therefore, briefly experimented with outlining their figures. Unfortunately, the outlines looked disappointingly thin on the burnished curving surface of a pot. The conflicting demands of persuasive narration and effective decoration stimulated the search for a better solution.

The solution came with the invention of the black-figure technique. The artist painted his figures in silhouette as before, so that they would look bold and telling, and then he incised their contours and inner markings with a sharp instrument that removed the paint along the line of incision and left the outlines clear. He also

62. Black-figure painting by Kleitias of Ajax carrying the body of Achilles on the handle of a krater (the 'François vase'), c. 570–560 BC, Museo Archeologico, Florence.

added touches of white and purplish-red, so that the scenes became more colourful. Since the added white and purplish-red proved less durable than the black paint and the basic orange of the background, on many black-figure vases little trace of them remains.

The vase painter Kleitias obtained wonderful effects with the black-figure technique around 570-560 BC (Fig. 62). The picture of Ajax carrying the body of Achilles is part of the decoration on the handle of a particularly richly painted krater (the so-called François vase). An extremely moving image has been created. The great hero Ajax rises with difficulty under the burden of the even greater hero whom he lifts. The body of Achilles is draped limply over the shoulders of his friend. The arms drop lifelessly, the hair hangs heavily. Notice the closed eye of the dead Achilles and how it contrasts with the wide-open, sorrowful eye of Ajax. Achilles was a fast runner (Homer calls him 'swift-footed Achilles'), but death has extinguished his speed. Kleitias recalls what Achilles was in life; look how carefully he has drawn the kneecaps and how he has indicated the strong muscles in the legs. Figure 63 reveals how unintelligible this picture would be if attempted in silhouette alone. The incised lines that articulate the image are obviously essential.

A generation later, in the third quarter of the 6th century BC, there lived the greatest of all black-figure masters: Exekias. A good

63. Drawing of Fig. 62 without the incision.

example of the exquisite refinement of his style is the image painted on an amphora (Fig. 64) showing Ajax and Achilles playing a game, the same two heroes we saw painted by Kleitias but here in a happier moment. The heroes' finely embroidered cloaks are rendered by means of the most delicate incision. The serene composition captures the tranquillity of the scene and the absorption of the heroes. As they bend towards the gaming board, the curve of their backs echoes the curve of the amphora. Exekias shows that he was very much aware that he was decorating a vase. Not only does he make the outlines of the heroes follow the outline of the vessel, but he also places the spears so that they lead the eye up to the top of the handles and arranges the shields behind the heroes so that they continue the vertical line formed by the lower part of the handles.

The stature of Exekias becomes very clear if one compares his amphora with one done by a lesser artist (Fig. 65) who has taken over the theme, and to a large extent also the composition, from Exekias. The differences are marked. Only the shield of the left-hand hero relates to the shape of the vessel, the embroidery on the cloaks is simpler; neither hero wears a helmet and the composition consequently lacks unity and tends to fall apart into two virtually symmetrical halves. Still, this is a good artist; it is only that his painting lacks the genius that makes Exekias' work so outstanding.

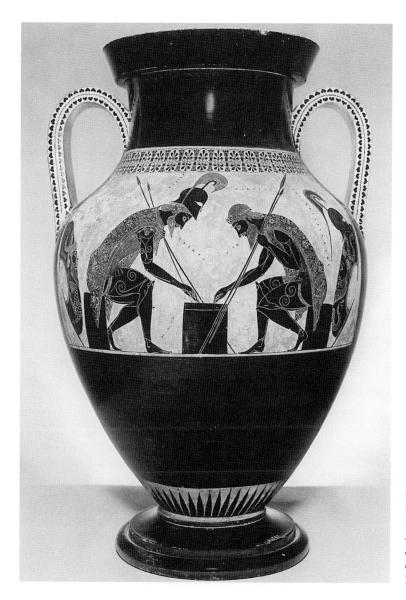

64. Black-figure amphora made and painted by Exekias showing Ajax and Achilles playing a game, c. 540–530 BC, height 61 cm, Vatican Museums, Rome.

THE SEARCH FOR NEW EFFECTS: THE RED-FIGURE TECHNIQUE

While few vase painters could attain Exekias' standard, most who were active in the next generation continued to use the black-figure technique. One of the more imaginative, however, decided to

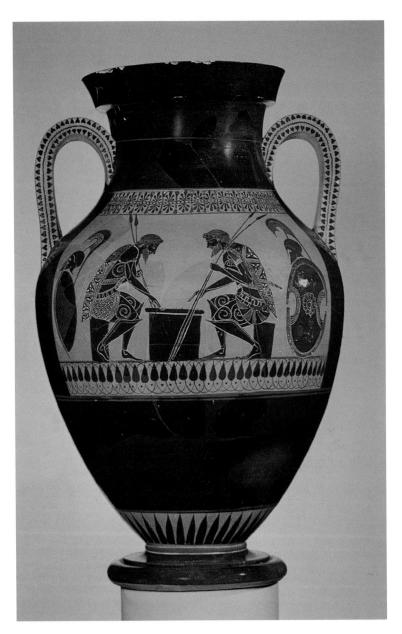

65. Black-figure scene on an amphora showing Ajax and Achilles playing a game, *c.* 530–520 BC, height 55 cm, H. L. Pierce Fund, 01.8037, photograph ©2003 Museum of Fine Arts, Boston.

experiment and try something different (Fig. 66). What he did was simply reverse the traditional colour scheme: instead of painting black figures on an orange-red ground, he left the figures in the natural colour of the clay and painted the background black. For painters this new red-figure technique had many advantages. It preserved the strong decorative contrast of the colours unchanged but it gave greater scope for drawing, since a supple brush could be used

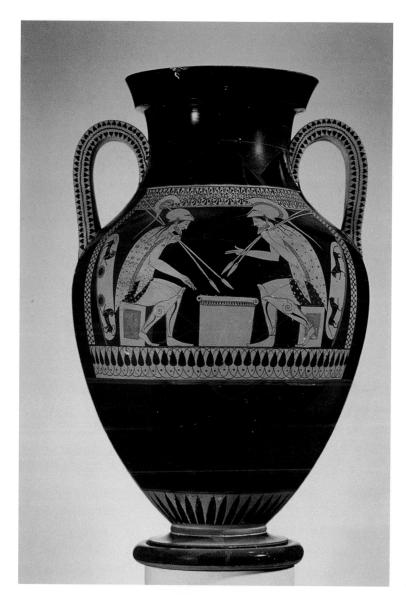

66. Red-figure scene on an amphora showing Ajax and Achilles playing a game (the other side of Fig. 65). Photograph © 2003 Museum of Fine Arts, Boston.

instead of a harsh engraving tool. Anatomy became livelier, cloth softer, and the figures more vibrant with life.

The red-figure technique was invented around 530 BC and was quickly taken up by the best and most ambitious painters, although mediocre painters continued working in black-figure until the middle of the 5th century BC. The older technique was used for special purposes right up until the 2nd century BC, but it had lost its fascination.

11 14 14

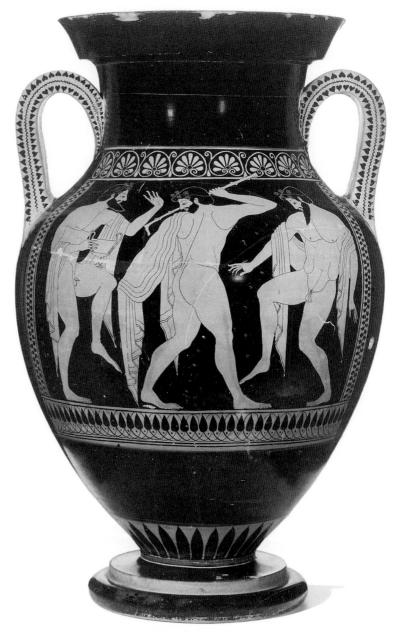

67. Red-figure amphora painted by Euthymides showing revellers, *c.* 510–500 BC, height 60 cm, Staatliche Antikensammlungen und Glyptothek, Munich.

Euthymides, working in the last decade of the 6th century BC, was delighted with the facility that red-figure gave him. Like artists carving reliefs at that time and also those doing free painting (as we learn from ancient writers), Euthymides was much concerned with the problems of three-dimensional representation, that is, with showing full, round figures convincingly rendered by means of

foreshortening (Fig. 67). To explore these effects he hardly needed to illustrate a story; scenes from everyday life were just as good. These had formed only a minor current in black-figure painting. On the amphora shown in Figure 67, he depicts three drunken revellers carousing. The central one is most striking. He is drawn from the back, a novel point of view. Euthymides was so pleased with this work that he wrote on the vase 'Euphronios [a rival vase painter] never did anything so good': a proud boast, for works by Euphronios that we know are powerful indeed. The remark gives us a vivid insight into the lively competition between artists that spurred them on to face and overcome ever new problems.

No one at the time could have challenged the inventiveness and excellence of Euthymides' drawing, nor could anyone have failed to marvel at the way he suggested the massiveness and volume of his figures. The surface of the amphora has been transformed into a field for the exhibition of advances in foreshortening; for the best artists there could now be no turning back. And yet, was it appropriate to decorate the curving surface of a vase in this way? Are not plain silhouettes, or even the highly elaborated silhouettes of Exekias (Fig. 64), more suitable? Regarded purely as applied decoration, is not the geometric vase (Fig. 59) the most satisfying? Perhaps, as we have seen before, progress in one direction (naturalistic drawing) has produced problems in another (decorative effectiveness).

By the beginning of the 5th century BC, the red-figure technique had been thoroughly mastered. Now it could be used expressively, as is shown in a painting on a hydria that depicts the mythological sack of Troy (Fig. 68). The old king, Priam, sits on an altar. This ought to have assured him of divine protection, but an arrogant young warrior grasps him by the shoulder to steady the old man as he prepares, heartlessly, to deliver the death blow. King Priam puts his hands to his head. It is a gesture less of self-protection than of despair. His grandson, brutally murdered, lies on his lap, the child's body gashed with horrible wounds. How different this scene of the death of Priam is from the crude and simple image on the Corfu pediment (Fig. 44)!

Another part of the painting shows a Greek warrior harshly pulling a woman away from the statue of a goddess to which she clings for protection. Notice the eloquence of the pleading hand

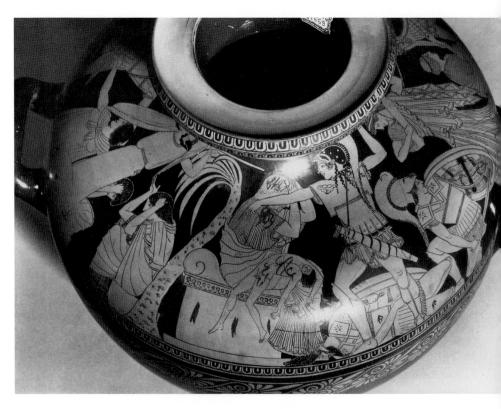

above and opposite 68. Red-figure hydria shoulder showing the fall of Troy, c. 490–480 BC, total height 42 cm, Museo Nazionale, Naples.

she extends towards him. Old men, children, defenceless women – these are the ones who suffer in war. The artist knew it well; he was an Athenian living at the time of the Persian Wars.

ADVANCES IN WALL PAINTING: POLYGNOTOS

The most famous artist in the quarter-century following the Persian Wars, the early classical period (about 475–450 BC), was the painter Polygnotos. He was a mural painter, and none of his works survive, but from what ancient writers tell us and from imitations and adaptations of his and his contemporaries' work in sculpture and vase painting, we can get some idea of what his revolutionary paintings must have been like.

Polygnotos was most interested in the delineation of human character, and this he did through quiet and intense scenes. The still, tense, expressive group of figures in the east pediment of the Temple of Zeus at Olympia (Fig. 46), with their sensitively rendered,

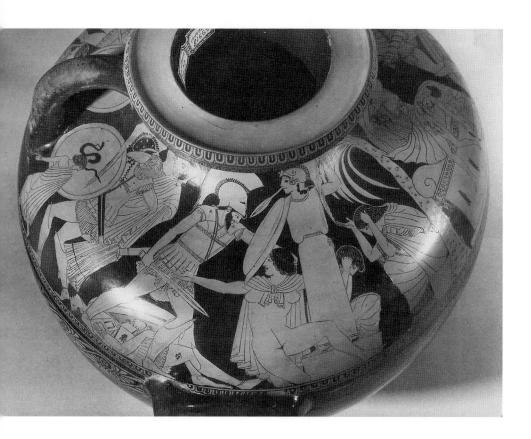

contrasting personalities, show profound influence from Polygnotos. Something of his special quality can also be seen echoed in a painting on a krater which shows Orpheus, the legendary musician who could charm animals and stones and even the gods of the Underworld with his songs, playing to four Thracian listeners (Fig. 69). The characters of the four and their attitudes toward the spellbinding music are all finely differentiated. The youth to the left of the singer has yielded entirely. He closes his eyes and listens enraptured. His companion (far left) leans on his shoulder and gazes dreamily at the singer. The two men at the right seem less well disposed towards music. The one closest to Orpheus stares intently at him, angrily trying to fathom the power of his art. The one on the far right is thoroughly disapproving and turns to leave (notice his feet), but he looks back; he cannot break the spell. Orpheus himself, absorbed in his song, belongs to a wholly different realm.

Such a static scene works well in a small panel on a vase, but Polygnotos decorated great walls with huge compositions filled with

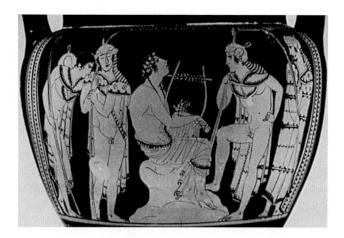

69. Red-figure krater showing Orpheus playing to the Thracians, c. 440 BC, height 51 cm, Antikensammlung, Staatliche Museen zu Berlin, Preussischer Kulturbesitz, Berlin.

a large number of figures. Depictions of actions make for exciting arrangements, but since Polygnotos wished to reveal character through quiet, motionless figures, he had to devise a different way of making his compositions lively. What he did was to distribute his figures up and down the wall at different levels so as to cover the surface with interesting groups. A possibly unexpected consequence of this innovation was that the figures higher up looked as if they were further away; that is, the figures appeared to be receding behind each other, and the wall itself ceased to appear entirely flat but began to suggest an indefinite space.

We do not know whether Polygnotos was pleased with the illusion of depth created by his novel distribution of the figures or was disappointed that the pattern he had carefully composed on the surface of his painting had been disrupted by the suggestion of space. In any case, what his paintings threatened to do was to pierce a hole in the wall they decorated, and that must have been a startling, even alarming, idea when it first arose.

A few vase painters tried to copy Polygnotan compositions (Fig. 70). It was a mistake. The shiny black background negates the suggestion of space, and the scatter of figures looks odd and purposeless. Now, for the first time, vase painting and free painting go their separate ways.

THE ILLUSION OF SPACE

We take it for granted that three-dimensional objects and threedimensional space can be represented on a flat surface; illusionistic

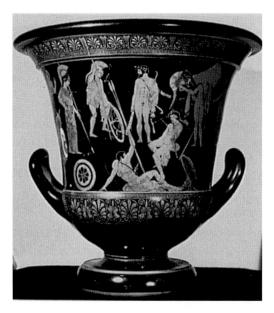

70. Red-figure krater showing the influence of Polygnotan painting, *c.* 450 BC, height 54 cm, Louvre, Paris.

pictures are part of our everyday experience. Before the Greeks, they did not exist. The Greeks invented them.

Euthymides (Fig. 67) and his contemporaries in the late 6th century BC began using foreshortening in their drawing of individual figures in order to give them the appearance of being three-dimensional. By the end of the 5th century BC, the painter Parrhasios was supposed to have been able to draw outlines so suggestive that they seemed to reveal even what was concealed. This he seems to have done without the aid of internal markings or shading. Something of his achievement may be reflected in a white-ground lekythos that was used as a funeral offering (Fig. 71): it shows striking economy of line and spareness of internal marking combined with an impressive suggestion of volume.

Zeuxis, a contemporary of Parrhasios, was also concerned with making his figures appear to have mass. He chose to indicate mass not through suggestive outline but through the clever use of shading. His was the approach that captured the imagination of later painters. Parrhasios' immense skill in drawing was much valued, and examples of his work were treasured for centuries, but it was Zeuxis' more painterly method of indicating volume by means of modelling that was developed further. Still later, painters began to study the effects of highlights and reflected light.

Massive bodies seem to exist in their own space. When they are shown overlapping, the space is deepened, and when some are shown

71. White-ground lekythos perhaps showing the influence of Parrhasios, end of the 5th century BC, height 30 cm, National Archaeological Museum, Athens.

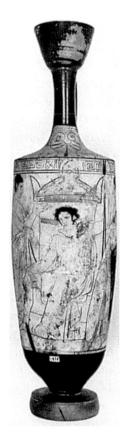

higher than others, as in Polygnotos' paintings, there is some hint of the existence of space itself and of the fact that figures are set into it.

The idea of creating a sense of space in its own right seems to have been explored in the later 5th century BC by Agatharchos, who painted stage sets. His experiments with vanishing points (receding lines in architectural drawings that converge at a point) apparently stimulated contemporary philosophers (Democritus and Anaxagoras) to make a theoretical study of perspective. Such, at any rate, is the testimony of Vitruvius, one of the writers from whose works we derive much of our information about classical painting.

WRITTEN SOURCES OF INFORMATION ON THE ARTS

Vitruvius lived in the time of the Roman emperor Augustus (31 BC-AD 14) and wrote a book about the theory and practice of architecture. From time to time, almost in asides, he says something about painting. Other authors, such as Plutarch (who wrote biographies), Aristotle (who wrote criticism of poetry), Cicero (the Roman orator who also wrote philosophical treatises) and Lucian (who composed witty satires), also mention Greek painters and painting. From these incidental remarks we can learn a great deal.

Two ancient writers, however, stand apart from the rest, for they give us more than just snatches of information.

The first is Pliny the Elder. He was a Roman polymath, interested in everything. (The breadth of his intellectual curiosity finally killed him, for he died while investigating the cataclysmic eruption of Vesuvius in AD 79.) He wrote an encyclopaedic book, *Natural History*, which was a descriptive work divided into sections on animals, vegetables and minerals. In part of the section about minerals, he dealt with the stones and metals used by sculptors and some of the pigments used by painters that are made from minerals, and this led him to give a short history of sculpture and painting. Pliny discussed the development of the arts, the contributions of different artists and some celebrated individual works.

The second major source of information is Pausanias. He was a Greek traveller who lived in the 2nd century AD and wrote a guide to

Greece addressed to the tourists of his time. He walked through the most important cities and sanctuaries in mainland Greece, noting things of interest and describing the famous works of art that he saw. He devoted long passages to paintings by Polygnotos, and it was from studying his detailed descriptions that modern scholars realised that Polygnotos set some figures higher than others and were able to recognise that kraters like the one shown in Figure 70 were reflections of his work.

Such authors also tell us a great deal about sculpture. Much of the information they set down comes from Greek sources dating from the 4th century BC or earlier. By then the Greeks had realised that in their art they had created something entirely new and noteworthy and were eager to comment upon it. Even as far back as the 6th century BC, some architects had written books about their work, and we know that the sculptor Polykleitos in the 5th century BC wrote a treatise explaining the principles on which he made his Spear-bearer (Fig. 25). Actual histories of art were written in the 4th century BC, and many anecdotes were recorded about artists. Unfortunately, most of this material is lost, but the fragments that are preserved, embedded in the works of Pliny, Pausanias and other authors, give us valuable insights we could not obtain elsewhere.

Even so, we learn disappointingly little about the lives and personalities of archaic and classical artists. Myron was famous in his time, but Pliny (*Natural History* 34.57–8) only tells us where he was born and who his teacher was, enumerates his best-known works and makes some general remarks on his style. Lucian's detailed description of Myron's Discus-thrower, 'who is bent over in the throwing position, is turned toward the hand that holds the discus and has the opposite knee gently flexed, like one who will straighten up after the throw' (*Philopseudes* 18), enables us to recognise Roman copies of this work (Fig. 20). But other masterpieces, like the Zeus of Artemisium (Fig. 18), cannot with certainty be ascribed to any artist we know of, while many of the names recorded in ancient texts cannot be related to any works that survive, either in the original or in copies.

The fragments of information that we can glean from literary sources are sometimes contradictory. Some of the stories about Pheidias, one of the most celebrated of ancient artists, exemplify this. Pheidias, Plutarch tells us (*Life of Pericles* 13), was put in charge of all the public works constructed at the time of Pericles' ascendancy in Athens. Pericles was the statesman who guided the Athenian democracy at the peak of its political and creative power. The Parthenon and the Propylaea on the Acropolis (Fig. 91) were erected under his influence. His friend Pheidias, as general overseer, must have guided and supervised the execution of the architectural sculpture of the Parthenon (Figs. 51–54, 56 and 98), though he did not do any work with his own hand. He was much too busy at the time creating the great *chryselephantine* (gold and ivory) statue of Athena that was to go inside the temple. Pheidias was most renowned for his huge chryselephantine statues of gods – he made another one, of Zeus, for Olympia – though he also worked in bronze and marble.

Because of his friendship with Pericles, we hear more of Pheidias than of most artists of the archaic and classical periods. Plutarch (Life of Pericles 31) writes that political enemies of Pericles tried to attack the statesman through the artist he favoured. They accused Pheidias of having embezzled some of the gold intended for the statue of Athena, and when the charge was convincingly disproved, they accused him of impiously representing himself and Pericles on the shield of the statue, for which supposed indiscretion he was taken off to prison, where he died. Plutarch implies that these events took place shortly after the statue of Athena was completed, but archaeologists have established that Pheidias went on to Olympia to make his Zeus after he had finished his work for the Parthenon. Since, furthermore, Pausanias (5.14.5) tells us that descendants of Pheidias continued to hold a special position at Olympia for many generations, the story that the great sculptor ended his life in an Athenian prison seems unlikely to be true.

We must, obviously, be cautious in our use of literary sources. If, however, we use them carefully, we can occasionally attach a name and a reputation to an original statue or a Roman copy. One can enjoy the art of Greece and Rome by just looking at it, but for an understanding of its history and development, the context in which great works were created and the influence they exerted, the written sources are essential.

PART II. THE FOURTH CENTURY BC AND THE HELLENISTIC PERIOD: INNOVATION AND RENOVATION

4: SCULPTURE

THE DECLINE OF THE CLASSICAL POLEIS AND THE RISE OF THE HELLENISTIC KINGDOMS

The Peloponnesian War took a heavy toll. Powerful Athens had been defeated, but mighty Sparta had also been weakened. For a little while in the 4th century BC, Thebes gained ascendancy, but it was limited in time and influence. No force seemed able to unite or subjugate the Greek poleis permanently. By the end of the 1st century BC all this had changed. Dominated first by Macedonia and then by Rome, the poleis were never again to have anything more than nominal independence.

Though the Macedonians were Greek-speaking people, they differed profoundly from the citizens of the Greek poleis. They were ruled by kings and lived more or less on the fringes of Greek civilisation. Philip II, who ruled from about the middle of the 4th century BC, nevertheless appreciated what was best in Greek culture. He enticed to his court one of the most renowned Greek philosophers of the day – Aristotle – to act as tutor for his son and also, perhaps, one of the greatest Greek painters, whose name is lost to us, to decorate the royal tombs (Fig. 82). Philip dreamed of leading the Greeks in an expedition against the Persians to avenge the Persian invasion of the early 5th century BC. Through keen political shrewdness and aptly deployed military might, by 338 BC he had conquered or made allies of all the Greek poleis on the mainland. But before he could turn his dream into reality, he was murdered.

His twenty-year-old son Alexander, known to later ages as 'the Great', succeeded to Philip's throne and to his plans. The recently subjugated Greek poleis took the first available opportunity to rebel against Macedonian domination. Alexander's response was swift and characteristic. To serve as an example he had the entire city of Thebes razed to the ground – except for the house owned in the

previous century by the celebrated poet Pindar. The rebellion was quelled. Henceforth the Greeks, like the Macedonians, followed quietly where Alexander led, until his mighty armies had advanced right into India. Then the soldiers refused to go on. Alexander, obliged to turn back, died in Babylon in 323 BC at the age of 32. He had conquered all the lands from the Ionian Sea to the Punjab and from the Caucasus to the borders of Ethiopia. He left no adult heir.

Alexander's huge empire fell apart. His generals, able and gifted men, remained in control of several parts of the empire but were constantly at odds with one another. Their rivalries were inherited by their descendants along with the lands they ruled. The empire split into vast kingdoms: Egypt ruled by the family of the Ptolemies; western Asia governed by the Seleucids; Greece dominated by and Macedonia ruled by the Antigonids. From the early 3rd century BC to the later 2nd, the enterprising and cultured dynasty of the Attalids carved out a domain for themselves in Asia Minor, centred on their capital at Pergamon. There were also some smaller kingdoms, and some venerable Greek cities were nominally free. In the meantime, little appreciated by anybody but the Attalids, the power of Rome was growing. By 31 BC the entire Hellenistic world had been absorbed into the Roman empire.

The kingdoms of the Hellenistic world (Map 2) were very different from the poleis of the Hellenic world (Map 1). 'Hellenic' is an adjective that the Greeks in ancient times used to describe themselves. 'Hellenistic' is a modern adjective used to describe the period between the death of Alexander and the final conquest of the Greek-speaking world by Rome (323–31 BC). It means 'resembling the original Hellenes' and is related to 'Hellenic' as 'realistic' is related to 'real'.

The Hellenistic kingdoms were ruled by Greco-Macedonian dynasties, the successors of Alexander. Cities on the Greek model had been founded along Alexander's path of conquest and settled by his Greek and Macedonian soldiers. These cities differed from those of the mother country both in size and in political structure; they were often vast metropolises like Alexandria or Antioch, and they were not free in anything but name.

The intimacy and independence of the Hellenic poleis were gone forever. Men, being no longer citizens of a polis but rather subjects of huge kingdoms, felt they no longer belonged to a group but only to themselves. Public buildings had dominated the old cities in Greece and private houses had been extremely modest. Private houses in Hellenistic cities, by contrast, ranged from comfortable to luxurious, for they were the domain of the individual. Public monuments were also grand, but they were built by monarchs, not the people. The temper of the times had radically changed.

The cities were dominated by Greeks – many new settlers had migrated to them from the homeland – but the surrounding peoples were quickly attracted to these centres of higher civilisation. They tried to absorb Greek culture, but inevitably they broadened, distorted and vulgarised it.

The new tendencies that developed in Hellenistic art can already be discerned in the 4th century BC.

NEW TRENDS IN SCULPTURE IN THE 4TH CENTURY BC

Three new trends distinguish sculpture in the 4th century BC from that of the second half of the 5th. First, there was a vigorous new push towards naturalism and with it a revival of interest in differentiation. Human beings were characterised not only in terms of age and personality, as they had been in the first half of the 5th century, but now also in terms of emotion and mood. Second, there was increasing specialisation, even among artists, some of whom became adept in the rendering of passion and others in portraying more lyrical moods and gentler emotions. Third, new concepts – often even abstract ideas – became subjects for art. These could be conveyed by means of personifications, that is, representations in human form of concepts (like Peace) or states of mind (like Madness). Modern personifications such as the figure of Britannia on the old British penny or the Statue of Liberty in New York harbour are derived from this Greek tradition.

All three trends were exploited by the citizens of Megara, near Athens, when they commissioned five new statues for their Temple of Aphrodite. They had an old ivory image of Aphrodite, the goddess of love, but towards the middle of the 4th century BC they decided to amplify the meaning of the sanctuary in almost philosophical terms. The Megarians asked Skopas, a sculptor who was distinguished for his representations of passion, to create statues representing Love, Desire and Yearning, and Praxiteles, noted for his rendering of the tenderer emotions, to sculpt the gentler figures of Persuasion and Consolation.

Thus the Megarians encouraged sculptors to produce images of emotions and moods hitherto little explored in the visual arts; they took advantage of the specialities of famous artists, and, finally, they made explicit five different aspects of the goddess Aphrodite. Giving concepts a visible and human form was an artistic response to contemporary philosophical thought, which was engaged in clarifying similar analytic ideas.

In the first half of the 5th century BC (500-450), Greek artists had tried to capture in stone or bronze the subtle qualities that distinguish men of different ages and temperaments. The sensitivity of these characterisations had given a breadth of humanity to Greek art that made it outdistance anything that had been seen before. In the second half of the century (450-400 BC), however, there had been a shift away from the exploration of diversity and towards the consolidation of a more universal ideal. The impetus for this shift derived chiefly from the influence and prestige of the two greatest sculptors of the age: Pheidias, the director of works on the Parthenon, who was praised for his sublime portrayal of the gods, and Polykleitos, the bronze-caster who created unsurpassed images of men. Both had died by the early years of the 4th century BC, and with their passing there came a revival of interest in naturalism, diversity and characterisation. These tendencies, which gave the art of the 4th century its special character, continued to be explored and elaborated in the succeeding Hellenistic period.

72. Knidian Aphrodite by Praxiteles, Roman copy of the original made *c.* 370 BC, height 204 cm, Vatican Museums, Rome.

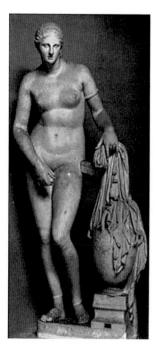

THE FEMALE NUDE: A NEW THEME IN GREEK ART

Praxiteles was renowned for statues that conveyed lyrical emotions. His most famous creation was a nude Aphrodite which was bought by the citizens of Knidos. The statue was extravagantly praised for its

beauty, the melting glance of the eyes, the radiance and joyousness of the expression. Poems were written to celebrate it – in one, the goddess herself is supposed to have exclaimed 'Wherever did Praxiteles see me naked?' Men fell in love with it, and an enthusiastic collector, Nikomedes, the Hellenistic king of Bithynia, was so smitten by it that he offered to cancel the whole of the Knidian public debt (which was enormous) in exchange for it. But the Knidians wisely declined, for the statue made their city famous.

The statue is now lost. From uninspired Roman copies (Fig. 72) it is difficult to see what all the fuss was about. The colouring of the original must have made a great difference, giving a soft blush to the cheeks and a wonderful melting glance to the eyes. Praxiteles himself, when asked which of his statues he considered the finest, replied 'Those Nikias has painted.' Nikias was also a famous painter of pictures, but he apparently did not feel that painting Praxiteles' statues was beneath his dignity.

Even through the clumsy Roman copy, one can grasp something of the beautiful ease and self-containment of the original pose. Praxiteles has cleverly applied the Polykleitan invention of contrapposto to the female form. Notice the contracted side of the body (to our left), where the hip rises and the shoulder drops. On the other side, the hip of the relaxed leg is lowered and the shoulder of the arm holding the drapery rises so that the line of the torso is extended. The inner harmony, the balance of a living organism, the sense of freedom and of repose which made Polykleitos' Spear-bearer a classic work (Figs. 25–28) are just as effective here, but a new dimension has been gained by the application of Polykleitan principles to the rounded forms of the female nude: sensuousness.

This is easier to appreciate in a Renaissance drawing by Raphael (Fig. 73). The contrapposto is the same, but more obvious and clearer to the eye; the Praxitelean invention has been sensitively adapted. Like the Roman copy (Fig. 72), this drawing is not an original. The figure was created by Leonardo da Vinci, but like Praxiteles' work it is lost, and Raphael's drawing is merely a copy – a copy, however, by a great artist.

Though the male nude had long been accepted as a challenging subject for artists, Praxiteles was revolutionary when he created a major statue representing a nude female figure. She is shown with

73. Raphael drawing, copy of 'Leda' by Leonardo da Vinci, showing the use of contrapposto, early 16th century, 30.8 × 19.2 cm, Windsor Castle.

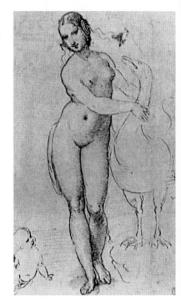

the naturalism to be expected in the 4th century BC, naturalism not only of form and detail but also of action, for she holds her clothes quite simply, having just taken them off to prepare for a bath. The bath water is ready in the jar to her left (the combination of clothing and jar supplying the necessary support for the marble arm of the original). The inert fall of the drapery and the rigidity of the hydria contrast piquantly with the soft living forms of the body. The goddess holds her right hand in front of her genitals. This might be interpreted as a gesture of modesty, but it is more likely that, since this is an image of Aphrodite, the goddess is here indicating the source of her power, just as the bath she is about to take is a ritual bath, not just an everyday affair. The graceful integration of natural appearance and religious significance is one of the great achievements of Praxiteles.

If we try to imagine Praxiteles' statue of Aphrodite as it originally was, radiantly poised, gracious and beautiful, it is not difficult to understand that once a female nude had been portrayed in this expressive pose, the pose was copied, varied and developed throughout antiquity and from the time of the Renaissance rediscovery of antiquity up to modern times. The female body only came to be appreciated in art in the 4th century BC; its success thereafter became so great that eventually it almost eclipsed the male.

Besides the wholly nude Aphrodite, the 4th century BC also produced a half-draped type (Fig. 74). We do not know the name of the artist who created the original of which the 'Aphrodite of Capua' is a Roman copy. It portrayed the goddess with her whole sensuous torso revealed, holding a shield to her left and in its reflection admiring her own beauty. The shield (now lost) kept the drapery of the legs in place to produce a work which, through hints and partial concealment, was as erotic as any nude. The invention was much appreciated and was copied, with variations, for centuries.

74. Aphrodite of Capua,

Roman copy of an original

of the mid 4th century BC,

height 210 cm, Museo Nazionale, Naples.

NEW PROBLEMS IN THE HELLENISTIC PERIOD: FIGURES IN SPACE

The Spear-bearer of Polykleitos (Figs. 25–28) embodied the classic solution to the problem of presenting a figure in motion that was

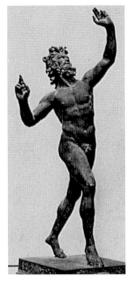

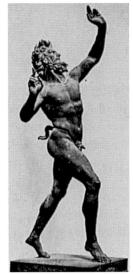

75. Two views of the dancing faun, Roman copy of an original of the 3rd century BC, height 71 cm, Museo Nazionale, Naples.

effective and handsome from all four principal views. By the beginning of the 3rd century BC, this solution was no longer considered satisfactory – or rather the problems it solved were no longer sufficiently stimulating. Sculptors, particularly those working in bronze, now wished to create figures that looked beautiful from *all* points of view and that in fact led the eye (and the observer) round them. As if this were not difficult enough, the demands of the new naturalism insisted that the resulting pose should be rationally motivated, not just some arbitrary distortion for artistic purposes.

A work which satisfied both these conditions is the dancing faun (Fig. 75) found in Pompeii, a fine bronze statue that may have been an expensive Roman copy of a Greek original of the early 3rd century BC. The joyous movement of the dance into which this half-wild creature whole-heartedly throws himself naturally produces a dramatically twisted pose. Figure 76 shows what would happen if a rectangle of cardboard, white on one side and hatched on the other, were placed on the planes of the shoulders, the chest and the abdomen and then progressively on the planes connecting the knees, the calves and the feet; the consequent rotation of the cardboard along with the body is clearly apparent.

Two views are enough to show how satisfactory the design is when seen from different angles. At the same time, the figure looks perfectly natural. Not only is the movement natural, but so is the anatomy – far more than in the works of the 5th century BC. Compare the head, with its combination of wind-blown hair, bony structure

76. Diagram showing the rotation of the body of the dancing faun (Fig. 75).

and soft pouches of skin, with the smooth head of the Spear-bearer, or contrast the sinewy body, with its careful distinctions of texture between the firm and the flaccid and between muscles, fat and bone, with the body of the Spear-bearer, which consists entirely of suggestive generalisations lacking in specific detail (Figs. 25–28).

HELLENISTIC VARIETY: NEW SUBJECTS - FOREIGNERS AND GROUPS

The search for new problems to solve was a constant stimulus to artists. By the middle of the 3rd century BC, naturalistic representation had been fully mastered and could be effectively combined with a multiplicity of viewpoints in single figures. It was a challenge to try to do the same thing with a free-standing group.

The Greeks had considerable experience in working with groups of figures when they designed pediments (Figs. 44–47), but these were seen only from the front. A free-standing group, visible from all sides, was quite another matter. Such groups became very popular in the 3rd and 2nd centuries BC and were often powerfully expressive as well as aesthetically satisfying.

A group showing a defeated Gaul who has just killed his wife and is about to kill himself must have been magnificent in the original bronze. The Roman copy (Fig. 77), even with its faulty restoration (the extended arm of the wife should hang parallel to her other arm), is still impressive. The group is roughly pyramidal. It is complex, interesting and revealing from all sides. But there is more than just artistic skill and formal achievement here; there is also a sense of drama and pathos.

The work was set up in Pergamon, a Hellenistic city in Asia Minor, as the central feature of a war memorial. The Pergamenes had recently repulsed an incursion of the Gauls and were justifiably proud of their victory. They felt they had done as much to preserve Hellenistic civilisation as the Athenians had in the 5th century BC when they defeated the Persians.

The Pergamenes' sense of triumph did not lead them to belittle the heroic enemy they had beaten. In fact, respect for the enemy was an old part of the Greek tradition. Even as far back as the Homeric

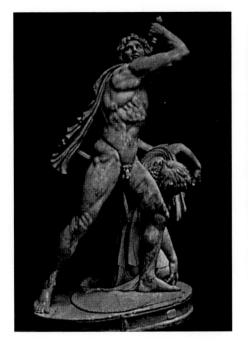

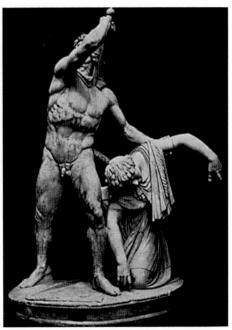

epics, the Trojan Hector is portrayed as valiant and brave. Similarly here, the Gauls are depicted in full dignity. The noble adversary who sees that defeat is inevitable is too proud to submit. Only death will conquer him. He has killed his wife because he loves her. In the *Iliad*, Hector laments for his wife, foreseeing that when Troy falls she will become a slave. The Gaul will not permit this fate to overtake *his* wife. As she falls limply to the ground, he looks back, defiant to the last, and prepares to plunge the sword into his throat.

The contrasts implicit in the scene – living and dead, man and woman, draped and nude – are dramatically accentuated. Notice how the lifeless feminine arm of the wife hangs beside the strong, tense, masculine leg of her husband.

The Gauls, who were tall and had thick hair and hard muscles, were physically very different from the Mediterranean types they fought. Hellenistic artists revelled in portraying the differences. The scope of art had by now greatly widened. Nude women, barbarians, children, old people – all were now considered challenges to artists and worthy of portrayal. This was part of the more tolerant and less exclusive attitude that pervaded Hellenistic society. The interest in naturalism, combined with the interest in foreign types, led to some of the most sensitive depictions of northern Gauls, black Africans and South Russian Scythians that have ever been produced.

77. Two views of the Gaul killing his wife and himself, Roman copy of an original of the second half of the 3rd century BC, height 211 cm, Palazzo Altemps (Museo Nazionale Romano), Rome.

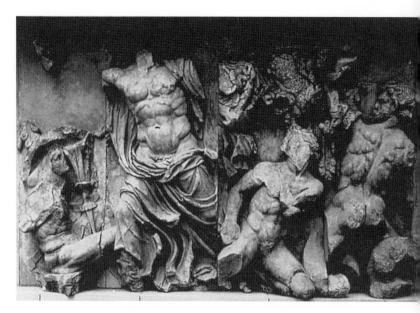

right and far right 78. Part of the frieze of the Pergamon altar showing Zeus and Athena fighting giants, first half of the 2nd century BC (c. 180–160), height 230 cm, Antikensammlung, Staatliche Museen zu Berlin, Preussischer Kulturbesitz, Berlin.

NEW DRAMA IN OLD COMPOSITIONS

The sculptural group of the Gaul and his wife was the centrepiece of a monument erected in the second half of the 3rd century BC, shortly after a Pergamene defeat of the invading Gauls. Half a century later, probably between 180 and 160 BC, a still more elaborate monument was set up in Pergamon. It took the form of a huge altar to the chief of the gods, Zeus, the base of which was decorated with a dramatic portrayal of the battle of the gods and giants (Fig. 78).

The relief is extremely high, and the figures almost burst out of the background. Bulging muscles and swirling drapery convey a tremendous sense of explosive energy. A key episode on the east side, the first a visitor would encounter, showed Zeus (to the left), his powerful body revealed as his drapery slips from his shoulder, simultaneously fighting three giants, while Athena (to the right) turns back to dispose of another. The giants, who are getting the worst of it, are depicted with snake legs, or winged, or in ordinary human form. One falls to the left of Zeus and is shown in profile; another, smitten, collapses on his knees to the right, his body in a three-quarter view reflecting the three-quarter view of Zeus; a third (further right) rises on his snake legs to fight on and is shown in back view. The careful arrangement and variation of the positions of the figures is not immediately obvious, but it contributes to the effect of the whole. Actually, the arrangement is based on a 5th-century BC

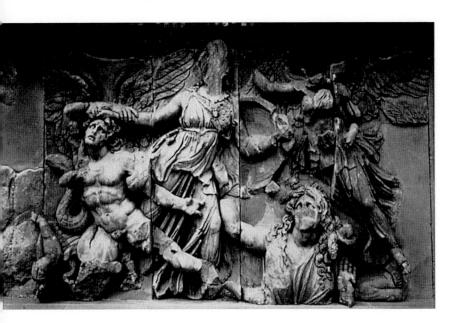

Athenian relief and is not the only classical reminiscence in the work, as we shall see.

Athena, striding vigorously away from Zeus, seizes her adversary by the hair (Fig. 78). His wings fill the upper part of the relief. He looks up at her with anguished eyes – this is a further development of that expression of pathos and drama for which Skopas was famous in the 4th century BC (p. 62). To the right of Athena, the goddess Earth, mother of the giants, rises up from her own element and with painfully drawn brows begs Athena to spare the life of her son. Athena is unmoved, and a winged Victory, knowing the outcome, flies over Earth's head to crown Athena.

The dominant motif of Zeus and Athena, powerful god and goddess, moving in opposite directions but turning back to look at each other, is the very composition (though reversed) used in the centre of the west pediment of the Parthenon (Fig. 47). The visual quotation would have been obvious to any observer in antiquity and would have underlined the claim of the Pergamene kings to be the cultural heirs of the 5th-century Athenians. It is a splendid and creative adaptation of a great work of the past.

USES AND ABUSES OF THE PAST

In time, adaptations of works of the past became less creative, as if some of the fire had gone out of Greek artists. A characteristic work

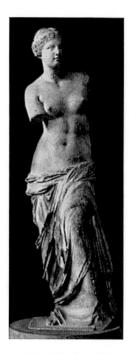

79. Aphrodite from Melos ('Venus de Milo'), second half of the 2nd century BC, height 204 cm, Louvre, Paris.

of the second half of the 2nd century BC (150–100) is the celebrated Aphrodite from Melos (Venus de Milo) (Fig. 79). A half-draped figure of the goddess, she obviously combines the partial nudity and the pose of the Aphrodite of Capua (Fig. 74) with the contrapposto and facial type of Praxiteles' Knidian Aphrodite (Fig. 72). The amalgam is successful, and the statue is justly famous, but it is much more obviously derivative than the Zeus and Athena on the Pergamon altar.

The dependence of artists on the past grew heavier with time. Imitations of older works became less creative. An example from the 1st century BC illustrates the sorry degeneration (Fig. 80). Two figures are combined to produce the group of Orestes and Electra, mythological brother and sister. Orestes is modelled on an early 5th-century BC type of youth, and Electra is practically a copy of the late 5th-century BC Venus Genetrix (Fig. 32), with only slight variations – for instance, the right arm has been moved to rest across the youth's shoulders, and the drapery has been adjusted for greater modesty. It is a dry work, an unattractive pasting together of two unrelated older statues that makes the Aphrodite of Melos (Fig. 79) look fresh and original by comparison.

The group is not worked out in terms of space and depth; the two figures are just strung out along a single plane. The front and back views are satisfactory, but the side views are virtually worthless. There was now a vogue, which continued with the Romans (or may have actually been promoted by them), for displaying statues against a wall, so that many groups (and even single figures) were designed for one view only.

It is but a short step from unimaginative adaptations like the Orestes and Electra group (Fig. 80) to the production of exact copies of older masterpieces. This had begun by the later 1st century BC and was greatly stimulated by demand from the Romans. The Romans by then ruled Greece, but they had come under the sway of Greek art. They needed copies for decoration and display. The production of copies began at this time to play a significant role in the economics and technique of Greek sculpture; the Romans, as patrons, now called the tune.

80. Orestes and Electra, 1st century BC, height 139 cm, Musco Nazionale, Naples.

THE HELLENISTIC CONTRIBUTION

A great deal of sculpture was made during the Hellenistic period; we have touched on only a few characteristic examples. The most significant trends were a widening of subject matter (to include female nudes as well as male, foreigners as well as Greeks, extremes of babyhood and old age as well as the ideal of youthful maturity); a deepening of emotional characterisations (with special emphasis on the portrayal of suffering and pain, dramatically conveyed through facial expression, turbulent drapery and expressive pose of the body); and formal innovations (including the invention of the many-sided, twisting figure and complex free-standing groups).

Sculptors travelled widely during the Hellenistic period and worked more for private patrons than for the political communities or sanctuaries of the gods they had served in the past. The taste and preferences of individual patrons increasingly directed the development of sculptural style.

By the middle of the 2nd century BC, admiration for the art of the past began to influence the design of sculptures, at first through creative adaptations and visual allusions but eventually through increasingly lifeless imitations. Exact copies, which began to be made with mechanical aids at the very end of the Hellenistic period, though totally lacking in creative input, nevertheless were an improvement over the poor stuff that preceded them.

5: PAINTING

SOURCES OF INFORMATION AND THEIR VALUE

A lthough we know that many masterpieces were painted in the 4th century BC and the Hellenistic period, hardly anything has survived. In order to get some idea of what painting was like at that time, we have to rely on three sources of information: pictures on pottery, copies of paintings made for the Romans and descriptions by ancient authors. None of these is entirely satisfactory.

Vase painters never copied wall paintings exactly, but they sometimes made use of new ideas about the treatment of space, perspective and the handling of light that are so alien to the technique of vase painting that we can deduce that they must have been inspired by developments in free painting. After the 5th century BC, vase painting became a minor art and could only dimly reflect the great achievements taking place elsewhere. By the end of the 4th century BC, it had virtually died out.

Copies of Greek paintings made for the Romans, though closer to the sources of their inspiration than paintings on pottery, are not as accurate as the more mechanically produced Roman copies of statues. Sometimes, when we can compare several copies of the same original, it becomes obvious that the Roman painters freely adapted and modified their models (Figs. 104 and 105, p. 101).

Descriptions by ancient writers, though often vivid and entertaining, can never bring lost works before our eyes. From the time of the Renaissance on, they have stimulated artists to produce splendid and original works in an effort to re-create Greek paintings, but these works tell us only about the painters who made them, not the paintings the ancient authors saw.

THE 4TH CENTURY BC AND ITS LEGACY

It is a great pity we have so little evidence about the painting of the 4th century BC, for it was clearly full of exciting novelty and invention. The painters, Pliny tells us, were lively personalities and great technical innovators.

By the end of the 4th century BC, foreshortening of the body (both human and horse) had been brought to perfection, modelling in terms of light and shadow had been mastered, the effects of highlights and even of reflected light had been studied, the expression of emotion had been explored, and some rudimentary work on perspective had been done.

A summary of the achievements of the painters of the 4th century BC can be seen in a Roman mosaic that is a copy of a painting probably made at the beginning of the 3rd century BC (Fig. 81). A mosaic is made up of tiny squares of stones of different colours assembled to make a pattern or look like a picture. The Greeks had become technically accomplished in the making of mosaics in the course of the 3rd century BC. When this mosaic was made for a Pompeian client in the 1st century BC, mosaicists were able to use such minute pieces of stone and such a wide range of colours that they were able to reproduce even very elaborate and subtle paintings. This example, known as the Alexander mosaic, is such a copy. The painting glorified and dramatised Alexander the Great's victory over the Persian king Darius III.

Although parts of the mosaic have been destroyed, we can still see how vividly it conveys a sense of the mêlée of battle while at the same time keeping prominent the chief characters in this historical drama.

Alexander, helmetless, his hair blowing in the wind, rides forward energetically from the left. His head is clearly silhouetted against the sky. He has thrust his spear through one of Darius' devoted servants, who was just clambering off his fallen horse when Alexander's spear pierced his side. To the right, another Persian nobleman has dismounted and holds the head of his restive horse. This chestnut horse is seen from the rear, superbly foreshortened, with effective highlights glancing off its rump and rather more tentative shadows cast by its legs. Meanwhile, Darius looks back from his chariot and reaches out a compassionate hand toward the follower who is ready to die for him – a portrayal showing characteristic Greek respect for the enemy. Darius' head and his helpless extended arm are silhouetted against the sky. He is the counterpart

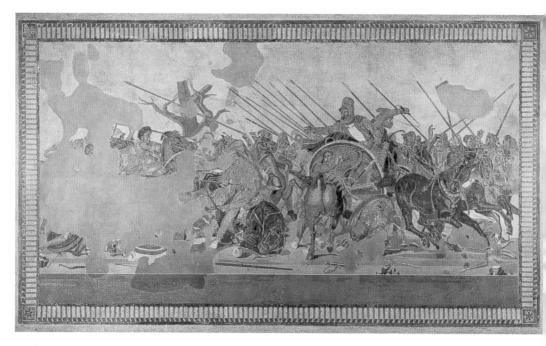

81. Alexander mosaic showing the battle of Alexander the Great and Darius III, Roman copy of an original of the early 3rd century BC, height 217 cm, Museo Nazionale, Naples.

of Alexander; the two kings oppose each other above the heads of the other figures. But there is not a moment's doubt who the victor will be.

Darius' charioteer, slightly to the right of the king, furiously whips the horses on to make a greater effort, careless that they may run down the fallen warrior whose back is to us but whose face is reflected in his polished shield. The black horses of Darius' chariot gallop forward and to the right: once again the skilful use of highlights and foreshortening makes the complex arrangement clear.

It is amazing that such subtlety of modelling and such evocative colour gradations can be caught in the relatively crude mosaic technique. The colour range is restricted – there are no greens or blues – but this was probably a characteristic of the original painting, not its translation into mosaic, for Pliny tells us that some painters restricted their palette to just four colours: red, yellow, black and white (and, of course, mixtures of these).

While the technical achievements of the painters up to the end of the 4th century BC are splendidly revealed by this mosaic, so are their limitations. The whole drama is acted out on a narrow stage, the depth of which is defined only by the foreshortening of the

figures and their overlappings. The setting, too, has received short shrift. A few rocks on the ground and a single dead tree do for a landscape.

The Alexander mosaic is very impressive. The creation of a great artist has been transmitted with only slight loss of effect through the skill of the mosaic copyist. Nevertheless, it does not have the stunning impact of a direct encounter with an outstanding work of art.

In contrast, the paintings discovered in 1977 that decorated the royal tombs at Vergina in Macedonia – though much damaged – are truly staggering. One scene that is better preserved than most shows the god of the Underworld, Pluto, abducting the corn maiden Persephone. The girl was picking flowers with her friends when the god emerged from the earth, seized her and carried her off in his chariot. A detail (Fig. 82) shows the urgent god, his hair blowing wildly as he grasps the tender body of the girl, her eyes anxious and arms helplessly extended. The freedom and power of the brush-strokes, the certainty of the effects, the intensity of emotion – all reveal the hand of a truly great artist, one having the calibre and flair of a Rubens. Such stature is seldom apparent in the paintings that have come down to us from antiquity.

82. Painting from the Macedonian royal tombs showing Pluto abducting Persephone, second half of the 4th century BC, Vergina, Greece.

HELLENISTIC ACHIEVEMENTS: NEW THEMES AND SETTINGS

The paintings on the royal tombs at Vergina give us a glimpse of the quality of the work that must have been produced by the greatest Greek painters of the 4th century BC. But it is a solitary glimpse. In order to learn more about how Hellenistic painting developed, we must rely on literary sources and the evidence of Roman copies.

The Hellenistic period was one of great expansion for the Greeks, not only geographically but also artistically and intellectually. Painting, like sculpture, showed not only considerable technical advances but also a widening of themes. Before the Hellenistic period paintings had dealt chiefly with mythological subjects and occasionally, as in the Alexander mosaic, with historical events. Now, with artists' greater interest in ordinary people, their everyday life and everyday things, the range of subjects considered appropriate for painting broadened. For instance, Pliny records that a certain Peiraikos painted barbers' shops, cobblers' stalls, asses, eatables and similar subjects, earning himself the name of 'painter of odds and ends'. Such a selection of themes, quite lacking in moral uplift, would hardly have appealed to Polygnotos. This broadening of acceptable themes meant that many unheroic subjects entered painters' repertoire - vignettes of daily life, still lifes, flower paintings and representations of animals and birds - as well as the more usual men and gods.

By the end of the 3rd century BC, considerable advances had been made in creating the illusion of reality on a flat surface. A fine mosaic (Fig. 83), which is a copy of a 3rd-century BC painting, shows a scene from a comedy that includes a group of street musicians (all of whom are wearing masks) and an unmasked boy, who may have played a mute part or is just an onlooker. The modelling of the figures is fully convincing, and the play of light is handled with consummate skill. Notice the accurate rendering of the cast shadow of the tambourine player as it falls on the pavement and then climbs up the wall, and notice also the bright highlights and deep shadows in the shiny clothes of the musicians. The space above the players and to the side is generous, but depth is still restricted to a narrow shelf on which the action takes place.

83. Mosaic showing a scene from a comedy, Roman copy of an original of the 3rd century BC, height 43.7 cm, Museo Nazionale, Naples.

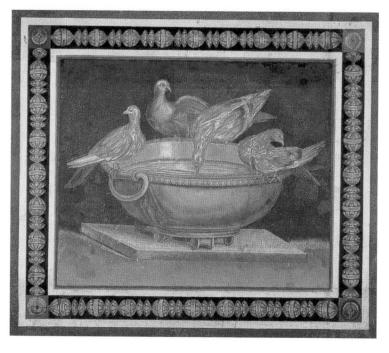

84. Mosaic showing doves drinking, Roman copy of an original by Sosos of Pergamon made in the 2nd century BC, height 85 cm, Museo Capitolino, Rome.

The most famous mosaicist in antiquity was Sosos, who lived in Pergamon in the 2nd century BC. Among his celebrated works was one that represented doves drinking. A Roman copy of this work (appropriately, in mosaic) (Fig. 84) gives some hint of the serenity of the subject and the dignity that can be imparted even to birds. The copy, nevertheless, lacks one feature that was particularly praised in the original: the shadow in the water of the dove that has its head inclined into the bowl to drink. A subtle effect indeed this must have been!

Probably around the middle of the 2nd century BC, artists became seriously interested in the representation of space in its own right, not just as the ambience in which people and things exist. Painted scenery for tragedies had already in the 5th century BC stimulated an interest in perspective. The painter Agatharchos is supposed to have painted a perspective setting for a play by Aeschylus (probably a revival) and to have inspired contemporary philosophers to undertake a theoretical study of the subject (p. 56). One suspects that the system of perspective was still rather haphazard, but by the 1st century BC, when Roman painters copied and adapted Greek perspective settings (Fig. 85), much progress had been made.

There was a vogue for painting architectural vistas in Rome during the 1st century BC (Fig. 107). Since these vistas, whether they represent cities, palaces or sanctuaries, contain no figures, we may assume that they were inspired by stage sets, which in the theatre would have been populated by actors.

A cityscape found at Boscoreale near Pompeii provides a charming example (Fig. 85). A firmly shut door within a wall defines the front plane of this architectural painting. Above the wall one catches delightful glimpses of the city – a balcony jutting out to the right, an enclosed tower rising to the left, two houses between, with a ladder reaching to an upstairs window. In the distance, long colonnades stretch off to the right. Skilfully applied shadows within the wide tonal range of warm reds, glowing yellows, clear whites and tranquil blues help to give a sense of depth and distance, but it is the receding lines of the buildings themselves that do most to suggest space. The perspective, however, is neither unified nor consistent. Each element is foreshortened more or less independently, without any regard to the whole. Such a piecemeal perspective scheme suggests

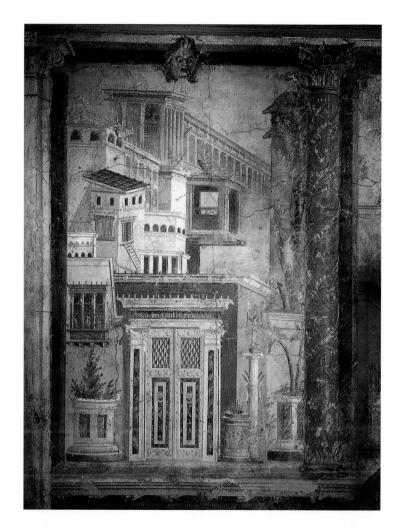

85. Wall painting from Boscoreale showing a city, Roman copy of a Greek painting of the 2nd century BC, height 244 cm, Metropolitan Museum of Art, New York, Rogers Fund, 1903. (03.14.13) Photograph by Schecter Lee. Photograph ©1986 The Metropolitan Museum of Art.

below

86. Wall painting of scenes from the *Odyssey*, one shown in its entirety and part of another to the right. Odysseus in the Underworld, Roman copy of a Greek painting of the 2nd or 1st century BC, preserved height 150 cm, Vatican Museums, Rome.

that however evocative the Greeks made their architectural vistas, they never fully developed a single-point perspective system such as was later formulated in the Renaissance. This is the opinion of many scholars, but others disagree. They cite Roman architectural paintings in which no fewer than forty *orthogonals* (receding lines) meet at a single point, and argue that this could hardly have happened by chance. They believe that the Greeks had in fact mastered single-point perspective but that the Roman copyists did not always transmit their achievements accurately.

While depth in architecture can be indicated by means of receding lines, depth in landscape can be suggested only by means of subtle changes in colour with distance and the blurring of the furthest features. This is exactly what we see in the so-called Odyssey landscapes (Fig. 86). These are Roman copies of late Hellenistic originals that illustrate episodes in the Odyssey, but they are very different from the 7th-century BC krater showing a scene from the Odyssey (Fig. 61), in which the figures are everything. In the Odyssey landscapes, by contrast, the figures are virtually lost in the breadth of the view. Odysseus' ship rides at anchor to the left, while the hero himself strides with a few friends through the eerie cavern that is the opening of the Underworld. The shadowy dead – small, wispy figures - emerge into the strange light to meet him. In the foreground, a river god (compare Figs. 55 and 56) reclines beside his element. But it is the landscape itself - rocks, caverns, sea and sky, all finally mastered by the painter's brush - that dominates the scene.

Painting was now as versatile as sculpture, as fully in command of all the resources of the medium. Hellenistic painters had learned how to represent space and light, and they had introduced new subjects. Still life, landscape, portraiture, genre painting – anything from lofty allegories to homely objects – all could now be rendered in paint. It was this richness in the range of themes and mastery of technique that the Greeks bequeathed to the Romans.

6: ARCHITECTURE AND PLANNING

S everal of the most important tendencies in the development of Hellenistic architecture can be grasped if we look at just three types of buildings: houses, theatres and sanctuaries.

THE HOUSE: NEW LUXURY IN PRIVATE LIFE

During the Hellenistic period, when people lived as part of huge kingdoms governed by remote rulers, they could no longer identify so immediately with their communities and began to feel isolated and alone. Their interest became focused on themselves at a time when emphasis, both emotional and economic, withdrew from the group and shifted on to the individual. People thought increasingly about their private lives and tried to make the intimate world around them more attractive and agreeable. They began to build more elaborate and comfortable houses for themselves; rulers, too, touched by the same sense of isolation, began to build palaces.

Fifth-century BC houses in Athens had been very modest (Fig. 87a). They usually consisted of two storeys and were built of unbaked brick on a low stone base. The entrance was somewhere along one side and led, sometimes rather indirectly, to a central courtyard. The courtyard was a simple affair, a source of light and air for the rooms that opened off it. A blank wall faced on the street, pierced only by small windows whose height above the street ensured privacy.

By the 4th century BC, such humble dwellings had, whenever possible, been improved upon. A contemporary orator noticed the distinctions that were then appearing between the rich and the poor and lamented the passing of the good old days when only public buildings caught the eye with their magnificence.

Houses built in the 4th century BC in Priene, a city on the west coast of Asia Minor (see Map 2), were squared up instead of being irregular and fitted neatly into the newly laid out rectangular grid plan of streets (Fig. 87b). Most rooms still opened off an inner

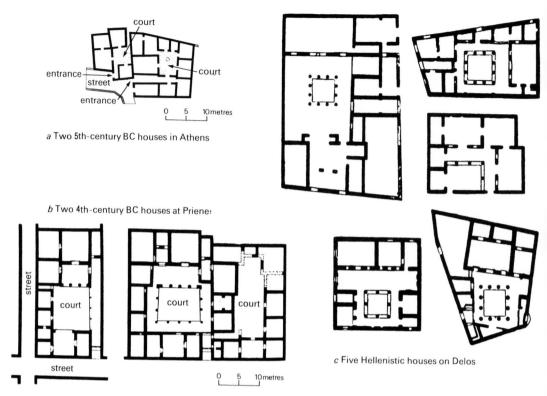

87. Plans of Greek houses from the 5th to 2nd centuries BC.

courtyard, but this had become grander and sometimes had a row of columns along one side or even around all four sides (an internal peristyle).

By the Hellenistic period, the courtyards of most houses were adorned with gracious peristyles (Fig. 87c). Many walls were now decorated to simulate marble inlays, and handsome mosaics were laid on the floors; this was the period in which Sosos worked (Fig. 84). Notice how varied the designs of houses built in Delos in the Hellenistic period were (Fig. 87c). The arrangement of the rooms, their size and relationship, and even the placement of the entrance were left to the individual. This freedom and lack of regimentation is characteristically Greek.

THE THEATRE: THE ACTOR BECOMES THE PRINCIPAL

The interest in the individual that led to the development of the spacious, attractive peristyle house also manifested itself in the

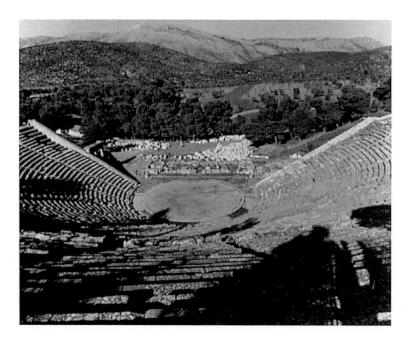

88. The theatre at Epidauros, 4th century BC.

development of the theatre. In drama, as in life, emphasis came to be placed ever more on the individual rather than the group. In drama, this meant on the actors rather than the chorus.

Greek plays were performed as part of the celebrations in honour of the god Dionysus. In the earliest plays most of the action was provided by the chorus, and the role of the individual actors was very limited. During the course of the 5th century BC, the actors became increasingly important and by the time of the latest surviving comedy by Aristophanes, written in the first quarter of the 4th century BC (388), the chorus had virtually disappeared. It took a little while for staging and architecture to catch up with these developments.

In the 5th and 4th centuries BC, theatres had been designed with primary emphasis on the *orchestra*, the circular dancing place where the chorus performed and interacted with the actors. The *cavea (theatron)*, carved out of the side of a hill, had grown as a watching place around the orchestra, a sort of natural grandstand that eventually was given architectural form.

The beautiful 4th-century BC theatre at Epidauros (Fig. 88) gives a good idea of what a classical theatre looked like. It consists of three independent parts: the round orchestra in the centre, the stage buildings on one side, and on the other the cavea, consisting of tier upon tier of seats sweeping round in something over a semicircle.

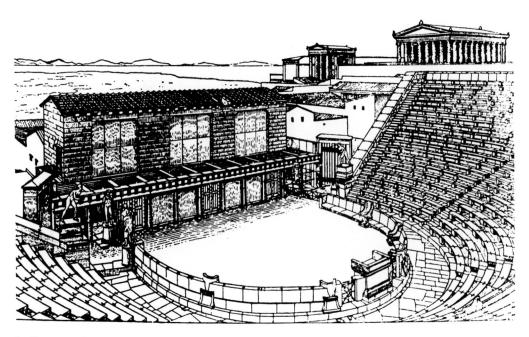

89. Reconstruction drawing of the 2nd-century BC renovation of the theatre at Priene.

A splendid view of the countryside is to be had from the seats in the theatre. Since Greek dramas were always performed in daylight, this must have presented quite a challenge to playwrights, who had to make their plays gripping enough to prevent the audience's attention from wandering off into the landscape.

As actors became more and more important for the action and the chorus dropped out, theatres were redesigned to accommodate the new style of performance better. In the 5th- and 4th-century BC theatres the stage building had been used for storing props and sets. In front of it there might be a single-storeyed façade, the *proskenion*, against which the stage sets were placed. The roof of the proskenion could be used occasionally for the appearance of gods, when such was required by the play. Otherwise all the action took place in the orchestra.

By the 2nd century BC, the theatre at Priene had been remodelled (Fig. 89) so that the actors could be isolated and elevated and thus accorded the prominence that their parts demanded. This was done by turning the roof of the proskenion into a stage. Great openings were cut into the wall of the stage building behind the roof of the proskenion. Stage sets and backdrops could be placed in these gaps. The illusion of space that could eventually be conveyed by such painted sets is suggested by the Roman paintings they inspired (Fig. 85). The orchestra and its backdrop now became less important,

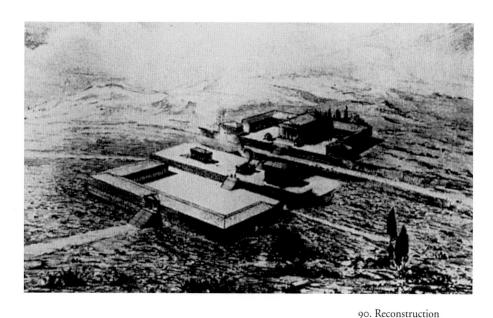

drawing of the sanctuary of Asclepius on Kos, built from the 4th to the 2nd centuries BC.

and the elevation of the actors on to a high stage brings us closer to modern theatre practice.

When the proskenion roof became the acting stage, the proskenion itself was moved forward at the expense of the orchestra, which now ceased to be a full circle (Fig. 89). As a consequence, instead of consisting of three fully independent parts, the theatre began to look more unified: cavea bonded to orchestra, orchestra attached to the scene building. These tendencies were carried even further by the Romans (Figs. 122, 123 and 130).

THE SANCTUARY: UNIFICATION OF ARCHITECTURAL COMPLEXES

As theatre design developed, architects became less interested in preserving the independence of each individual part and more inclined to bring the parts together. So, too, architects working on larger complexes tried to unify spaces and relate buildings to one another. A single example will clarify the principle, which applies no less to city planning and civic centres than to sanctuaries.

The sanctuary of the god Asclepius on the island of Kos was built over two centuries (from about 360 to 160 BC) and on three different levels, yet the whole complex emerges as a unit (Fig. 90). The three-sided, colonnaded *stoas* at the top and the bottom bind

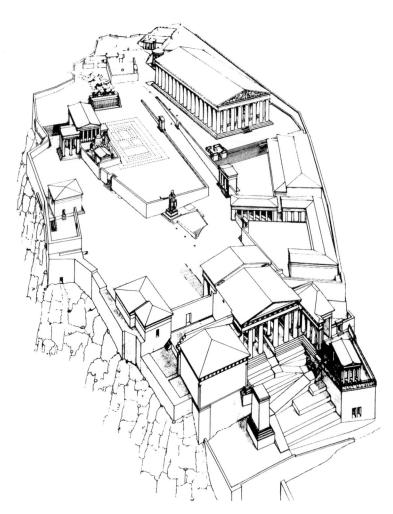

91. Reconstruction drawing of the acropolis at Athens showing the placement of the major 5th-century BC buildings.

the elements together, while the central flights of steps give a sense of unity, accent and climax.

The impression is very different from that given by the layout of the temples and shrines on the Athenian acropolis (Fig. 91). These were all built within a single half-century (447–406 BC), yet each building seems to have been thought out separately, and there appears to have been little effort to organise the space as a whole. The large complex of structures towards the bottom of the drawing is the Propylaea, the entrance gate to the acropolis and its attached buildings. It has roughly the same orientation as the Parthenon, the large temple to the upper right, but there is no axial connection between the two. Emerging from the Propylaea, one does not see the Parthenon from the front but from one corner. On the opposite

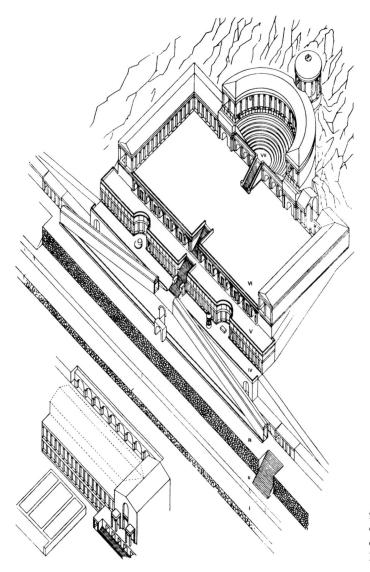

92. Reconstruction drawing of the sanctuary of Fortuna at Praeneste, Roman, 1st century BC.

side of the acropolis (to the left of the drawing) is the small and elaborate Erechtheum, which contrasts markedly with the severe grandeur of the Parthenon. Other smaller buildings, offerings and shrines are scattered freely about the precinct.

Although the impression of the sanctuary of Asclepius on Kos (Fig. 90) is one of unity and balance, many parts have retained their independence. Notice, for instance, the way the altar on the middle terrace is 'balanced' by a small temple. Nevertheless, both the design and the placement of individual elements are controlled by a sense for organisational coherence that was far less pronounced when the

classical acropolis was built (Fig. 91), but there was still a long way to go before architects could create the splendid order that the Romans imposed on an entire hillside at Praeneste in the 1st century BC (Fig. 92).

The arrangement at Praeneste is strictly symmetrical. A strongly accentuated axis leads the eye straight up the centre of the complex. The small paired hemicycles on terrace IV herald the grand theatre-like hemicycle that crowns the sanctuary. Rigorous axial symmetry is combined with a most imaginative play of curved and rectangular forms to produce a climactic ascent to the apex. By contrast with this wonderful Roman discipline, the sanctuary at Kos preserves that touch of independence and freedom which is so characteristic of Greek art.

PART III. THE ROMAN WORLD: ADOPTION AND TRANSFORMATION OF THE GREEK LEGACY

7: ROMAN STATUES AND RELIEFS

THE EMERGENCE OF THE ROMAN EMPIRE

We know they were great admirers of Greek art and ordered copies of sculptures and paintings which, in some cases, give us the only information we have about celebrated Greek originals (Figs. 20, 25, 31 and 32; 72, 74, 75 and 77; 81, 83–86; 104 and 105).

The city of Rome had begun in a small way in the 8th century BC. By the 4th century BC it had already established a republican form of government and begun the inexorable growth that was eventually to make it the centre of a vast empire.

Encounters with the Greeks began in earnest in the 3rd century BC in southern Italy and Sicily, where Greeks had long established colonies. Roman admiration for the Greeks was soon tempered by irritation as rival Hellenistic powers began to call on Rome to assist them in their struggles, for the Hellenistic kings were as frequently at war with one another as the classical poleis had been. The Romans were militarily better organised than the Greeks and politically more efficient. When their patience ran out with the endlessly squabbling Greeks, they began to subjugate the Hellenistic kingdoms one by one. The last to fall was Egypt, conquered by Augustus in 31 BC. At the same time, the republic vanished, leaving only a handful of traditional forms. Augustus, having finally eliminated all his rivals, became emperor, and the Roman republic, though Augustus claimed to have restored it in 27 BC, became the Roman empire.

The huge empire flourished for well over two centuries, bringing peace and prosperity along with its domination, but it fell upon hard times during the 3rd century AD. In AD 284 the emperor Diocletian came to power and stemmed the decline by astutely reorganising the empire; in AD 330 the emperor Constantine moved the imperial residence to Constantinople. Rome's days of grandeur were over.

Though the Romans dominated the Greeks politically and militarily, they submitted to their superiority in art and culture. The Roman poet Horace put it succinctly: 'Captive Greece led her rude captor captive.'

The Romans were fascinated not only by Greek art but also by Greek poetry, rhetoric and philosophy. This was a great boon to Greek intellectuals and craftsmen – teachers, scholars, thinkers, sculptors and painters – for it was the enthusiastic Romans who gave them employment.

An immense amount of sculpture was carved both before and during the period of the Roman empire (31 BC-AD 330); most of it consisted of copies, adaptations or variations of Greek prototypes. This provided business for many hundreds of skilled sculptors throughout the empire who knew their materials and how to work them. These craftsmen were available, trained and ready when, occasionally, the Romans asked them to produce original works.

PORTRAITURE: SPECIFICITY OF PERSON

By temperament and by tradition, the Romans were very different from the Greeks. While the Greeks enjoyed abstraction and generalisation in thought and art, the Romans, down to earth and practical as they were, preferred the specific and the factual.

Greek portraits were almost exclusively of famous men and women: people who had won their reputations as athletes, poets, philosophers, rulers and orators. Something typical always clung to their representations to help define in what category they had won their fame. Roman portraits could be of anybody who had the money, family connections or distinction to order them. What the Romans wanted from a portrait was the accurate image of a particular person. Under the influence of Greek art, sculptors working for the Romans often modified their style of portraiture and made their subjects look more beautiful or more powerful than they really were, but the sculptors never sacrificed their unique characteristics, the specificity so highly valued by the Romans.

An impressive portrait of the first emperor, Augustus (31 BC–AD 14), illustrates the sort of compromise that a Greek sculptor working to the order of a Roman patron could achieve (Fig. 93).

Polykleitos' Spear-bearer (Fig. 25) was the acme of classical sculpture, and the Romans deeply appreciated the air of serenity and dignity conferred on the figure by the carefully constructed pose. It was therefore chosen to provide the framework for a representation of Augustus that was meant to convey to his subjects both respect for his authority and admiration for his grace and control. But the Greek statue could hardly be taken over as a model just as it was, since it had several features that offended Roman taste.

First of all, the Spear-bearer was an ideal figure — perhaps an imagined representation of the Homeric hero Achilles but certainly not the image of any real person. This had to be changed, and so the head of the Spear-bearer was modified as much as was necessary to capture the actual features of Augustus, which were, nevertheless, made just smooth enough to reflect the Spear-bearer's purity of form.

Second, the Spear-bearer was nude. This was, of course, natural for a heroic Greek statue and furthermore essential to reveal the harmonious contrapposto. But it might have seemed improper for a Roman, especially one like Augustus, who posed as the guardian of ancient traditions of propriety and sobriety. So the sculptor dressed his imperial subject in armour and even gave him a cloak. The armour was, however, made so form-fitting that, while decency was preserved, the modelling of the torso still remained clearly visible.

Third, the Spear-bearer lacked focus and direction. It was not felt right that the Roman emperor should stroll so dreamily through space. On the contrary, he should address his subjects directly and dominate the spectators who stood before him. Only slight modifications of the pose of the Spear-bearer were needed to bring this about: the head lifted and turned a little to look forward and outward, and the right arm raised as if to issue a command. Thus Augustus, by gaze and gesture, as if through the force of his personality, controls the space in front of him.

The statue was placed against a wall, as was often the case with Roman sculpture, and so all the emphasis is concentrated on the front view. The sides are less carefully thought out than in the

93. Augustus from Prima Porta, c. 19 BC, height 204 cm, Vatican Museums, Rome.

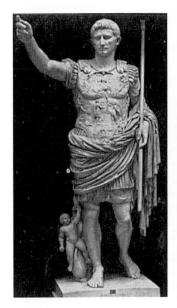

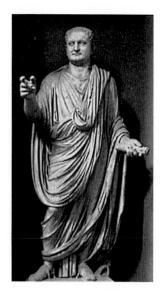

94. Titus, c. AD 80, height 196 cm, Vatican Museums, Rome.

Spear-bearer, and the back is not even finished. Perhaps this is why the accomplished sculptor who carved this statue did not mind destroying Polykleitos' contrapposto by raising the shoulder on the same side as the raised hip. The balance of the torso is somewhat obscured anyway by the armour and the cloak, and in the front view the curve of the raised arm responds handsomely to the curve of the relaxed leg on the opposite side. The internal balance and self-contained rhythm of the classical statue have been lost, but a new rhythm, one which captured the authority of the imperial subject, was created.

Thus the Spear-bearer was transformed into Augustus, the classical structure Romanised. Enough of Polykleitos' invention is preserved to give the image an air of naturalism, dignity and apparent inevitability, while the modifications have turned it into a fitting image of the first emperor. This was an inspired compromise, one that was very characteristic of the achievements of Roman art.

95. Sabina (wife of the emperor Hadrian) as Venus, *c.* AD 130, height 180 cm, Museo Ostiense, Ostia.

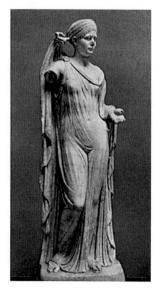

ROMAN PORTRAITS AND GREEK FORMS

A portrait of the later emperor Titus (AD 79–81) seems more emphatically Roman (Fig. 94). Titus is shown wearing the traditional Roman toga, a huge more or less oval garment that fell in a multitude of voluminous folds and required considerable skill to be draped properly. The specificity of the characterisation is marked. No idealised Greek beauty tempers the crude features of the emperor who, we may be surprised to find out, was considered the darling of mankind and praised for his good looks!

Yet the lessons learned from classical Greek art have not been forgotten or neglected. The technique of carving so as to reveal the pose of the body through the way the folds of the drapery fall was invented by the sculptors of the 5th century BC (compare Figs. 32, 54 and 98); its application to the portrait of the emperor is the Roman contribution.

A further example of the persistence of Greek ideas and forms is the portrait of Sabina (Fig. 95), wife of the emperor Hadrian (AD II7–I38). The body of the statue is simply a copy of the famous 5th-century BC Venus Genetrix (Fig. 32), but Roman modesty has

made the sculptor cover the left breast. The statue, with the portrait head of Sabina set on top of the classical image of Venus, is a visual allegory. In Roman legend, the goddess Venus was supposed to be the mother of Aeneas, ancestor of the Roman people. This portrait of Sabina suggested that she had the same maternal relationship to the Roman populace of the time as the goddess had in the mythical past.

Allegory is also an element in the brilliantly carved portrait of the disagreeable emperor Commodus (AD 180–192) (Fig. 96). Commodus is draped in the lion skin of Hercules (the Latin name for Herakles) and carries the hero's club in one hand and the apples of immortality in the other (compare the Atlas metope from Olympia, Fig. 49). Alexander the Great had been portrayed in the guise of Herakles, whom he claimed as founder of his line, and some Hellenistic kings had followed his example. Here, at a distance of half a millennium, a Roman emperor is doing the same.

The smooth surfaces of Commodus' skin are polished till they gleam, contrasting with the rich play of light and shadow in the hair and beard. Heavy-lidded, immaculately groomed, with an air of incontestable superiority, the emperor gazes out from beneath his Herculean disguise. This brutal ruler acted out the hero's role in hideous parody. Having collected all the legless inhabitants of Rome, he fitted these unfortunates with serpent-like trappings attached to the stumps of their limbs, gave them sponges instead of rocks and slew them mercilessly, declaring that he was Hercules punishing the obstreperous giants. This insightful portrait, while preserving the official dignity of the emperor's image, still manages to hint at the character of the perverted sadist who occupied the position.

The craving for specificity that we see in Roman portraits is also apparent in Roman reliefs. The most characteristic of these are the historical reliefs that were carved to decorate monuments erected to commemorate particular events (altars, arches, columns). Greek architectural sculpture (see Chap. 2) usually depicted timeless myths; even the Parthenon frieze, which was in its own way

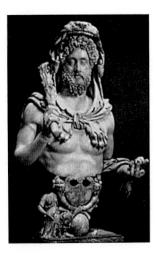

96. Commodus as Hercules, last quarter of the 2nd century AD, height 141 cm, Museo dei Conservatori, Rome.

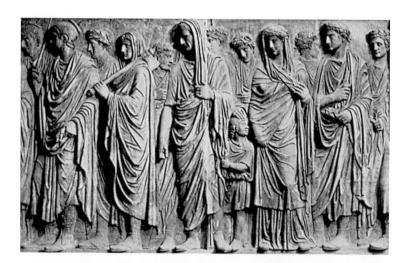

97. Part of the procession from the Ara Pacis, 13–9 BC, height 155 cm, Rome.

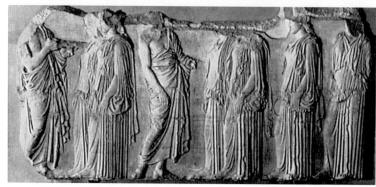

98. Part of the frieze from the Parthenon, 442–438 BC, height 106 cm, Louvre, Paris.

commemorative, lacks the explicitness and specificity of person and event that was apparently necessary and meaningful to the Romans.

The Altar of Peace (Ara Pacis) erected by Augustus (31 BC–AD 14) demonstrates the Roman attitude. As was typical of Augustan art (see the Augustus of Prima Porta, Fig. 93), Greek models were used to impart dignity and grace to the subject, but Roman ideas pervade the whole.

The altar enclosure was richly decorated with reliefs. Some of them showed a procession (Fig. 97) which called to mind the procession carved on the Parthenon frieze (Fig. 98). The beautiful play of light on the folds, the clear articulation of the bodies under the drapery, the wonderful sense of rhythmic progress – all these owe much to the forms of the Parthenon frieze. But whereas on the Parthenon individuals cannot be identified (see Fig. 53 for several well-preserved heads), nor the exact moment determined, on the Ara Pacis recognisable portraits are carved, and the procession itself

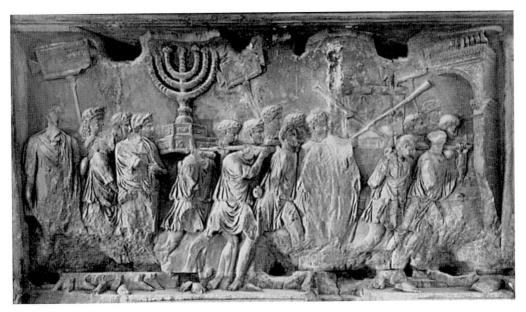

99. Triumphal procession, spoils from Jerusalem, *c.* AD 81, height 200 cm, Arch of Titus, Rome.

can be dated to the day (4 July 13 BC, though the carving was finished only four years later).

The uniqueness of the participants and of the event – it was the inauguration of the altar itself – is stressed. The priests in front wear their special spiked hats, a man with veiled head follows them carrying the axe to kill the sacrificial animals, then comes the tall general Agrippa, to whose robes a timid child clings – all this is very different from the non-specific representations of classical art.

The decoration on the Arch of Titus (Fig. 99), like the portrait of Titus (Fig. 94), seems less dependent on classical prototypes than do the reliefs and portraits carved for Augustus. The panel showing Titus' soldiers carrying the spoils from Jerusalem is particularly vivid. Since Roman sculpture and relief, like Greek, was always coloured, the carvings representing the golden objects looted from the Temple would have been gilded. Imagine how convincing this procession would have been when the soldiers' tunics were still brightly painted and the golden menorah (seven-branched lamp holder) glittered against a painted dark blue sky. Much space has been left uncarved above the heads of the figures, and this gives the impression that they have much greater freedom of movement in a more natural setting than the members of the procession on the Ara Pacis, most of whose heads touch the confining top of the frieze (Fig. 97).

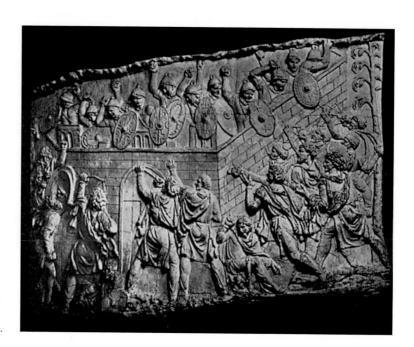

100. Romans attacked by barbarians, AD 113, height of frieze *c.* 100 cm, Column of Trajan, Rome.

A very different approach is used in the delicate low reliefs that decorate the great column celebrating the victories of the emperor Trajan (AD 98–117) over the Dacians (Fig. 100). Quite another sort of realism is used here, not the vivid visual realism of the Arch of Titus but instead a sort of documentary, diagrammatic realism, conceptual truth being preferred to the truth that the eye sees.

The Romans are confined within their well-built camp, beating off the attack of the barbarian Dacians. Light-armed Dacian troops carrying bows and arrows and slings threaten the camp from the front and the right. Helmeted Romans within the camp hurl missiles down on the besiegers from the top of the wall. Though perfectly intelligible, the whole scene lacks visual logic. The Dacians are seen straight on, but the camp from above. The walls of the camp have been made ridiculously low so that the artist could focus attention on the interesting combatants. Had he tried to keep all the elements in the scene in correct proportion, he would have had to devote most of the space to the depiction of immense dull stretches of wall and would have had to make the men tiny.

The conceptual (as opposed to the visual) approach used on the reliefs on the Column of Trajan enables the artist to show complex action clearly by means of a certain amount of schematisation. This

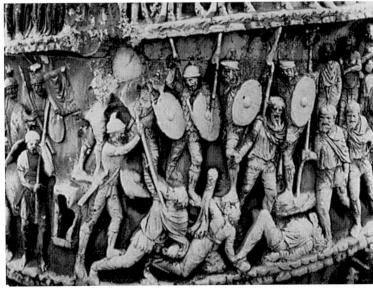

seems very different from anything we have seen in Greek art, which insists on visual logic and consistency of presentation. And yet, even within the brilliantly original carving of the Column of Trajan, tribute is paid to the fame and authority of Greek art. The interlude between the two campaigns that made up the Dacian wars is marked on the column by the figure of Victory (Fig. 101) inscribing Trajan's triumph on a shield. Does she look familiar? She is none other than the much loved Aphrodite of Capua (Fig. 74) dressed up for the part and equipped with wings.

Less than a century after the column decorated with reliefs was erected to glorify Trajan, another column was erected and carved in honour of Marcus Aurelius (AD 161–180). Work on it continued throughout the reign of Marcus Aurelius' son Commodus (AD 180–192). Like the portrait of Commodus (Fig. 96), the sculpture on this column is revealing; it is both more emotional and more expressive than the carvings on the Column of Trajan.

A characteristic relief (Fig. 102) shows a massacre of barbarians. A harsh and brutal contrast is made between the armed and aggressive Romans at the top stabbing down mercilessly on their unarmed foes and the helpless, pleading barbarians, fallen or dead. The man slightly to the right of centre who throws back his arms and screams in horror captures the mood of the scene.

above left
101. Victory writing on a
shield, AD 113, height of
frieze c. 100 cm, Column
of Trajan, Rome.

above right
102. Massacre of
barbarians, AD 180–193,
height of frieze c. 130 cm,
Column of Marcus
Aurelius, Rome.

The relief is much more deeply cut than on the Column of Trajan (Figs. 100 and 101) and is as deficient in subtlety of modelling as it is lacking in correctness of drawing (notice how unnaturally long are the legs and body of the Roman at the left). The carving, though highly expressive, has none of the smooth skill that was mustered for the portrait of Commodus (Fig. 96). Troubled times that were now overwhelming the empire have affected the spirit of the people and the sculptors working on the column. The work here heralds the breakdown of style and decline in skill that were characteristic of most sculpture (with the exception of portrait sculpture) during the 3rd century AD.

RELIEFS FOR PRIVATE INDIVIDUALS: SARCOPHAGI

Little official sculpture was produced for the State after the first quarter of the 3rd century; the government had other things to worry about than the erection of commemorative monuments. Between the years 235 and 284 some twenty-six emperors reigned, constantly threatened by usurpers. Only one died a natural death. Civil war plagued the empire, while at the same time the barbarians were hammering on the frontiers.

Many people hoped for better times in the life to come, and those who could afford it ordered elaborate carved coffins (*sarcophagi*) in which to have their bodies entombed. The fashion for burial in sarcophagi had begun somewhat before the middle of the 2nd century and grew considerably in the difficult period of the 3rd century. Sarcophagi and portraits were almost the only kind of sculpture produced then.

Sarcophagi were decorated in several different ways. Sometimes the relief carvings on them illustrated Greek myths, sometimes Roman battles, sometimes typical incidents from the life of the deceased; sometimes they were ornamented with representations of the seasons, scenes of Bacchic delight or just lush hanging garlands.

Only a few of these sarcophagi are artistic masterpieces. They are, however, very important for the history of art, for many of them survived from antiquity and were rediscovered during the

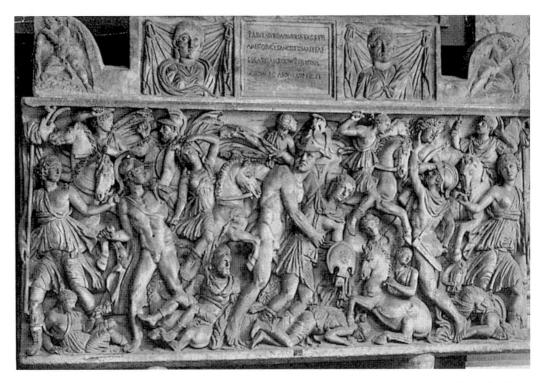

103. Sarcophagus showing Achilles and Penthesilea, mid 3rd century AD, height 117 cm, Vatican Museums, Rome.

Renaissance, when they were extravagantly admired and proved a great source of inspiration to artists.

A mid-3rd-century sarcophagus (Fig. 103) that was much appreciated during the Renaissance depicts on its front the story of Achilles and Penthesilea. Penthesilea was queen of the Amazons, a legendary band of warrior women. According to the myth, the Amazons were allies of the Trojans and came to fight beside them when the Greeks were attacking Troy. Achilles, the champion of the Greeks, fought the Amazon queen in single combat and killed her. His triumph, however, was hollow, for as she expired he realised that he had fallen in love with her.

The sarcophagus shows Achilles prominently in the centre holding the lifeless body of Penthesilea. Around them the battle continues to rage. Warriors, male and female, and their horses fill the entire height of the sarcophagus. Some of the figures are tiny; others are as large as Achilles. At either side a large Amazon flees but turns her head to look back. The two are mirror images of each other. Their formal symmetry, so at odds with the disorder of the battle, gives a clue to the principle of design used in the carving of the sarcophagus: it is meant to be decorative. The artist thought that enough

of the story was conveyed by the central group. He used the other figures as fillers, shrunken in size or enlarged as necessary, in order to make the entire panel a rippling surface of light and shadow. He was interested neither in composing a plausibly naturalistic scene nor in telling a story convincingly. What the artist was searching for was an overall decorative pattern not too different in aesthetic aim from the geometric vase painted by a Greek artist a thousand years before (Fig. 59).

Roman sculpture, then, lay under heavy debt to Greek sculpture. Original Roman contributions were stimulated by characteristically Roman demands for representations of particular people and events, and led to new creations in portraiture and the carving of documentary commemorative reliefs. But from the end of the 2nd century AD, an increasing interest in expression and decoration began to draw the Romans away from the rationality and restraint that had always been a part of Greek sculpture.

8: ROMAN PAINTING

GREEK INSPIRATION FOR ROMAN PAINTING

The Romans admired Greek painting as much as they admired Greek sculpture and encouraged the artists they employed to make copies of particularly famous or popular Greek works for them (Figs. 104 and 105). Single figures, groups and entire panel paintings were reproduced, adapted, spoiled or beautified according to the ability of the painters and the demands of the patrons.

While Greek painting has been largely lost, a great deal of Roman painting has survived. Most of what we have comes from the walls of private houses and public buildings in Pompeii and Herculaneum, two provincial but fashionable towns that were buried when Vesuvius erupted in AD 79. A few other paintings have also been found in Rome and elsewhere. It appears that the Romans

below left

104. Roman wall painting
showing Perseus freeing
Andromeda, copy of a
Greek original, 1st century
AD, height 122 cm, Museo

Nazionale, Naples.

below
105. Roman wall painting
showing Perseus freeing
Andromeda, copy of the
same Greek original as
Fig. 104, 1st century AD,
height 38 cm, Museo
Nazionale, Naples.

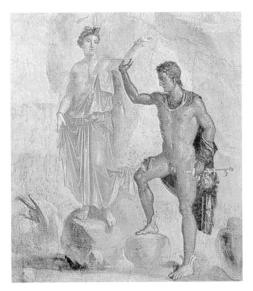

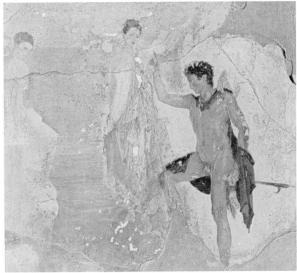

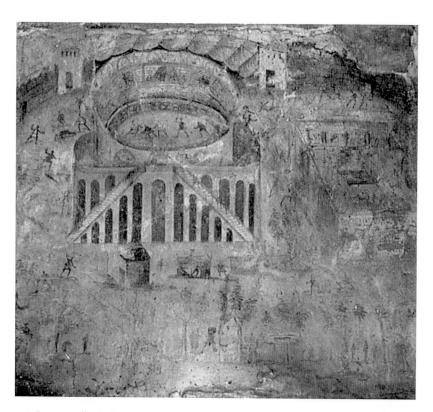

106. Roman wall painting from Pompeii showing the riot in and around the amphitheatre in AD 59, third quarter of the 1st century AD, height 170 cm, Museo Nazionale, Naples.

decorated their walls with mural paintings much more frequently than did the Greeks.

The impression given by this abundant material is generally attractive, occasionally beautiful, but taken as a whole second-rate and derivative.

AN EXAMPLE OF A THOROUGHLY ROMAN PAINTING

Some paintings seem untouched by the pervasive Greek influence. One such is a lively portrayal of a riot in the amphitheatre in Pompeii (Fig. 106). This was a real event: a fight broke out between the Pompeians and visitors from nearby Nocera in AD 59, and the disturbance was so great that the emperor ordered the amphitheatre closed for ten years after the fray. The choice of subject is very Roman, as is the visually illogical but intellectually lucid way in which the riot is portrayed.

The oval interior of the amphitheatre is seen from a bird's-eye view; the figures within it are seen head-on and are overlarge. The

exterior is drawn in a frontal view. The great triangle in front is the support for flights of stairs that led up the outside of the amphitheatre and over the top to the seating inside. The artist has helpfully turned the staircases outwards so that the steps can be seen. Actually, of course, they would not have been visible from the angle at which the rest of the exterior is shown. The whole picture reminds us of parts of the decoration on the Column of Trajan (Fig. 100).

The paintings that are copies of Greek originals (compare Figs. 85, 86, 104 and 105) look a great deal less naive than this Roman provincial scene.

ROMAN SETTINGS: THE FOUR POMPEIAN 'STYLES'

The Romans devoted great care to the painted settings in which they placed their copies of Greek paintings, and the complex and changing organisation of their painted walls makes an absorbing study.

Scholars have divided the decoration of Pompeian walls into four 'styles'. The *First Style*, one that was common throughout the Mediterranean world during the 2nd century BC, was hardly a matter of painting at all. It consisted simply of covering the wall with plaster painted and shaped to look like different kinds of marble slabs. It was supposed to make the whole wall appear as if veneered with expensive foreign marbles, which is presumably the way palaces were decorated.

About the beginning of the 1st century BC, some Roman painters discovered that they did not have to make the plaster protrude physically to give the impression of three-dimensional blocks; they could paint the wall illusionistically to give the same effect.

Once the idea of illusion had dawned, a radical change took place in the style. If one could paint the illusion of protruding blocks, why not paint the illusion of open windows and distant landscapes, people, animals, birds and gardens?

Thus was born the *Second Style*. It was an original Roman creation. Second Style walls were painted to suggest either that the confines of a room had been pushed back or that they had been

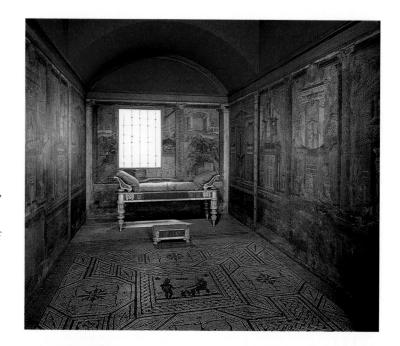

107. Second Style room from Boscoreale, Roman wall paintings of *c.* 40 BC, dimensions of the room 436 × 656 cm, Metropolitan Museum of Art, New York, Rogers Fund, 1903. (03.14.13) Photograph by Schecter Lee. Photograph ©1986 The Metropolitan Museum of Art.

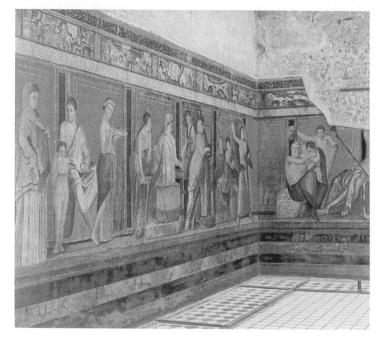

108. Second Style room from the Villa of the Mysteries, mid 1st century BC, height (of figures) c. 150 cm, Pompeii.

totally removed. Sometimes a parapet was painted upon which figures stood or sat (Fig. 108); sometimes a colonnade was painted through which one could see distant views (Fig. 107); sometimes the whole space above the parapet was illusionistically opened up

and the walls of the room were made to look like a charming garden. The illusions are always rational and naturalistic, giving a plausible extension of the space, but they are deliciously varied.

A little room from a villa at Boscoreale (near Pompeii) was painted in the Second Style with views mostly of architectural vistas (Fig. 107). The lowest part of the wall, the dado, is decorated rather simply with stripes and imitation flat marble panels. This is the part of the wall that might easily be obscured by furniture or damaged in cleaning. Above it there is a painted ledge on which some red columns appear to stand. Between the columns there is a view of city streets on either side of an enclosed sanctuary. It is as if one looked out of a small room onto a spacious scene beyond.

The furthest section of the room is separated by tall white pilasters which extend all the way to the floor. Above the dado on the back wall there is an idyllic landscape and, on either side, views of shrines. Despite much formal symmetry, the vistas seem perfectly possible, even though we know that most (if not all) the scenes are probably copies of Greek prototypes (Fig. 85).

Sometimes the illusionistic extension of the room does not penetrate so far. In the celebrated Villa of the Mysteries at Pompeii, the bottom section of the wall is treated the same way as in the little room at Boscoreale, but on the platform, instead of columns which give onto a distant vista, there are large figures performing the ritual associated with a cult of Dionysus in front of a flat crimson wall (Fig. 108).

This visually logical and plausible style began to pall by the last decade or so of the 1st century BC, and artists and patrons began to look for something new. This led to the invention of the *Third Style*, which emphasised the flat confining nature of the walls, delighted in delicate and sophisticated details and outspokenly denied all appearance of rationality and logic.

An enchanting example of the Third Style comes from a villa at Boscotrecase (near Pompeii) that was owned by members of the imperial family, and presumably shows what must have been the most up-to-date and elegant fashions. The whole wall (except for the dado) is painted black (Fig. 109). Above the dado there is an extremely narrow, illusionistically painted ledge on which two pairs of impossibly thin columns stand. The outer, sturdier columns hold

above right
109. Third Style wall from
Boscotrecase, Roman wall
painting from the late 1st
century BC, dimensions of
the the room 470 × 540
cm (preserved height 238
cm), Metropolitan
Museum of Art, New
York, Rogers Fund, 1920.

above
110. Detail of Third Style
wall from Boscotrecase
(Fig. 109), floating
landscape.

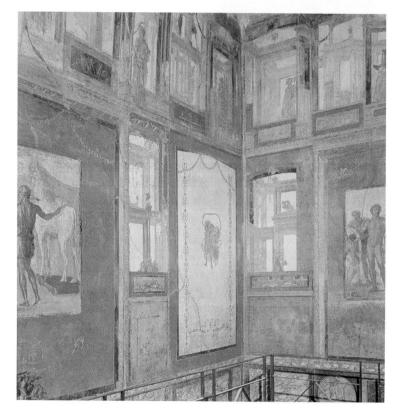

III. Fourth Style room in the house of the Vettii, Roman wall paintings from the third quarter of the 1st century AD, Pompeii (see Fig. 112 for a view of the whole of the back wall).

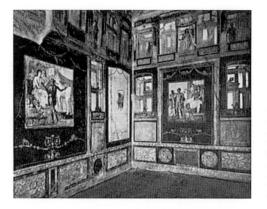

112. Fourth Style room in the house of the Vettii, Roman wall paintings from the third quarter of the 1st century AD, Pompeii (see Fig. 111 for a detail in colour).

up a delicate gable from which pearls and gems seem to dangle. It is a sort of jeweller's architecture, rich, fanciful and exquisite. The inner columns support a frieze that looks like an embroidered ribbon.

In the centre of the flat, black, spaceless wall there is a little landscape (Fig. 110). It is convincingly three-dimensional – the deft treatment of light gives a vivid impression of depth – but it floats in midair in a most unlikely manner. The black background can be interpreted either as flat and spaceless or as deep and spacious. The illuminated landscape accentuates this ambiguity and playfully foils any attempts at rational analysis.

By AD 62, when Pompeii was shaken by an earthquake and many houses had to be redecorated, most people had tired of the Third Style. Once again they wanted paintings that created the illusion of space and appeared to open out the confining walls of their often very small rooms. In the *Fourth Style* they tried to create a new synthesis between Second Style spaciousness and Third Style elegance.

A room in the Pompeian 'house of the Vettii' gives a good example of Fourth Style decoration (Figs. 111 and 112). In the centre of each wall there is a flat, red panel framing a square painting (usually a copy of a Greek work). On either side of and above this red panel, the wall appears to be opened up to allow for a view into the distance. The expansive views are distinctly theatrical and in this differ from the everyday views of the Second Style. The side walls are treated the same way as the back wall, but as they are longer, there is space for an additional white panel. This panel is painted in the Third Style, with a delicate border and a pair of figures floating in an unlikely manner in the middle of the white nothingness, which can be interpreted either as airy space or flat wall (Fig. 112).

This rather vulgarly painted room gives an idea of the general level of painting at Pompeii: cheerful but rather crude. The central

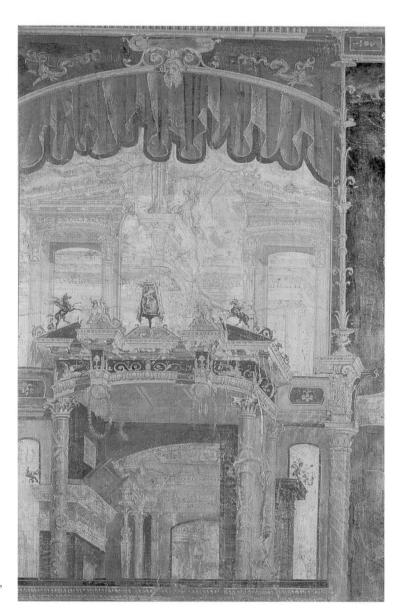

113. Fragment of Fourth Style decoration from Herculaneum, Roman wall painting from the third quarter of the 1st century AD, height 195 cm, Museo Nazionale, Naples.

pictures are fashionable but usually insensitive copies of Greek models, and some rather flashy effects are sought in the theatrical views. A fragment of a far finer painting comes from another house (Fig. 113). It must have been placed fairly high on the left-hand side of a wall-scheme like that in the house of the Vettii (Figs. 111 and 112), judging from the angle suggested by the perspective. The delicacy of the painting, the sureness of tonal range and the bravura make this theatrical vista the equal of any of the masterpieces of baroque decorative painting sixteen centuries later.

9: ROMAN ARCHITECTURE: ADAPTATION AND EVOLUTION

HOUSES AND TEMPLES: DWELLINGS FOR MEN AND GODS

The Romans built houses and temples long before they came into contact with the Greeks, and they had strong, old and sanctified traditions as to how these should be constructed.

The traditional Roman house, unlike the Greek house, was built according to a strict and invariable plan (Fig. 114). It was entered through a door placed in the centre of the short side, giving it from the outset a strong sense of central axis that was totally lacking in the more casual Greek houses (Fig. 87 a–c). The entrance (*fauces*) led into the *atrium*, a great central space with a rectangular opening in the roof which let in light and air (rain, too, which was collected in a basin, the *impluvium*, connected to a subterranean cistern). On a direct line with the fauces, on the opposite side of the atrium, was the *tablinum*, the main room in which the master of the house presided. The rest of the rooms opened off the atrium in an arrangement that was less rigorously prescribed, though always basically symmetrical.

When the Romans encountered the Greeks during the Hellenistic period and fell under the spell of their superior culture, they could not fail to admire the charm and flexibility of Greek houses. They were particularly impressed by the gracious peristyles that were then a feature of the courtyards of many Greek houses (Fig. 87c).

The Romans had great respect for tradition and were unwilling to alter the traditional layout of the rooms in their houses, as it was associated with important functions within their society, yet they wished to incorporate some of the qualities they admired in Greek houses. The solution they arrived at is so simple that it is almost mechanical (Fig. 115). They continued to build the front part of their houses in the traditional manner, but added onto the back – the more private part of the house – a Greek type of peristyle with rooms casually arranged around it.

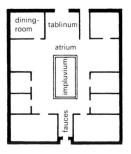

114. Plan of a traditional Roman atrium house.

115. Plan of a Roman house with the traditional atrium in front and a peristyle added at the back.

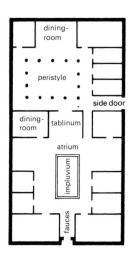

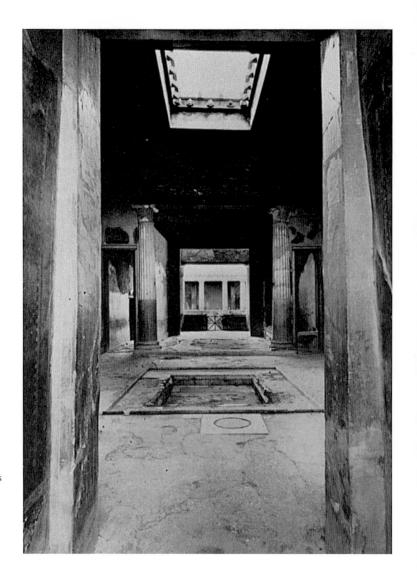

116. View from the fauces through the atrium into the peristyle of a house (the House of the Menander) in Pompeii, 1st century BC.

On paper the plan of this new type of Roman house may not look very exciting, but in fact the play of light and shadow and the contrast of illuminated atrium, dark tablinum and light-filled peristyle beyond, make for a very beautiful and striking effect (Fig. 116). Notice, too, the sense of order, the axial build-up to a climax, which much resembles the principles of planning that underlay the sanctuary of Fortuna at Praeneste (Fig. 92).

Tradition also dictated the form of the Roman temple. Following Etruscan precedent, temples were normally built on a high podium, accessible only by a flight of steps in front (Fig. 117). The *cella* (the main room of the temple, which might be single or divided into

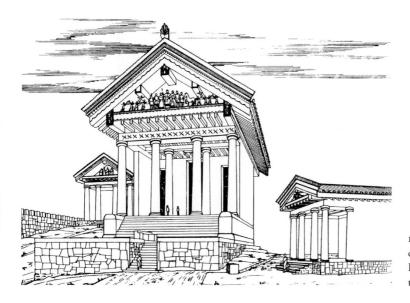

117. Reconstruction drawing of a traditional Etruscan–early Roman type of temple.

three parts) covered the full width of the podium and also reached all the way to the back. The only part of the podium not covered by the cella was the front, where a deep porch led from the top of the flight of steps into the cella. Both the plan and the elevation of a Roman temple were different from the Greek (Figs. 33–38).

A Greek temple was normally not set very high; it was usually supported all round on just three steps; by contrast, a Roman temple on its high podium towered above everyone approaching it (Fig. 117). A Greek temple generally looked much the same from all four sides (Figs. 37 and 38); not so a Roman temple. The front, which was accentuated by the flight of steps and the porch, looked strikingly different from the sides, which were of little importance, and the back, which was negligible. The back, in fact, was so unimportant that it was often built against a wall. Thus the Roman temple could become attached (like a relief) rather than remaining a free-standing building.

When the Romans became acquainted with the Greeks, they began to improve the appearance of their temples along Greek lines, but, as in the matter of their houses, they did not violate traditional usages. Once again a compromise solution was found, and it is well illustrated in the Augustan temple built at Nîmes in southern France (Fig. 118).

The Romans were struck more by the external peristyles of Greek temples than by any other feature, so it was this handsome embellishment that they tried to apply to their traditional type of temple.

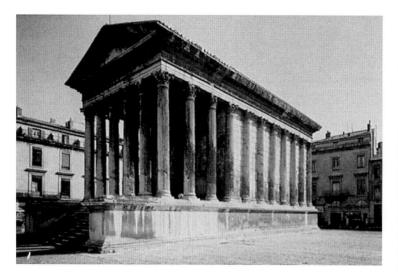

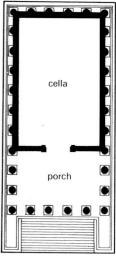

above
118. The Maison Carrée, a
Roman temple with
partially attached
peristyle, late 1st century
BC, Nîmes, France.

above right 119. Plan of the Maison Carrée (Fig. 118). From the plan (Fig. 119) it is obvious that the characteristic form of the Roman temple has been preserved – the temple is set on a high podium accessible only by steps at the front and that the cella, preceded by a deep porch, extends all the way across and to the back of the podium. The great innovation was the extension of the porch colonnade all round the temple so that it appears to be encircled by a peristyle. The full round columns of the porch had to be squashed into attached half-columns (*engaged columns*) when they were forced to share the edge of the podium with the outer walls of the cella (Fig. 118). Compromises are seldom perfect; still, this was a good one, made in much the same spirit as the statue of Augustus from Prima Porta (Fig. 93), with which it is contemporary.

A Greek temple was best appreciated from one corner (Fig. 38), for this approach immediately reveals the principal dimensions of the temple and establishes its independence as a free-standing building. Gateways in Greek sanctuaries were generally arranged so that the worshippers' first view of a Greek temple was from this angle (Fig. 91). For the Roman temple, however, this view is less satisfying (Fig. 117). The abrupt change from free-standing colonnade to attached half-columns where the walls of the cella intrude on the illusion of a peristyle is disturbing.

Consequently, the layout of Roman sanctuaries and precincts usually obliged visitors to take up a position directly opposite the front of a temple. There is a feeling of inevitable rightness once one stands facing the temple at Nîmes directly (Fig. 120). The flight of steps invites one to mount (while the high podium approached

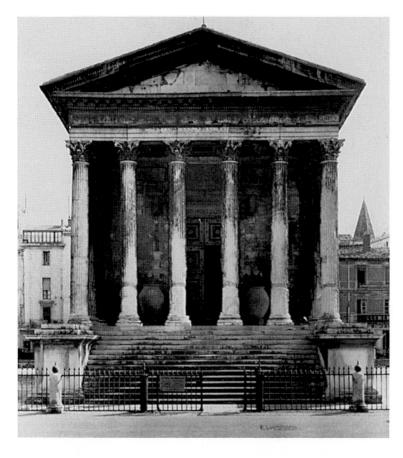

120. The Maison Carrée (same as Fig. 118) seen from the correct angle.

from any other angle discourages further advance), and the shady porch draws one in. The tall façade, looming up with strong vertical emphasis, dominates the space in front of it, just as the statue of Augustus from Prima Porta (Fig. 93), with its powerfully raised arm, dominates the space before it.

Not all Roman temples show this compromise between Roman tradition and Greek trappings. Some were remarkably original. One of the most amazing is the Pantheon, built in Rome in the time of the emperor Hadrian (AD 117–138) and fortunately still extremely well preserved (Fig. 121).

The architect of the Pantheon (who may have been the emperor himself) draws on old Roman traditions, techniques and materials to create something dazzlingly new. Circular as well as rectangular temples had been built in Rome from ancient times. Inside, circular temples were cramped cylinders. The vast uncluttered interior of the Pantheon (Fig. 121), breathtaking in its serenity and grandeur, was quite novel. The height of the dome is equal to the diameter of

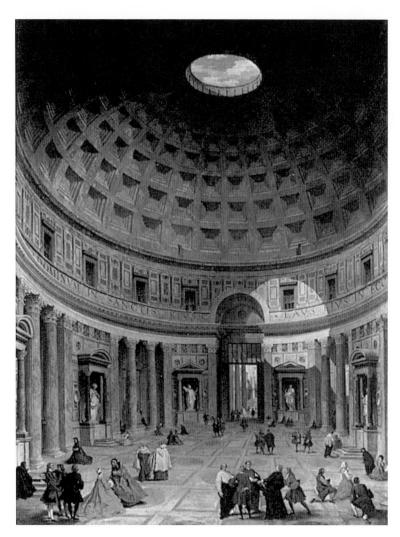

121. Interior of the Pantheon, a 2nd-century AD Roman round temple, painted by Pannini in the 18th century, National Gallery of Art, Washington, DC, Samuel H. Kress Collection.

the base, so that the great hemisphere tranquilly resting upon the ample drum seems to shape a sphere of space. The circular opening at the centre of the dome floods the building with light and throws a moving circle of sunshine on the walls. An 18th-century painting shows the rich inlays of marble that lined the interior. (Possibly it was effects of this sort that wall painters in the first Pompeian style were striving to capture.)

Only a dome could roof the great central space of the Pantheon without requiring intermediate supports. By the 2nd century AD, the Romans had amassed considerable experience in building arches, vaults and domes. They used them in numerous works of practical and ornamental architecture. An arch is built of wedge-shaped

stones (*voussoirs*) which become self-supporting once the keystone is in place. Until then it has to be built on a framework (*centring*) of wood. An arch extended in length becomes a barrel vault; an arch that is rotated becomes a dome. The structural principles are the same for all three forms.

The dome of the Pantheon does not require a keystone because it is built of concrete, which, once set, is self-supporting. Knowledge of how to build arches and vaults was necessary for its construction, as was also a huge wooden centring, but the final form was possible only because of the Romans' experience and skill in the use of concrete.

The Romans began to use concrete in the 2nd century BC. It was cheap, strong and malleable and could be used for huge projects such as the sanctuary of Fortuna at Praeneste (Fig. 92), where the whole side of a hill was transformed into an architectural complex. Buildings of concrete were constructed as follows. Two low walls were built (if below ground, of wooden shutters; if above ground, of mortared bricks). The space between the walls was filled with broken stones (aggregate). Next, mortar – the best quality, composed of lime and a local volcanic sand (pozzolana) mixed with water was poured in. It flowed around the pieces of stone that made up the aggregate and then hardened. As soon as it was hard enough, the containing walls were built to a higher level, more aggregate was laid between them and a new batch of mortar was poured in. As the building rose, the nature of the aggregate was altered. Heavy stones were used at the bottom, lighter ones as the walls grew higher. Very light materials, like pumice, would be used in the aggregate of a dome, for which a wooden centring would have to be employed.

The shape of the final concrete building was defined by the shape of the containing walls between which the aggregate was laid. Since the Romans usually used bricks or, alternatively, carpented wood to construct these walls, they could be flexibly and imaginatively curved. Furthermore, concrete could take the shape of anything that was pressed against it before it dried. Thus, wooden moulds were used to make the coffers of the dome of the Pantheon (Fig. 121). Once the concrete had set, the moulds were removed but the shape remained. The coffers make a great aesthetic contribution to the appearance of the dome, for they make its sphericity apparent, defining the curve and the recession by means of light and shadow

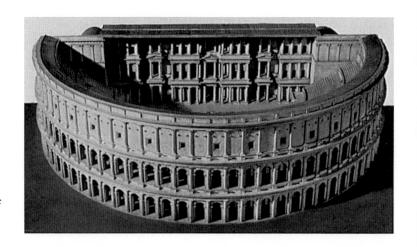

122. Model of the theatre of Marcellus, Rome, late 1st century BC.

and subtly used perspective. A smooth dome, evenly flooded with light, as the dome of the Pantheon is, would just look flat. Notice how undefined the central portion of the Pantheon's dome is, where there is no coffering to catch the light and throw shadows.

FROM THEATRE TO AMPHITHEATRE

Engineering experience in the use of arches and vaults and practical experience in the use of concrete enabled the Romans to create buildings in shapes and on a scale that could never have been dreamed of by the Greeks. Such techniques also enabled them to transform the Greek theatre. Greek theatres were built into hillsides (Fig. 88); they were not free-standing buildings. The Romans ingeniously used tiers of arches made of cut stone and concrete to construct the equivalent of a hillside on which to rest the seats of the auditorium. Thus they were able to build theatres anywhere, even in the flattest stretches of desert, for the theatres they built were free-standing and independent (Fig. 122).

The Romans gave their theatres an appearance of unity and coherence by erecting a scene building (*scaenae frons*: plural *scaenarum frontes*) that was as tall as the top of the auditorium and connected laterally with it (Fig. 122). Thus the semicircular area of the theatre was completely enclosed, and the three originally distinct parts of the Greek theatre (Fig. 88) were welded into a single unit (Fig. 123).

Spectacles in the theatre were addressed to the audience. Actors would stand with their backs to the scaenae frons and direct their speeches to the crowds that only partially encircled them. Other

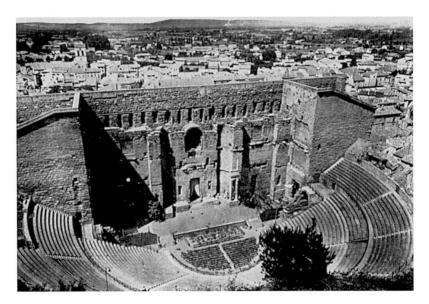

123. Roman theatre, 1st century AD, Orange, France.

entertainments that the Romans enjoyed did not have any such built-in, necessary sense of direction. The bloody fights of gladiators, or men against wild beasts, or wild beasts against each other, like modern bullfights or football games, did not have to be viewed from any one direction. In fact, they were better viewed from all round.

The Romans created an architectural form to fit the need. The invention has the simplicity of genius: two theatres were constructed back to back but with the intervening walls of the scaenarum frontes omitted. What resulted was an oval arena encased in an oval of tiered seats; not a theatre but an amphi theatre. The coin in Figure 124, which shows a representation of the most famous of all amphitheatres, the Colosseum in Rome, conveys in a single glance the essentials of the structure. Like the painting of the riot in the amphitheatre in Pompeii (Fig. 106) and some of the carvings on the Column of Trajan (Fig. 100), visual realism has been sacrificed for the sake of diagrammatic clarity. Thus one sees the interior of the amphitheatre and, at the same time, the exterior, which was built on superimposed tiers of arches. A combination of cut stone and concrete was used to construct this giant arena (Fig. 125), the dedication of which was one of the principal events in the short reign of the emperor Titus (AD 79-81). It was not the first amphitheatre – the one in Pompeii was earlier – but it was probably the finest. The arcades of the exterior were filled with sculptures. These have long been lost, but the fact that they once existed gives an indication of

124. The Colosseum as shown on a coin minted AD 238–244.

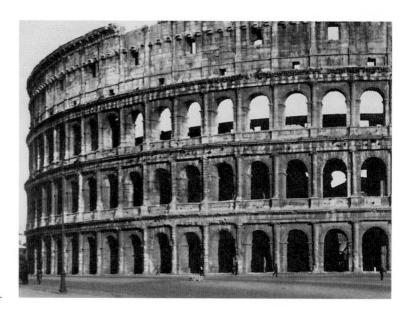

125. Exterior of the Colosseum (the Flavian amphitheatre), inaugurated AD 80, Rome.

what an immense quantity of sculpture was produced during the period of the Roman empire.

Greek theatres (from which the Colosseum is derived at two removes), having been built into the sides of hills, had no exteriors. The Colosseum, by contrast, had a gigantic one. Much thought was given to its decoration (Fig. 125). In addition to the statues placed within the arches, a veneer of Greek orders was superimposed on the arcades. On the lowest register, attached Doric half-columns support an attached architrave; on the second register, there are attached Ionic half-columns; on the third, attached Corinthian half-columns; and at the top, which was added later, attached Corinthian pilasters. These orders support nothing. They are not structural but ornamental. This does not mean they were unimportant.

The application of these orders served two functions. First, they clearly alluded to Greek architecture. This was the way the Romans showed their appreciation of Greek culture. Adding Greek orders to the exterior of a theatre or an amphitheatre was rather like adding a Greek peristyle to a Roman temple (Figs. 118–120), a touch of Greek elegance that did not affect the basic Roman structure underneath.

Second, the application of the orders gave the impression of scaling down the building, making it more accessible to human beings without diminishing its tremendous size. The naked, unarticulated structure of the Colosseum (Fig. 126) is gigantic, dwarfing any people who might approach it. The Roman architects wanted Roman

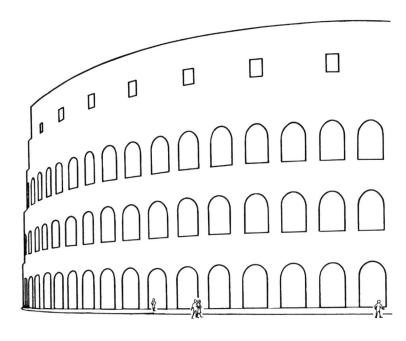

126. Drawing of the Colosseum showing the structure without the addition of the applied orders.

citizens to appreciate the grandeur of their creations, but they also wanted them to feel that they shared in that grandeur, not that they were tiny and insignificant. Faced with the great mass of the building, an individual might have been daunted; however, since the orders have been applied, one does not have to relate to the whole building but merely to a single bay. Notice in Figure 126 how small a person is in relation to the entire structure but how much larger he seems (Fig. 125) when measured only against the rectangle described by the columns and architrave that frame a single arch. Because of the addition of the orders, a Roman citizen could feel himself a significant part of the huge building and the huge empire that it represented.

IMPERIAL THERMAE: THE 'PALACES OF THE PEOPLE'

A much prized leisure activity among the Romans was an afternoon visit to the baths. The fee, if there was one, was so small that even the poorest could afford to pay, and what they received in return was far more than just a wash. Even the most elementary bathing establishments (some 800 of these existed in Rome at the height of the empire) included cold, warm and hot rooms, while the grandiose

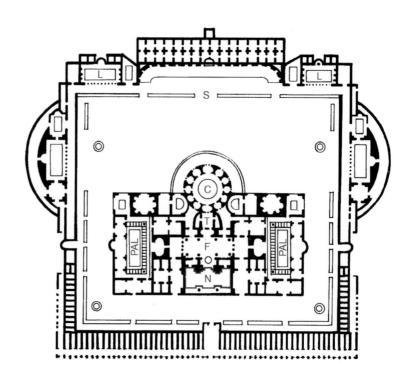

127. Plan of the Baths of Caracalla, AD 216.

bath establishments (*thermae*) built by the emperors were something quite spectacular.

The huge Baths of Caracalla (Figs. 127 and 128), completed in AD 216, covered an area as great as might be occupied by a small town and included a vast range of amenities. The actual bath building was enclosed in ample grounds that provided viewing stands for watching foot races (S), promenades for strolling, and libraries (L) for intellectual stimulation – all within elegant, enormously spacious surroundings (400 by 300 metres).

The bath building itself was large enough to accommodate 1,600 bathers at a time. The brilliant symmetrical plan (Fig. 127) was designed to conserve heat and to promote the easy flow of bathers, who could complete (or vary) the circuit without having to retrace their steps. The climactic circular room for hot baths (*caldarium* C), at the end of the short axis, faced south-west in order to catch the afternoon sun and was almost as large as the Pantheon (Fig. 121). Opposite it, at the other end of the short axis, was an unroofed swimming pool (*natatio* N). In between there was a huge hall (*frigidarium* F), the scale of which may be imagined from the reconstruction drawing (Fig. 128). Providing the transition between the hot and the cold baths was a warm room (*tepidarium* T).

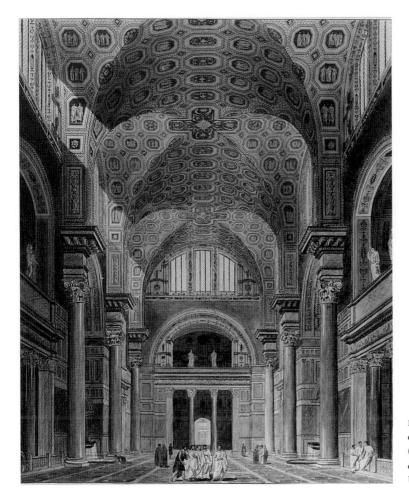

128. Reconstruction drawing of the frigidarium (Great Hall) of the Baths of Caracalla. Fototeca Unione.

Along the long axis there were carefully contrived vistas punctuated by colonnades, fountains and sculptures leading to open-air exercise grounds (*palaestras* PAL).

Rooms of different sizes were roofed in different ways, some vaulted, others domed, and still others had flat roofs or no roofs at all, producing a play of light and shadow comparable to that in the atrium house (Fig. 116) but on a much grander scale. The bather progressed through a series of differently shaped volumes, large or small, rectangular or rounded, enclosed or open, to meet with a sequence of architectural surprises. And, in addition, the whole complex was elaborately (perhaps even gaudily) decorated with marble facings or mosaics on the walls, floors and ceilings and gigantic statues or statuary groups – a veritable museum combined with a playground, which all together accommodated ball games,

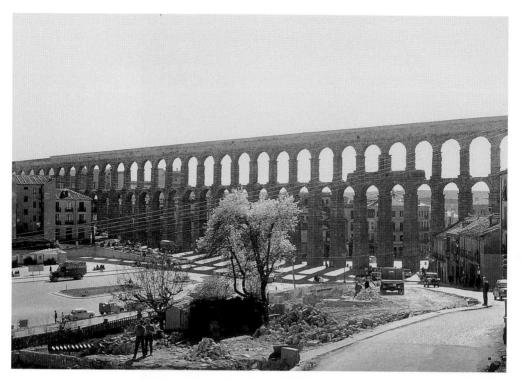

129. Aqueduct at Segovia, 1st century AD.

athletic exercises, massages, ablutions, swimming, snacking or just amiable gatherings of friends. Such thermae, providing something like palaces for the people, were among the most seductive features of the Roman empire, as attractive in the provinces as in the city itself.

A good supply of water was essential to serve the baths, whether they were modest private enterprises or the magnificent gifts of emperors. The Romans, always first-rate organisers and engineers, found this no problem: throughout the empire they ensured abundant water supplies by means of aqueducts. Whenever possible, these were led along the ground, but when necessary, water could be carried along the top of lofty structures supported by arches that sometimes stretched for miles (Fig. 129). After surveying the impressive provisions made for the city of Rome, Frontinus (who wrote about the water supply in the late 1st and early 2nd centuries AD) invited his readers to compare what had been achieved with 'the idle pyramids or all the useless, though famous, works of the Greeks!' (De Aquis Urbis Romae 1, 16).

Rome itself had several magnificent aqueducts, but the provinces were not neglected, and to this day one is awed by the towering construction still functioning in Segovia in Spain (Fig. 129).

10: WORLD RULERS

WORLD ARCHITECTURE FOR WORLD RULERS

The Romans were great organisers and great builders. Wherever they went – and they went all over the western part of the civilised world (Map 3) – they established colonies and built cities. These cities were then graced with the amenities that made Roman civilisation attractive to conquered people. To house such amenities, the same types of buildings as had been created in Rome were erected outside the city in the newly acquired domains, although local methods and materials often had to be used to construct them.

130. Theatre at Aspendos, 2nd century AD.

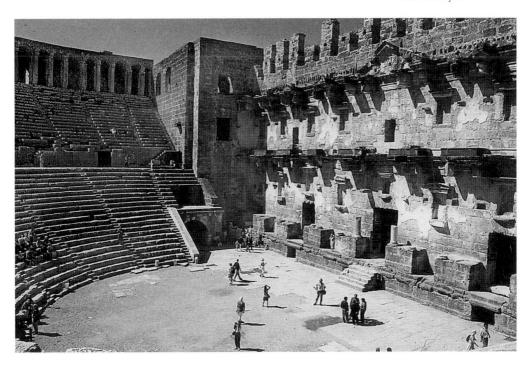

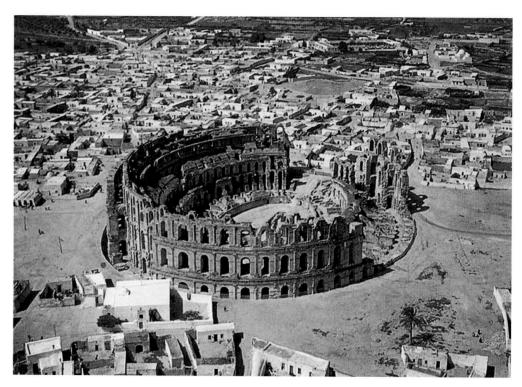

131. El Djem (amphitheatre), mid 3rd century AD. © Roger Wood/CORBIS.

We have already seen how a theatre in the Roman style was built at Orange in southern France (Fig. 123). Similar theatres can be found throughout the Roman empire. The best preserved is at Aspendos in Asia Minor (Fig. 130). As at Orange, the scaenae frons still stands up to its full height and is linked to the top of the cavea. The audience was, therefore, contained within an enclosed space, isolated from the outside world; this was very different from the open aspect of the Greek theatre at Epidauros (Fig. 88).

The scaenae frons was, in its original state, a glamorous affair. Statues stood in niches framed by columns, each pair of columns topped by its own entablature. This lively decorative scheme was on two levels, supported by the outcroppings still protruding from the back wall of the scaenae frons. On the upper level, the pairs of columns were further enriched by alternating triangular and rounded pediments. In the centre, an enlarged triangular pediment, just perceptible in Figure 130 above the large central door, embraced a pair of niches. A splendid and rich effect must have been produced by the rows of paired columns with their elaborate entablatures, similar to, or even more complex than, the scaenae frons reconstructed

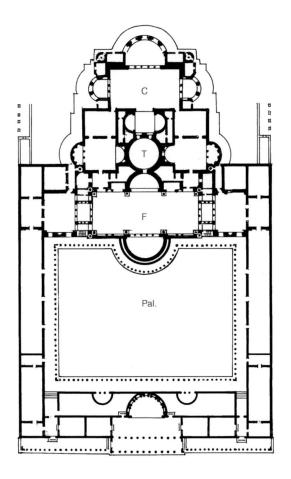

132. Plan of the Imperial Baths at Trier, early 4th century AD.

on the model of the theatre of Marcellus (Fig. 122). The scale of the building can be appreciated when one sees how small the people visiting it are.

Amphitheatres, too, proliferated, built to accommodate the gruesome entertainments that had become popular, particularly in the western part of the empire. The remains of a huge amphitheatre can still be seen at El Djem in North Africa (Fig. 131). Even in this remote provincial location, care was taken to produce work worthy of the dignity of the Roman empire, and the exterior was decorated with a veneer of classical orders, attached columns and entablatures, similar to those adorning the Colosseum (Fig. 125). Though partially ruined, the amphitheatre still towers over the humble dwellings that surround it, a reminder that it stood at a crossroads of traffic between the coast and the interior and reflected the

prosperity of the olive-growing communities that flourished in the area.

The most seductively attractive of Roman amenities, bath buildings, were constructed wherever the Romans went. The majority were very modest, consisting simply of the basic hot, warm and cold rooms, but some were constructed in a style and on a scale that rivalled the grandeur of the imperial city itself.

The Imperial Baths at Trier were the second large public thermae to be built in the city and were never completed (Fig. 132). Covering a vast area (260 by 150 metres), their elegant and efficient design resembles that of the Baths of Caracalla (Fig. 127). As in the Baths of Caracalla, the layout is symmetrical, with the actual bathing rooms (caldarium C, tepidarium T and frigidarium F) on the central axis, flanked by dressing rooms, latrines and other facilities. Here, too, the hot room (caldarium C) is orientated towards the south in order to make maximum use of the warmth of the sun. The exercise grounds (Pal), however, are just attached to the north of the main building block and not integrated into it, unlike the Baths of Caracalla, which were considerably larger and set within a huge garden precinct.

This handful of examples drawn from as far east as Turkey (Aspendos), as far south as Tunisia (El Djem) and as far north as Germany (Trier) may suffice to suggest the pervasive influence of Roman customs throughout the sprawling empire.

UNITY AND DIVERSITY

Building forms and the way of life that they accommodated were not the only things to travel from one end of the empire to the other; ideas – and even myths – travelled too.

Greek myths, along with other aspects of Greek civilisation, had been absorbed into Roman culture well before the beginning of the imperial period and long continued to be illustrated in paintings (Figs. 104 and 105), on sarcophagi (Fig. 103) or in mosaics wherever cultivated Romans lived.

One such myth, perhaps surprisingly popular, was the story of the discovery of Achilles among the daughters of Lycomedes.

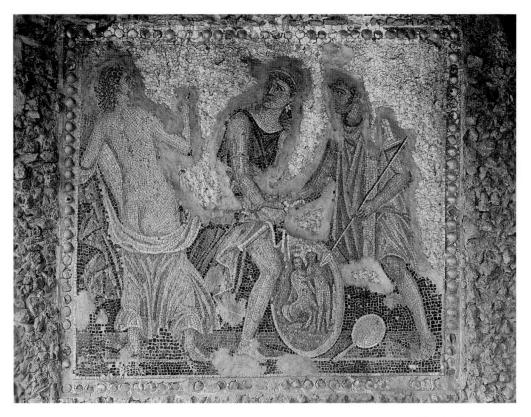

133. Mosaic, Discovery of Achilles among the daughters of Lycomedes, 1st century AD, Pompeii. DAIRome.

According to this tale, when the hero Achilles was still a young boy, his mother, anxious that he should not be conscripted into the fighting against Troy, hid him among the fifty daughters of Lycomedes. The Greeks, collecting forces to fight against Troy in order to recover Helen, knew that Achilles was concealed there and also knew that he was destined to be a great warrior. They were, therefore, anxious to recruit him. The problem was how to detect the beardless youth among the girls – without giving undue offence.

Clever Odysseus devised the following plan. He and a fellow Greek came to the court of Lycomedes disguised as merchants. In this role they offered a range of feminine articles and also a spear, shield and sword, equipment fit only for a warrior.

The girls came and viewed the goods, Achilles, prettily dressed, unrecognisable among them. Odysseus then did the thing that gave him his reputation for superior intelligence: he had a trumpeter sound the alarm. The girls responded with terror, but Achilles, his true nature rushing irrepressibly to the surface, immediately

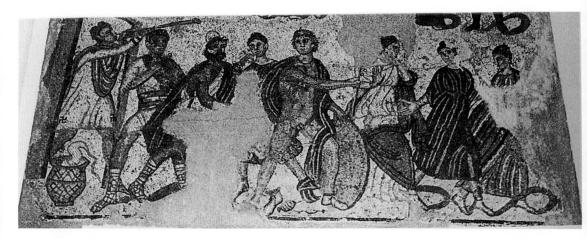

134. Mosaic, Discovery of Achilles among the daughters of Lycomedes, early 4th century AD, Algiers Museum.

seized the arms and so revealed himself – with no embarrassment to anyone.

This scene of the discovery of Achilles among the daughters of Lycomedes greatly appealed to the Romans. It was frequently painted on walls or used to decorate sarcophagi, and also appears in about a dozen surviving mosaics. Some show characteristics derived from the same model, but others display individual variants.

A mosaic found in Pompeii (Fig. 133) depicts Achilles, still clothed in his feminine attire, in the centre, grasping a shield with one hand and a sword with the other. Odysseus, who laid the trap, approaches from the right, while Achilles turns to look at the astonished girl at the left, whose agitated gesture has displaced her clothing. She was not actually surprised to discover that Achilles was a man, for she was already pregnant with his son, but she was horrified at the consequences sure to follow upon this revelation. The Roman artist may well have found the juxtaposition of the nude woman and the male figure in drag pleasantly titillating.

Another mosaic (Fig. 134), this one from Tipasa in Algeria, is both more crowded and less well preserved. Achilles is still recognisable in the centre, holding a shield in one hand and a spear in the other. In this image he has shed his feminine garb and is fully revealed as male, with only a cloak loosely draped over one arm. Puzzled girls are shown to the right, while Odysseus steps forward from the left to take hold of Achilles, and the trumpeter, whose action was so critical in distinguishing the youth from the girls, appears at the far left.

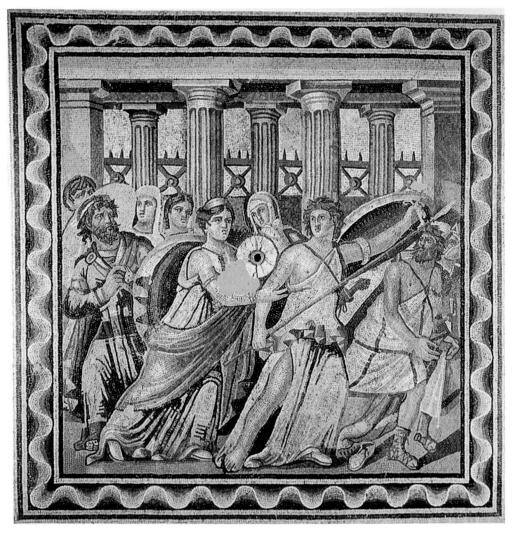

A third mosaic (Fig. 135), uncovered in Zeugma on the Euphrates in eastern Turkey in 2000, shows the three major figures, all almost fully clothed, in a palatial architectural setting. Achilles is again central, still wearing female clothing, but clothing that has now become sufficiently disordered to reveal an unmistakably masculine chest. He holds a spear in his right hand, his sword is at his side and he has already fitted the shield to his left arm, so that he seems ready for battle. Odysseus, to the right, cowers away from the raised shield, while Achilles' lover, heavily draped, reaches out for him. Minor figures in the background complete the scene.

135. Mosaic, Discovery of Achilles among the daughters of Lycomedes, first half of the 3rd century AD, Zeugma, Turkey. Courtesy A Turizm Yayinlari, Istanbul.

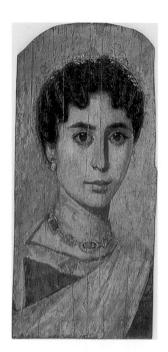

136. Portrait of a woman, encaustic on limewood with added gold leaf, about AD 160–170, 44.3 × 20.4 cm, British Museum, London. © The British Museum.

This Greek myth had become an accepted part of Roman culture; its main lines are recognisable in all three mosaics. Nevertheless each artist has illustrated the story in a slightly different way.

NON-ROMAN ETHNIC TRADITIONS UNDER ROMAN RULE

Although Roman culture pervaded the empire, a variety of ethnic traditions were occasionally combined with Roman forms to produce something new. Such are the mummy portraits painted in Egypt during the Roman period. These solemn and beautiful images representing the deceased were placed over the faces of the dead once they had been mummified. Mummification was, of course, practised by the Egyptians from remote antiquity, and the practice was continued even after Egypt had been conquered, first by Alexander the Great and then by the Romans. Invaders married native women; populations became mixed – and so, too, did their art.

The extraordinary vividness of many of these images is due to the accomplished naturalism that had been developed over many centuries. In the portrait shown in Figure 136, for example, the clever touches of white to highlight the eyes, nostril and the lower lip, the shading of the side of the nose and under the chin, and the subtle modelling of face and neck suggest a three-dimensional figure bathed in light.

This portrait was painted on wood using the encaustic technique, in which warmed (or emulsified) beeswax was employed as the medium to bind the pigments. The effects produced could be much like those of oil painting.

Most panel paintings created during classical antiquity were painted on wood and were lost when, in wet climates, the wood disintegrated. Since the dry climate of Egypt prevents wood from decaying, numerous mummy portraits have survived. Images like this one, with its engaging presence and subtle colour harmonies, are precious evidence of the heights Roman portrait painting could attain, even though this portrait was produced for a very un-Roman purpose.

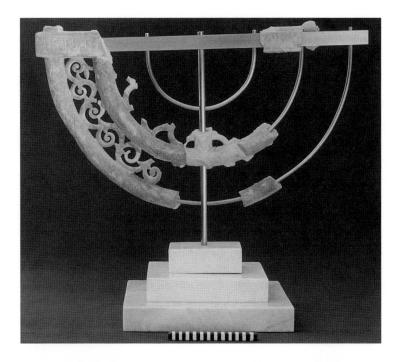

137. Marble menorah (seven-branched lamp holder), first half of 4th century AD, preserved height 56.5 cm, from the synagogue in Sardis.

© Archaeological Exploration of Sardis/Harvard University.

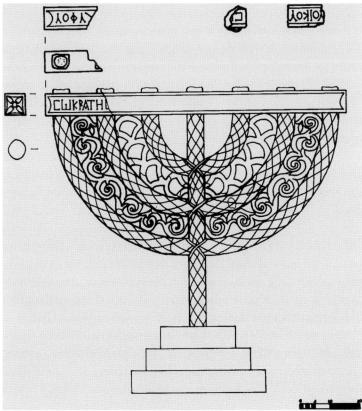

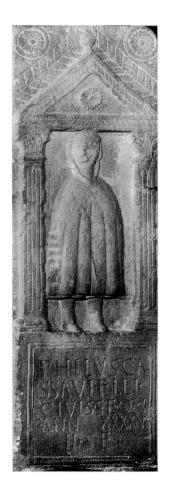

above and opposite
138. Grave stele of Philus
from Cirencester, about
the middle of the 1st
century AD, height 216 cm.
© Gloucester City
Museum and Art Gallery.

Among the large and diverse peoples included in the Roman empire were some who had traditional practices that were markedly at variance with the prevailing culture. As long as these did not interfere with the efficient running of the empire, the Romans could be remarkably tolerant and even willing to make concessions to ancestral customs.

By the time the Romans came to power, Jews were no longer concentrated only in the area around Jerusalem but had been scattered throughout the Mediterranean area and to the east in Mesopotamia, beyond the boundaries of the Roman empire (see Map 3). In some places the Jewish population constituted a distinctive and occasionally resented minority group. When conflicts erupted and Roman mediation was invoked, provided there was no real threat to Roman authority, the Romans would usually protect the Jews' right to preserve their religious rites and even excused them from sacrificing directly to the emperor, allowing them instead to make sacrifices in the Temple in Jerusalem *on behalf of* the emperor.

Local problems were dealt with locally, so that Roman tolerance toward the Jews dispersed around the empire persisted even after the great Jewish revolt was finally quashed with the sack of Jerusalem and the destruction of the Temple in AD 70 (see Fig. 99), and after two further bloody uprisings in the 2nd century AD had claimed hundreds of thousands of lives.

By this time a sizeable Jewish community had been living peaceably in Sardis (western Turkey) for hundreds of years. Not having been drawn into the rebellions against Roman authority, it continued to flourish virtually undisturbed. The Jews of Sardis were, therefore, able to build a large and impressive synagogue, the scale of which came as a surprise to 20th-century excavators. Many prosperous Jews made dedications to maintain the upkeep of the synagogue, expressing themselves more often in Greek (the local language in this part of the empire) than in Hebrew. In the 4th century AD, a certain Socrates dedicated a large marble menorah (Fig. 137). A fragment of his offering, with its outstanding virtuoso openwork carving of a floral design between the branches, has survived. (The reconstruction drawing suggests how complex and elaborate it originally was.) This finely executed but characteristically Jewish

object (compare Fig. 99, which shows the golden menorah looted from the Temple in Jerusalem) is just one illustration of how the same techniques as were used to produce the elegant stone carvings that graced so many pagan monuments were also employed by the various minority sects that made up the huge heterogeneous empire.

ART OUTSIDE THE CLASSICAL TRADITION

The slow but brilliant progress of the Greeks in discovering ways to represent human figures in a life-like manner and to fill spaces, however awkward their shape, with harmonious designs has been traced in Chapters 1–5. These achievements were passed on to the Romans and used in their most urbane works (Chaps. 7 and 8). But not all artists were trained to meet such high standards. Even in Rome itself naive compositions and ill-proportioned figures were sometimes created, and in the provinces many stone carvers who could manage to carve inscriptions extremely well were quite hopeless when it came to more sophisticated demands.

A tombstone from Cirencester in England displays well-cut Roman lettering and an architectural frame with fluted pilasters crowned with Corinthian capitals topped by a triangular pediment (Fig. 138). Within this frame is the image of the deceased, Philus by name, wearing a hooded cloak in local style.

The heavy garment does not simply obscure his body; he seems to have no discernible body under it at all! His head emerges at the top and two lower legs and feet at the bottom, but as there is no hint of underlying anatomy, his legs might as well be hanging directly from his shoulders. Drapery, even rather heavy drapery (see Athena in Fig. 49 or the procession on the Ara Pacis in Fig. 97), can be made wonderfully revealing of the body beneath – but it takes great skill and training to make it do so, and the naive artist here, who has got a good grasp only of the trimmings of Roman art, was clearly at a loss when it came to depicting a human figure.

The tombstone for Philus was made for a private individual, but another example of work made outside the classical tradition comes

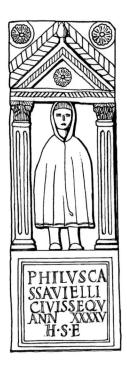

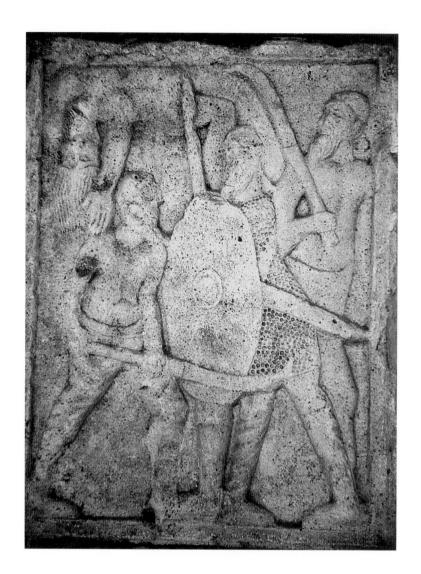

right, and opposite 139. Panel adorning the Trajanic monument (Tropaium Traiani), AD 107–108, 105 × 102 cm, National Museum of Romania, Adamklissi.

from a public monument: the large triumphal monument erected in the time of Trajan at Adamklissi (Romania). Here a huge mound supporting a gigantic stone trophy was encircled near the bottom by a series of metope-like rectangles. The rectangles were filled with figured subjects: military combats, anxious civilians, groups of trumpet-players or corps of standard-bearers. In one poorly preserved scene (Fig. 139), two barbarians are attacking the Roman between them, while a dead body is stuffed in horizontally at the top left. The craftsman carver here had little grasp of how to convey anatomy correctly, how to make action convincing or how to create

a satisfying composition with figures all on the same scale. The skill and training which enabled Greek artists to fill metopes with bold and handsome designs (Figs. 48–52) were simply not available to him.

The most aesthetically pleasing of these rather crude works are those in which a decorative effect is produced through repetition (Fig. 140). The curved trumpets carried by the men marching (more or less) in step make for a handsome design, and the drill holes that have been used to suggest their chain-mail armour create a lively pattern of light and dark. This unambitious composition relies on

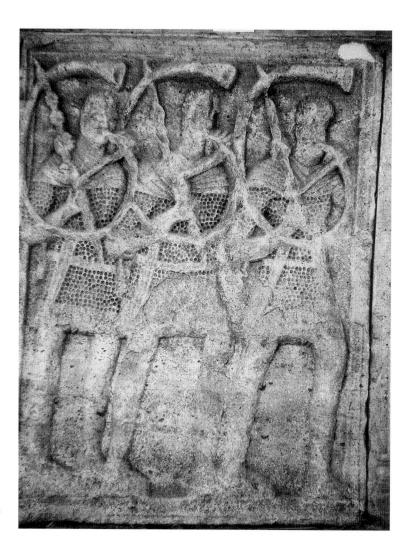

right, and opposite 140. Panel showing trumpeters from the same monument as Figure 139.

repeated forms to create an attractive pattern, the method used by the Greeks in the archaic period (compare Fig. 48).

The carvings at Adamklissi, virtually contemporary with the Column of Trajan (Fig. 100), provide an example of sculpture in and for the Roman empire untouched by the classical style so laboriously developed by the Greeks and enthusiastically espoused by the more sophisticated Romans. These awkward carvings, the product of workmen innocent of the hard-won achievements of classical artists, dramatically reveal how unusual, refined and astonishing was the classical style evolved by the Greeks.

The huge geographic expanse of the Roman empire was matched by the diversity of the people and the traditions it encompassed. Within

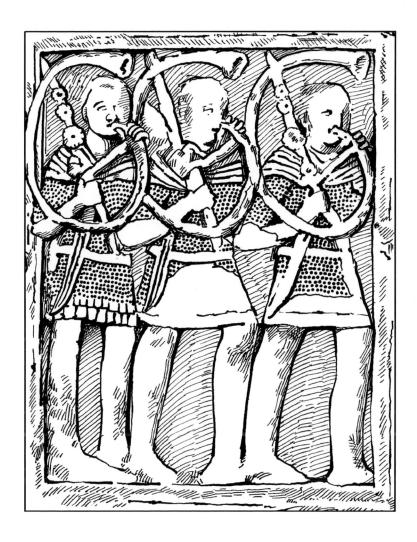

it, Roman forms and ideals were often eagerly adopted, sometimes subtly modified, occasionally drastically transformed or even totally ignored.

In time, after the fall of the empire, mighty buildings began to decay, marble veneers were stripped from walls, and roofs fell in; statues were looted and burned to produce lime or melted down for their metal; paintings disintegrated and turned to dust. Yet, even in ruins, the massive remains and pathetic fragments of what the Romans had built still astound the visitor and stir the imagination.

EPILOGUE

T ime, war and vandalism have all contributed to the destruction of the art of Greece and Rome. Mere fragments have survived, and yet these have often proved inspiration enough for later ages.

Even as early as the Carolingian period (8th-9th centuries), artists and thinkers began to look back to pagan antiquity for models of humanity and culture in art and literature. But it was only in the Renaissance (beginning in the 15th century) that the art of Rome came to be fully appreciated in its own right. From that time on it has been ceaselessly studied, copied, admired and analysed. During the neo-classical period (the 18th century) people became increasingly aware of the differences between Greek art and Roman art instead of lumping them together as 'classical antiquity', and this distinction has been further refined as Greek art has come to be increasingly well understood.

The newly emerging urban societies of the Renaissance were immensely impressed by what they learned of the urban societies of antiquity. For centuries the revival of antiquity seemed the highest possible goal for civilised man. Even plaster casts and humble Latin texts were enthusiastically used to open receptive eyes and minds to the glories of the past.

The 21st century has other concerns. The intensity of passion once felt for the art of Greece and Rome has faded, but the beauty and power of the creations themselves remain, mute but eloquent testimony to the glory that was Greece and the grandeur that was Rome.

APPENDIX: HOW WE KNOW WHAT WE THINK WE KNOW

onfronting what is left of Greek and Roman art is like entering a hopelessly chaotic museum where most of the exhibits have no labels and such labels as exist have all been thrown helter-skelter into some barely sorted piles. We have the actual remains of works of art – buildings, sculptures, paintings, vases, mosaics and suchlike – but seldom with any information attached to them that indicates when they were made, by whom, or for what purpose.

Fortunately, apart from these physical objects, we have some written sources of information (see Chap. 3, pp. 56–58): histories, biographies and inscribed stones. The literary works lack illustrations, and the inscribed stones – often naming the dedicator and the artist – are usually only bases that once supported statues now lost. An important task in trying to understand Greek and Roman art is to attach what has survived in written records to what has survived physically.

A few examples follow of how the history of Greek and Roman art has been built up into a deceptively clear account.

HOW GREEK AND ROMAN WORKS OF ART AND ARCHITECTURE CAN BE DATED

Plutarch, who lived in the 1st and 2nd centuries AD, wrote a biography of the Athenian statesman Pericles in which he mentioned the buildings erected under Pericles' influence. Among them is the Parthenon (Plutarch *Life of Pericles* 13, 31). Other sources give us dates for Pericles. In addition, fragmentary inscriptions on stone, which are dated, detail the expenditure on some of the sculpture adorning the temple. From these pieces of evidence, we can be confident of the dates of Figs. 47, 51–54, 56 and 98.

Such fixed points are rare, but highly useful. Works that in style seem earlier can be placed earlier; those that look more developed,

later; but where there is no further confirmation, this chronology cannot be considered conclusive.

From the time of Homer in the 8th century BC through most of the 6th century BC, speculation and the logic of stylistic development are practically all we have. The apparently logical sequence of kouroi (Figs. 1, 6 and 9) derives largely from the assumption that there was a desire among the sculptors to produce increasingly naturalistic images. This assumption is probably basically correct, despite the somewhat circular reasoning.

Dating Roman monuments is easier and usually surer. Literary sources often attribute certain creations to particular emperors, whose dates are documented. Quite often the monuments themselves bear inscriptions that indicate when they were made, for instance Trajan's column (Fig. 100). Occasionally, the date of a building will be supplied by the stamps impressed on the bricks used: through them it was discovered that the Pantheon (Fig. 121) was actually constructed in the time of Hadrian – despite the fact that an inscription on the façade attributes its erection to Augustus' general Agrippa.

The images of most of the emperors (Figs. 93, 94 and 96) and the hairstyles of their wives (Fig. 95) have been identified (often with the help of portraits on coins), and the fashion for imitating the styles used by the imperial family can provide a clue to dating images of ordinary people. For instance, Penthesilea as depicted on the sarcophagus in Fig. 103 is actually the portrait of a lady wearing the most up-to-date imperial hairstyle, one that helps to date the sarcophagus.

In some instances we have a date *post quem* (after which) certain works must be dated. Thus the great altar to Zeus in Pergamon (Fig. 78) must have been created after Pergamon began to flourish as a centre of Hellenistic art in the 3rd century BC. At other times we have a date *ante quem* (before which) certain works must be dated. Thus all the works in Pompeii, Herculaneum and other near-by Campanian centres (for example, Boscoreale and Boscotrecase) must have been created before the eruption of Vesuvius in AD 79 that buried them. Within these very general guidelines, refinements can be introduced, sometimes on the basis of

firm archaeological evidence (objects found during excavations at a deeper level are normally earlier than those found at a higher level), at other times based on little more than an assessment of the development of style as generally agreed among a number of scholars.

HOW WORKS CAN BE ATTRIBUTED TO ARTISTS KNOWN FROM LITERATURE

Pliny the Elder, who lived in the 1st century AD, listed many artists and the subjects of works that they made. Often these subjects are very vaguely defined: a discus-thrower, a man carrying a spear, an image of Athena, a heifer. Attributing specific works to artists mentioned in literary sources, therefore, also has its speculative aspects, but an attribution becomes increasingly likely when more than one source describes the work of an artist. For instance, Pliny the Elder states that Myron made, among other things, a discus-thrower (*Natural History* 34, 57–58). Lucian (who lived in the 2nd century AD) describes Myron's Discus-thrower in some detail (*Philopseudes* 18), specifying the unusual moment chosen for representation (see Chap. 3, p. 57). This information, combined with the numerous Roman copies and adaptations of the sculpture shown in Figure 20 that survive, make the attribution to Myron pretty secure.

Other attributions are more questionable.

HOW WE THINK MARBLE STATUES IN COMPLEX POSES MAY HAVE BEEN MADE

It appears that during the archaic period marble statues were generally carved in the Egyptian manner, with the sculptor being guided by the drawings on a grid on the four sides of the block (Fig. 4), but this method could hardly have been used to produce the immensely more complicated and asymmetrical poses created in the classical period.

above, below and opposite 141. Diagrams showing how a marble statue may have been carved with the aid of a clay model.

The evidence we have for the method used to carve these more complex statues is mostly derived from works that were left unfinished. It seems probable that initially the sculptor made a figure in clay, which he could then use as a guide when he began carving his marble. He could have employed some sort of 'pointing' process to measure how much marble he had to cut away in order to capture the shape of his clay figure. He may have set up a system of three axes, x, y and z. Any point in space could be related to these three axes — that is, a point could be defined as being so many units along on the x axis, so many units down on the y axis and so many units inwards on the z axis (Fig. 141).

Identical systems could be used for the clay model and the piece of marble to be carved. Measurements on the three axes could be taken on the clay model to determine the exact location of a prominent point — say, the nose, breast or knee of a figure. Then the same measurements would be made on the piece of marble, and the sculptor would remove as much stone as necessary to arrive at the same point.

The sculptor could repeatedly measure points on the clay model and then cut the marble away until he had reached them. He might well have worked from the front to the back, first establishing the most salient points and then carving away to define other points further back.

Once a sufficient number of major points had been determined to define the general outlines of the figure, an experienced sculptor could carve more freely, using callipers to measure distances within the marble statue itself. (Little knobs used as measuring points – for instance, on chins and foreheads – have occasionally been left by careless workmen that suggest this was the way sculptors worked.) The final product would correspond more or less closely to the original model depending on the skill, care and accuracy of the sculptor.

The same method was probably used both to make original sculptures in marble (for instance, Figs. 79, 93, 94 and 96) and to make copies for the Romans. In the case of Roman copies, casts made of a famous original Greek figure would be used and points measured from the casts.

HOW WE THINK THE ROMANS MADE COPIES (OR VARIANTS) OF GREEK STATUES

Although an immense quantity of sculpture was produced by the Romans, only a small part of it consisted of portraits (Figs. 93–96) or historical reliefs (Figs. 97, 99–102). Many statues of single figures (or occasionally groups), some cast in bronze, more carved out of marble, have been thought to be copies or adaptations of Greek works.

If a bronze statue has been copied in marble, certain adjustments have had to be made. Bronze statues, thanks to the tensile strength of bronze, can stand unsupported on their own two feet (Figs. 18 and 75); marble statues require supports. Tree-trunks reinforcing slender legs (Figs. 20 and 25) and critically placed struts (Fig. 77) sometimes indicate that a bronze prototype has been translated into a marble statue. It should be remembered, however, that all statues made in marble (originals or copies) require suitable supports, so that even an archaic statue like the late kouros Aristodikos (Fig. 9) was provided with struts at the hips intended to help secure the hands – which nevertheless were broken off. Plaster casts, a few of which survive, were apparently used in some workshops that made copies of celebrated Greek statues.

But not all Roman statues that have a classical look were necessarily copied from Greek originals. The Romans required a huge number of statues to decorate their private houses and villas and to adorn public buildings like baths, theatres and amphitheatres. Scholars now increasingly believe that the Romans, rather than always slavishly copying Greek statues, invented original new types of figures (gods, heroes, personifications) for their own purposes and produced them in abundance to suit their own needs.

We have already seen how the Romans used modifications and elaborations of Greek statues to create portraits whose impact was greater than could be produced by merely recording the subject's appearance. Thus the statue of Augustus from Prima Porta (Fig. 93) stands in a pose much like that of the classical bronze Spear-bearer (Fig. 25) in order to capture the sense of ease and authority conveyed by Polykleitos' statue. The marble statue of Augustus, like

any marble statue, naturally required adequate support. While the marble copy of the similarly poised Spear-bearer has the customary tree-trunk to help support the subject's right leg, the sculptor who carved the Augustus supplied a much more imaginative support: Cupid riding on a dolphin. The god Cupid was the son of the goddess Venus, as was also the hero Aeneas, the ancestor of the Romans. The little Cupid (who may have borne the features of one of Augustus' grandsons) therefore alludes to the divine ancestry of Augustus and the Roman people.

HOW WE THINK THE ROMANS USED COPIES OF GREEK PAINTINGS

Quintilian, who lived in Rome in the 1st century AD, mentions painters 'who study only to learn how to copy pictures by means of measurements and [plumb?] lines' (*Institutio Oratoria* 10.2.6). This suggests that some paintings were copied as exactly as possible, though it is impossible to verify examples of such work.

We know that the Romans admired Greek paintings. Sometimes very similar compositions appear in two or more different paintings (Figs. 104 and 105), and this has been thought to indicate that these paintings were derived from the same source. When the style of the figures is also what we would expect to find in a Greek painting, it seems possible that such works could be copies (often rather free ones) of Greek paintings. The fact, however, that compositions are seldom identical and that figures and groups are varied, apparently to suit particular contexts in Roman houses or public buildings, makes it doubtful that many paintings are faithful copies of Greek prototypes.

Speculation that the largely architectural Second Style paintings from Boscoreale (Fig. 107) are adaptations of theatrical stage sets rests on a remark by Vitruvius, who wrote his book about architecture in the 1st century BC. He described three kinds of theatrical sets:

Tragic sets are represented with columns and gables and statues and other trappings of royalty. Comic sets look like private buildings with balconies, and the views from their windows are designed, in

APPENDIX: HOW WE KNOW WHAT WE THINK WE KNOW

imitation, on the principles of private buildings. Satyric sets are ornamented with trees, caves, mountains, and all the other rustic features, fashioned to have the appearance of landscape. (*De Architectura* 5.6.8, trans. Ingrid D. Rowland)

As some of the Second Style paintings appear to be of three kinds – scenes with the trappings of royalty; cityscapes with private houses, including balconies; or idyllic landscapes – they are sometimes thought to correspond to the three types of stage sets that Vitruvius describes. Furthermore, stage sets would not include the depiction of any figures, as the actors performing in front of them would provide the figures. The absence of figures in this type of wall painting further suggests that it might be derived from stage sets.

GLOSSARY

ABACUS the topmost part of the capital: plain in Doric capitals, moulded in Ionic and Corinthian.

ACROTERIA (singular: ACROTERION) decorative ornaments placed above the three angles of the pediment on the front and back of a building.

AGGREGATE roughly cut stones placed between the brick (or stone) walls in a concrete structure and over which the mortar was poured.

ALABASTRON ovoid, narrow-necked perfume container (Fig. 60).

AMPHITHEATRE oval Roman building with seating facing inwards onto a central area for gladiatorial or other similar spectacles (Figs. 106, 124, 125 and 131).

AMPHORA capacious storage jar with two handles (Fig. 60).

AQUEDUCT Roman construction designed to carry water from a distant source to a desired location (Fig. 129).

ARCH semicircular masonry construction spanning an opening.

ARCHAIC term referring to the early period of Greek art from about 650 to 490 BC.

ARCHITRAVE a lintel or beam carried from the top of one column to the top of another (also called an *epistyle*).

ARYBALLOS small round container used by athletes to carry the oil they rubbed down with after exercise (Fig. 60).

ATRIUM central hall of a Roman house of the traditional type (Figs. 114–116).

BASE lowest member of a column (Fig. 41) (not used in the Doric order).

BLACK-FIGURE technique of vase painting in which the figures are drawn in black silhouette, details and internal markings are incised and touches of white and purplish-red are added. (The technique was invented by the Corinthians in the 7th century BC and widely used throughout Greece in the 6th century BC. It continued to be used for special purposes as late as the 2nd century BC.)

CALDARIUM hot room in a Roman bath building (Figs. 127 and 132).

CAPITAL top part of a column, crowning the shaft and supporting the architrave.

CAVEA the place for spectators in a Greek or Roman theatre (the auditorium).

CELLA the inner part of a Roman temple in which the image of the god was kept. Some temples which honoured three gods (the Capitoline Triad) had three cellas.

- CENTRING a temporary (normally wooden) framework for supporting a masonry arch or vault during construction before the structure is able to stand by itself.
- CHRYSELEPHANTINE statues that were plated with gold (for clothing) and ivory (for the flesh parts), probably constructed on a framework of wood.
- CLASSICAL term referring to the period in Greek art from 480 to 404 BC. See also *early classical* and *high classical*. 'Late classical' (399–323 BC) is not used in this book.
- COLUMN cylindrical support that consists of a shaft and capital (and sometimes, as in the Ionic and Corinthian orders, a base).
- CONTRAPPOSTO balanced pose of a human figure in which the weight is unevenly distributed and the axis of the shoulders slopes in the opposite direction from the axis of the hips (see Figs. 25, 72 and 73 for examples).
- CORINTHIAN CAPITAL a capital decorated with acanthus leaves and small volutes (Fig. 43). The Romans developed a Corinthian order making use of the Corinthian capital and based on the Ionic order, but with considerably greater elaboration of the cornice (Figs. 118 and 120).
- CORNICE the topmost member of an entablature.
- DENTILS small carved tooth-like features used instead of a continuous frieze in the Ionic order and in addition to it in the Corinthian.
- DORIANS people speaking the Dorian dialect of Greek and living chiefly on the mainland of Greece (the Peloponnese), the southern islands of the Aegean (including Crete and Rhodes) and the southern part of the west coast of Asia Minor.
- DORIC ORDER an architectural system controlling the design of column and entablature (Fig. 39).
- EARLY CLASSICAL the period from the end of the Persian Wars (479 BC) to about the middle of the 5th century BC, during which the bronze-caster Myron and the mural painter Polygnotos were active and the sculptures of the temple of Zeus at Olympia were produced.
- ENCAUSTIC painting technique in which warmed (or emulsified) wax was used as the medium to bind coloured pigments, producing an effect much like oil painting (Fig. 136).
- ENGAGED COLUMN OR HALF-COLUMN a column (or, more usually, a half-column, semicircular in plan) that is not free-standing but attached to a wall.
- ENTABLATURE the superstructure that is supported by the columns, consisting of architrave (which rests directly on the columns), frieze (above the architrave) and projecting cornice (including the gutter at the top).
- ETRUSCANS a people who lived to the north and south of Rome, who spoke a non-Indo-European language and who had an important political, religious and cultural influence on the early Romans.

- FAUCES entrance passage in a traditional Roman house leading to the atrium (Figs. 114–116).
- FLUTES vertical channels carved in the shafts of columns; Doric columns normally have twenty flutes that meet in sharp arrises; Ionic normally have twenty-four, each separated from its neighbour by a fillet (flattened arris) (Figs. 41 and 42).
- FORESHORTENING the apparent shortening of the form of objects in relation to the angle from which they are observed; perspective applied to single objects or forms. For example, a horse seen from the rear will appear foreshortened (Fig. 81).
- FRIEZE the horizontal band of stones resting on top of the architrave. Doric friezes are divided into triglyphs and metopes; Ionic friezes are continuous.
- FRIGIDARIUM cold room in a Roman bath complex.
- GENRE PAINTING representations of everyday life (as opposed to mythological or historical pictures).
- HELLENIC adjective used to describe Greek civilisation from the time of the fall of the Mycenaeans (end of the 12th century BC) until the time of Alexander the Great (356–323 BC), derived from Hellene, the name by which the Greeks called themselves.
- HELLENISTIC the modern adjective used for the period between the death of Alexander the Great (323 BC) and the final Roman conquest of all the lands ruled by his successors (31 BC). Hellenistic tradition (and the Greek language) remained strong in the eastern part of the Roman empire even after political independence had been lost.
- HIGH CLASSICAL period from about the middle to the end of the 5th century BC, during which Pheidias and Polykleitos were active and the Parthenon was being built.
- HYDRIA water jar with three handles, two horizontal ones at the sides for lifting and a vertical one at the back for pouring (Fig. 60).
- IMPLUVIUM shallow pool leading to a cistern in the atrium of a Roman house in which rainwater was collected.
- IONIANS people speaking the Ionian dialect of Greek and living chiefly on the islands of the Aegean, on the west coast of Asia Minor and in Athens.
- IONIC ORDER an architectural system controlling the design of column and entablature (Fig. 40).
- KORE (plural: KORAI) archaic statue of a draped female figure standing with the weight evenly distributed on the two legs, made from the mid 7th century BC until the beginning of the 5th century BC (Figs. 29 and 30).
- KOUROS (plural: KOUROI) archaic statue of a nude young man standing with one foot advanced and the weight evenly distributed between the

two legs; made from the late 7th century BC until the beginning of the 5th century BC (Figs. 1, 5–9, 11 and 12).

KRATER wide-mouthed bowl used for mixing wine and water (Fig. 60). KYLIX drinking cup (Fig. 60).

LEKYTHOS narrow-necked container used to contain oil (Fig. 60).

LOUTROPHOROS vessel used to carry the water for the ritual bath of brides (Fig. 60); the shape was sometimes used for funerary monuments on the graves of unwed persons.

MENORAH seven-branched lamp-holder; a golden one was looted from the Temple in Jerusalem (Fig. 99), a marble one was found at Sardis (Fig. 137).

METOPES stone or terracotta panels alternating with triglyphs in the Doric order.

MODELLING (in painting) technique for rendering the illusion of volume on a two-dimensional surface by means of shading.

MOSAIC technique for making a picture or design out of small pieces of stone or glass of different colours. Stones are usually cut to be four-sided (for tessellated mosaics); glass is used sparingly for floor mosaics but much more abundantly for wall and ceiling mosaics.

MYCENAEAN the modern name given to the spectacularly flourishing period of the civilisation of a people who spoke an early form of Greek and lived in Greece during the Bronze Age.

NAOS the central, inner part of a Greek temple, where the statue of the god was kept (literally: the dwelling of the god).

OINOCHOE jug (Fig. 60).

OPISTHODOMOS porch at the back of the naos of a temple.

ORCHESTRA place of action for the chorus (and probably also the actors, until the Hellenistic period) in a Greek theatre (literally: dancing place).

PALAESTRA exercise or wrestling ground attached to Roman thermae.

PANHELLENIC 'all Greek' – a term used for festivals or sanctuaries that were common to all Greeks irrespective of whether they were Dorian or Ionian and of the polis they came from.

PEDIMENT triangular end of a gabled roof, which could be filled with sculpture either carved in relief or free-standing.

PERISTYLE a continuous colonnade surrounding either a building or a space; thus, an external peristyle is the colonnade that surrounds the core of a Greek temple (Figs. 37 and 38), and an internal peristyle is the colonnade enclosing the space inside a courtyard, as in many Hellenistic and later Roman houses (Figs. 87c and 115).

PERSPECTIVE a technique for painting three-dimensional scenes on a two-dimensional surface to give the illusion of objects existing in space.

- PILASTER a shallow rectangular feature projecting from a wall and having a capital and base, rather like an engaged half-column, but rectangular in section.
- PODIUM the platform on which a Roman temple was built, accessible by steps from the front only.
- POLIS (plural: POLEIS) independent communities usually comprising an urban centre together with the surrounding countryside; the political unit favoured by the Greeks during the archaic and classical periods.
- POST-AND-LINTEL structural system by which vertical posts (columns or walls) support horizontal lintels (architraves or ceilings).
- POZZOLANA volcanic earth from the area of Pozzuoli, near Naples, which sets hard like cement after it is mixed with water; it is the active ingredient in Roman concrete.
- PRONAOS porch in front of the naos of a temple.
- PROSKENION colonnade (probably with backdrop) between the orchestra and the scene building in a Greek theatre.
- RED-FIGURE technique of vase painting in which the figures are left in the natural colour of the vase and the background and details are painted black. The technique appears to have been invented in Athens around 530 BC and was very popular during the 5th and 4th centuries BC; it was used, often with the addition of much white and gold, in Sicily and southern Italy during the 4th century BC.
- RELIEF sculpture which remains attached to the background, either very deeply carved (high relief) or shallowly carved (low relief).
- SARCOPHAGUS (plural: sarcophagi) carved marble coffin (Fig. 103).
- SCAENAE FRONS (plural: SCAENARUM FRONTES) the façade of the stage building of a Roman theatre that formed the backdrop for the stage and was as high as the top seats of the auditorium.
- SHAFT main body of a column, between the base (if there is one) and the capital.
- SIGNATURE (on vases) signatures appear sporadically on Greek vases; those accompanied by the word *egrapsen* (drew it) are presumably those of painters; those accompanied by the word *epoiesen* (made it) are presumably those of the potters. Some artists sign both *egrapsen* and *epoiesen* and therefore probably both made and painted the vase in question.
- SKYPHOS mug used for drinking (Fig. 60).
- STELE (plural: STELAI) an upright stone slab, bearing a design or an inscription, serving as a monument, document or marker.
- STOA a building with its roof partially supported by one or more rows of columns parallel to a rear wall.
- STYLOBATE top step of a temple, the platform on which the columns and walls rest.

TABLINUM room at the far end of the atrium in a traditional Roman house (Figs. 114 and 115).

TEPIDARIUM the warm room in a Roman bath complex.

THERMAE imperial Roman bath complex (Figs. 127 and 132).

TORSO what is left of the human body when the head and limbs have been removed.

TREASURY a small building usually erected in a panhellenic sanctuary by a polis as a repository for its offerings to the god of the sanctuary.

TRIGLYPH vertically grooved member of the Doric frieze (Fig. 39).

VASE conventional term used for Greek vessels made of pottery.

VOLUTES spiral scrolls curving to the right and left decorating the front and back of Ionic capitals (Fig. 40).

VOUSSOIR wedge-shaped stone forming one of the units in an arch.

WHITE-GROUND LEKYTHOS lekythos covered with a white slip (a thin coating of primary clay with little or no admixture of iron) on which, from around the middle of the 5th century BC, the decoration was sometimes drawn in fugitive colours (mauves, blues and greens) which were applied after firing and so did not have the durability of the more usual, rather restricted range of ceramic colours. Such vessels, which were too delicate for everyday use, were used to hold olive oil offered to the dead (Fig. 71).

FURTHER READING

GREEK ART

- B. Ashmole, *Architect and Sculptor in Classical Greece* (Phaidon, 1972). Architecture and architectural sculpture in the 5th and 4th centuries BC.
- J. Boardman, *Greek Art* (Thames and Hudson, 1996), paperback. General introduction, with short text and numerous illustrations.
- J. Boardman, The History of Greek Vases (Thames and Hudson, 2001). Authoritative, wide-ranging survey of various aspects of the production and study of Greek vases.
- W. B. Dinsmoor, *The Architecture of Ancient Greece* (Batsford, 1975). Detailed standard reference book.
- R. Martin, Living Architecture: Greek (Oldbourne, 1967). Illuminating brief introduction.
- J. J. Pollitt, *Art and Experience in Classical Greece* (Cambridge University Press, 1972), paperback. Sculpture, painting and architecture, primarily in the 5th century BC.
- J. J. Pollitt, *Art in the Hellenistic Age* (Cambridge University Press, 1986), paperback. Survey of all the arts during the Hellenistic period.
- G. M. A. Richter, Handbook of Greek Art (Phaidon, 9th ed. 2003), paperback. General introduction covering many topics, including major and minor arts.
- M. Robertson, A History of Greek Art (Cambridge University Press, 1975). Sensitive survey from the Geometric through the Hellenistic periods, excluding architecture; also available in a shortened version, A Shorter History of Greek Art (Cambridge University Press, 1981), paperback.
- R. R. R. Smith, *Hellenistic Sculpture* (Thames and Hudson, 1991), paperback. Well-illustrated, brief, intelligent survey of sculpture only.
- B. A. Sparkes, *Greek Pottery: An Introduction* (Manchester University Press, 1991), paperback. Clear exposition including archaeological and technical aspects of Greek vases not usually covered.
- A. Stewart, *Greek Sculpture* (Yale University Press, 1990), paperback. Comprehensive survey of Greek sculpture, including literary sources; lavishly illustrated.
- D. Williams, *Greek Vases* (British Museum Publications, 1999), paperback. Elegant survey concentrating on the collection of the British Museum.

- S. Woodford, *The Parthenon* (Cambridge University Press, 1981), paperback. Brief survey of sculpture, architecture, building procedures, early and later history.
- S. Woodford, *An Introduction to Greek Art* (Duckworth and Cornell University Press, 1986), paperback. Generously illustrated discussion of sculpture and vase painting from the 8th to the 4th century BC.

ROMAN ART

- A. Boethius and J. D. Ward-Perkins, *Etruscan and Roman Architecture* (Pelican, 1970). Detailed standard work.
- K. M. Dunbabin, *Mosaics of the Greek and Roman World* (Cambridge University Press, 1999), paperback. Authoritative survey of mosaics in classical antiquity.
- E. K. Gazda, ed. *The Ancient Art of Emulation* (Memoirs of the American Academy in Rome, suppl. vol. 1, University of Michigan Press, 2002). Multi-author critical review of traditional attitudes toward Roman sculpture and painting.
- M. Grant, *Art in the Roman Empire* (Routledge, 1995). Brief, sparsely illustrated but intelligent study of the relationship of art in the provinces and in the centre.
- M. W. Jones, *The Principles of Roman Architecture* (Yale University Press, 2000). Interesting analysis of Roman building procedures.
- D. E. E. Kleiner, *Roman Sculpture* (Yale University Press, 1992). Detailed survey from the foundation of Rome through Constantine.
- R. Ling, *Roman Painting* (Cambridge University Press, 1991), paperback. Comprehensive survey of the development of Roman painting, with numerous illustrations.
- W. I. MacDonald, *The Architecture of the Roman Empire: An Introductory Study* (Yale University Press, 1992), paperback. Stimulating detailed examination of important imperial buildings.
- P. MacKendrick, *The Mute Stones Speak* (Norton, 1983), paperback. General introduction to Roman art through the history of archaeological discoveries.
- N. H. Ramage and A. Ramage, *Roman Art* (4th ed., Laurence King Publishing and Prentice Hall, 2004), paperback. Excellent, clear, well-illustrated introduction to Roman architecture, sculpture and painting.
- I. S. Ryberg, *The Rites of the Roman State Religion in Art* (Memoirs of the American Academy in Rome, vol. 12, 1955). Copiously illustrated, illuminating analysis of numerous Roman reliefs.

- D. E. Strong, *Roman Imperial Sculpture* (Tiranti, 1961). Brief introductory analysis of Roman reliefs.
- M. Thorpe, *Roman Architecture* (Duckworth, 1995), paperback. Excellent short introduction to Roman architecture.
- J. M. C. Toynbee, *The Art of the Romans* (Thames and Hudson, 1965). Systematic handbook covering many topics, excluding architecture.

LITERARY SOURCES

- Pausanias, *Guide to Greece*, 2 vols. (Penguin, 1971), paperback. English translation.
- Pliny, *Pliny the Elder's Chapters on the History of Art*, ed. K. Jex-Blake and E. Sellers (Argonaut, 1968). Introduction plus text in Latin and English, carefully annotated.
- J. J. Pollitt, *The Art of Greece: Sources and Documents* (Cambridge University Press, 1990); *The Art of Rome 753 BC-337AD* (Prentice Hall, Sources and Documents, 1966), both paperback. Briefly annotated translations of intelligently selected passages from many different ancient authors.

INDEX

Abacus 25–26, 146	Antigonids 60
Acanthus 147	Antioch 60
Achilles 91	Aphrodite 61 see also Venus
on mosaics 126–129	from Capua 64, 70, 97
on a sarcophagus 99	from Melos 70
on vases 45-49	by Praxiteles at Knidos 62–4, 70
Acropolis 14, 58, 86–88	Apples of the Hesperides 33, 93
Acroteria 27, 146	Aqueduct 122, 146
Actor(s) 78, 83–85, 116, 145, 149	Ara Pacis 94–95, 133
Adamklissi 134–137	Arcades 117–118
Adaptation(s) 52, 69-72, 78, 90 109,	Arch of Titus 95
141, 143–144	Arches 93, 95–96, 114–119, 122, 146–147,
Aegean 2, 4, 26, 147, 148	151
Aegina (pediment of temple) 29	Archaeologists 14, 58
Aeneas 93, 144	Archaic 4-52, 57, 58, 136, 141, 143, 146,
Aeschylus 78	148, 150
Africa 125	Architect(s), 57, 85, 88, 113, 118
Africans 67	Architectural
Agamemnon 1	complexes 85, 115
Agatharchos 56, 78	paintings 78, 80, 105, 144, 145
Aggregate 115, 146	sculpture 27-37, 43, 58, 93
Agrippa 95, 140	Architecture 23–27, 38, 56, 80–88, 107,
Ajax (and Achilles) 45–49	109–126, 139, 144
Alabastron 42, 146	Architrave 25–26, 118–119, 146–148,
Alexander mosaic 73–75	150
Alexander the Great 2, 59–60, 73–76,	Arena 117
93, 130, 148	Argive 18
Alexandria 60	Argos 4
Algeria 128	Aristodikos (kouros) 10, 12, 14, 143
Allegory 80, 93	Aristonothos 43–44
Alloy 13	Aristophanes 83
Alps 2	Aristotle 56, 59
Altar(s) 23, 51, 68, 70, 87, 93–95, 140	Arris 148
of Peace 94–95, 133	Artemis 28
Amazon 99	Artemisium (Zeus of) 15–16, 18, 30,57
Amphitheatres 102–103, 116–118, 125,	Aryballos 42, 146
143, 146	Asclepius 85, 87
Amphora 40, 42–47, 51, 146	Asia Minor 2, 4, 5, 26, 60, 66, 81, 124,
Anavyssos kouros 10	147, 148
Anaxagoras 56	Aspendos (theatre) 123–124, 126
Tillanagoras jo	

	Bullfights 117
Athenian(s) 5, 13–14, 52, 58, 66,69, 86,	
	Caldarium 120, 126, 146
	Callipers 142
	Campanian 140
Atlas (metope from Olympia) 33, 93 Atrium 109–110, 121, 146, 148, 151	Capitals(s) 25–27, 133, 146–147, 150 Capitoline Triad 146
	Caracalla 120, 126
	Carolingian 138
	Casts 138, 142, 143
	Caucasus 60
	Cavea 83–85, 124, 146 see also
Augustus 56, 89, 91–92, 94–95, 112–113,	Auditorium
	Cella 23, 110–112, 146
	Cement 150
Axis (axial) 8, 86, 88, 109–110, 120–121,	Centaur(s) (Parthenon metopes) 34, 35
	Centring 115, 147
	Characterisation(s) 16, 30, 62, 71, 92
	Chariot 30, 73–75
	Charioteer 30, 74
	Chorus 83–84, 149
5 1 1	Christianity 24
Barrel vault 115	Chronology 140
	Chrysaor 28
146–147, 150 (Chryselephantine 58, 147
	Cicero 56
	Cirencester 132–133
TT :	Cistern 109, 148
	City-states 4
	Cityscape 78, 145 Clamps 25
	Clay 13, 48, 142, 151
	Club (of Hercules) 93
	Coffering 115–116
_	Coffin (sarcophagus) 98–99, 150
P.	Coin 117, 140
Biographies 56, 139	Colonies 4, 89, 123
	Colonnade 23–24, 78, 85, 104, 112, 121,
Black-figure 44–49, 51, 146	149–150
Boscoreale 78–79, 104–105, 140, 144	Colosseum 117–119, 125
Boscotrecase 105–106, 140	Colour
Bowl 42, 78, 149	in (wall) painting 74, 80, 130
Brick(s) 81, 115, 140, 146	on sculpture 16–17, 21, 63, 95
7 7 7 7 7 7 7 7 7 7 7 7 7 7 7 7 7 7 7 7	Colours
Bronze-caster(s) 4, 16, 18, 62, 147	in mosaics 73–74
Bull (metope at Olympia) 33, 34, 37	on pottery 38, 44–45, 149

Column(s) 23–27, 82, 93, 96–98, 103,	Democracy 58
105, 107, 112, 117, 136, 140, 144,	Democritus 56
146–148, 150	Dentils 26, 147
of Marcus Aurelius 97–98	Descriptions 57, 72
of Trajan 96–8	Diagrammatic (visually illogical)
Comedy 76, 83	representations 96, 102, 117
Commodus 93, 97–98	Dialects 4, 147–148
Composition 32, 34–35, 46, 53–54,	Diocletian 89
68–69, 133, 135, 144	Dionysus 83, 105
Concrete 115–117, 146, 150	Discus-thrower 16-19, 37, 57, 141
Constantine 89	Dome 113–116, 121
Constantinople 89	Dorian 2, 4, 147, 149
Contrapposto 19, 63, 70, 91–92, 147	Doric order 24–27, 118, 146–149, 151
Copies, Roman	Doves drinking (mosaic) 77-78
of sculpture 16-18, 21, 57-58, 62-65,	Drama 5, 32, 66, 68–69, 73, 74, 83, 84
67, 70–71, 89–90, 92, 141–144	Drapery 20–22, 63–64, 68–71, 92, 94,
of painting 72-74, 76-78, 80, 101,	133
103, 105, 107, 144–145	Drum (of column) 25, 114
Copies, later, of Roman art 138	
Сору	Earth 69, 75, 150
of Discus-thrower (18th century) 18	Earthquake 107
of Polygnotan composition 54	Egrapsen 150
of Leonardo da Vinci by Raphael 63	Egypt (Egyptian) 4, 6-11, 60, 89, 130,
Copper 13	141
Corfu 28, 32, 51	El Djem (amphitheatre) 125, 126
Corinth 4, 30, 39	Electra 70–71
Corinthian	Elevation 24, 85, III
capital 27, 133, 147	Elis 30
half-columns 118	Emperors (Roman) 56, 89, 91–93, 96,
Corn-maiden 75	98, 102, 113, 117, 120, 122, 132,
Cornice 25–26, 147	140
Courtyard 81–82, 109, 149	Empire
Cretan 33, 37, 147	Athenian 5
Cup 42, 149	of Alexander the Great 60
Cupid 144	Roman 3, 89–90, 98, 118–119, 122,
Cyclops 43-44	124–126, 130, 132–133, 136–137,
	148
Dacian 96, 97	Encaustic 130, 147
Dado 105	England 133
Daily life 76	Entablature 24–25, 124–125, 147, 148
Darius III (Persian king) 73-74	Epidauros 83, 124
Dating 57, 95, 139-140	Epistyle 146
Dedication 9, 32, 117, 132, 139	Epoiesen 150
Deities 23, 31	Erechtheum 86–87
Delos 82	Ethiopia 60
Delphi 5, 32	Etruscan(s) 2, 110, 147
- vo. so. g	

Euphrates 129	Groups (sculptural) 61, 66–68, 70–71
Euphronios 51	Gutter 147
Euthymides 50–51, 55	
Evidence 72, 76, 139, 141	Hadrian 92, 113, 140
Excavations 132, 141	Half-column(s) 112, 118, 147, 150
Exekias 45–47, 51	Handles 41–42, 45–46, 146, 148
Exterior (of amphitheatres) 117-118, 125	Hebrew 133
, , , , , , , , , , , , , , , , , , , ,	Hector 67
Façade 24, 84, 113, 140, 150	Heifer (on the Parthenon frieze) 36–37
Fauces 109, 148	by Myron 141
Faun, dancing 65	Helen 1, 3, 127
Female nude 20–21, 62–64, 71	Hellene(s), Hellenic 2, 60, 148
First Style 103, 114	Hellenistic 2–3, 25, 59–61, 64–88, 89,
Floors 82, 105, 121, 149	93, 109, 140, 148–149
Flutes (fluting) 25, 133, 148	Hephaisteion 25
Foreign (foreigners) 4, 66–67, 71, 103	Herakles 33, 93
Foreshortening 51, 55, 73–74, 78, 148	Herculaneum 101, 108, 140
Fortuna (sanctuary of) 87, 110, 115	Hercules 93
Fountains 121	Hero(es) 28–29, 32–34, 38, 45–46, 80,
Fourth Style 106–108	91, 93, 127, 143–144
Fragment(s) 3, 57, 108, 133, 137–139	Heroic 32, 66, 91
François vase 45	Hesperides (apples of) 33
France III, 124	Homer (Homeric epics) 2, 4, 41, 43–45,
Free-standing 4, 66, 71, 111–112, 116,	66, 91, 140
147, 149	Horace 90
Frieze 147–148, 151	Horse(s) 28, 30–31, 34, 73–74, 99, 148
architectural 25–27	House(s) 148–149, 151
of the Parthenon 35–37, 94	Greek 81–82, 109
of the Ara Pacis 93–95	Hellenistic 61, 82
Frigidarium 120–121, 126, 148	in Athens 81–82
Frontinus 122	on Delos 82
Fugitive colours 42, 151	of Pindar 59–60
	in Priene 81–82
Gable(s) 27, 107, 144, 149	Roman 109–110
Gaul(s) 66–68	of the Menander 110
Genre painting 80, 148	of the Vettii 106–8
Germany 126	painted walls in 101–108
Giant(s) 28, 43, 68–69, 93, 117	Herculaneum 101, 108
Gladiators 117, 146	
Glass (in mosaics) 149	Pompeii 101–108
Gorgon 28, 38	statues for 143–144
Grave	Hydria 42, 51–53, 64, 148
marker 10, 41–42, 149	Idellic ros ras
offering 42	Idyllic 105, 145 Iliad 2, 43, 67
Greco-Macedonian 60	
	Illusion (illusionistic) 54, 76, 84,
Grid (for carving marble) 7, 141–3	103–105, 107, 112, 149

Imitation(s) 52, 70–71, 105, 140, 145	Lekythos 42, 55, 149, 151
Imperial (Roman) 89, 91-92, 105, 119,	Leonardo da Vinci 63
126, 140, 151	Lettering 133
Impluvium 109, 148	Liberty, Statue of 61
Incised (incision) 44-46, 146	Libraries 120
India 2, 60	Lime 115, 137
Inlays (marble) 82, 114	Limestones 24
Inscription(s) 97, 133, 139–140, 150	Lintel(s) 24, 146, 150
Inset eyes 15, 16	Lion-skin of Hercules 93
Ionian(s) 4, 60, 148-149	Literary sources 56-58, 72, 76, 139, 141
Ionic order 24–27, 35, 118, 146–149, 151	Loot 95, 133, 137, 149
Italy 4, 89, 150	Loutrophoros 42, 149
Ivory 58, 61, 147	Lucian 56–57, 141
	Lycomedes 126–129
Jerusalem 95, 132–133, 149	
Jews 132	Macedonia 59–60, 75
Jug 42, 149	Mainland Greece 4, 5, 57, 59, 147
	Maison Carrée 111–113
Key-stone, 115	Marathon (battle of) 5
King(s)	Marble, 7, 10, 13–18, 24, 58, 64, 82, 103,
Agamemnon 1	105, 114, 121, 133, 137, 141–144,
Hellenistic 59–61, 89, 93	149–150
Oinomaos 30	Marcellus (theatre of) 125
Persian 5, 73–74	Marcus Aurelius 97
Priam 28, 51	Mediterranean Sea 67, 103, 132
Pergamene 69	Medusa 28
Kingdoms (Hellenistic) 59–61, 81, 89	Megara 61–62
Kleitias 45, 46	Menelaos 1
Knidians 63	Menorah 95, 131–133, 149
Knidos 62	Mesopotamia 132
Kore (korai) 20–21, 148	Metope(s) 25, 27, 32–36, 38, 93, 135,
Kos 85, 87–88	148–149
Kouros (kouroi) 9–12, 14–16, 19, 22, 24,	Milo, Venus de 70
41, 140, 143, 148	Monster(s) 27, 34, 43
Krater(s) 42-45, 53-55, 57, 80, 149	Monument(s) 4, 61, 68, 93, 98, 133–134,
Kritios boy 12–16, 30	140, 149–150
Kylix 42, 149	Mortar 24, 115, 146
	Mosaic(s) 73-76, 78, 82, 121, 126-130,
Lamp-holder (menorah) 95, 131–132, 149	139, 149
Landscape(s) 75, 80, 84, 103–107, 145	Motif 69
Lapith(s) (Parthenon metopes) 34–35	Mud-brick 24
Large-scale sculpture 7, 38	Mug 42, 150
Latin 93, 138	Mummy portrait 130
Latrines 126	Mural painting 52, 102, 147
Leda 63	Music 5, 53, 76
Legend(s) 1-3, 53, 93, 99	Mycenae (Mycenaeans) 1–2, 149

Myron 16 17 10 27 57 111 117	Danahasiaa
Myron 16–17, 19, 37, 57, 141, 147	Parthanan 58 (2. 62. 86. 87. 22. 24.
Mysteries (Villa of the) 105	Parthenon 58, 62, 69, 86–87, 93–94,
Myth(s) 1, 3, 28–35, 43–49, 51–53,	139, 148
68–70, 93, 98–99, 126–130	pediment 30–32, 37
> To	metopes 34–35
Nîmes 111–112	frieze 35–36
Naos 23–24, 149, 150	Patronage 31, 33, 70–71, 91, 101, 105
Naples 150	Pausanias 56, 57, 58
Natatio 120	Pavement 76
Neo-classical 27, 138	Pediment 27–32, 34, 37, 51–52, 66, 69,
Niches 124	124, 133, 146, 149
Nikias 63	Pegasus 28
Nikomedes 63	Peiraikos 76
Nocera 102	Peloponnese 147
Non-Indo-European 147	Peloponnesian War 5–6, 59
Non-Roman 130	Pelops 30
Nude	Penthesilea 99, 140
female figures 21, 62–64, 67, 71, 128	Pergamene(s) 66, 68, 69
male figures 9, 67	Pergamon 60, 66, 68, 70, 78, 140
	Pericles 58, 139
Odysseus 43, 79–80, 127–129	Peristyle
Odyssey 2, 43, 79–80	external, around temples 23–25, 82,
Oinochoe 42, 149	111–112, 118, 149
Oinomaos 30	internal, within houses 82, 109–110,
Olive oil 41–42, 146–147, 149, 151	149
Olympia 5, 29–34, 36–37, 52, 58, 93, 147	Persephone 75
Opisthodomos, 23, 149	Perseus 28, 38
Orange (Roman theatre) 117, 124	Persian(s) 5–6, 12–14, 52, 59, 66, 73, 147
Orchestra 83–85, 149, 150	Personifications 61, 143
Orders (architectural) 24–26, 118–119,	Perspective, 56, 72–73, 78, 80, 108, 116,
125, 147–148	148–149
Orestes 70–71	Pheidias 57–58, 62, 148
Orpheus 53–54	Philip II of Macedon 59
Orthogonals 80	Philosophers 56, 59, 78, 90
Oxen (metope from the Sicyonian	Philus 132–133
treasury) 32–33	Pigments 56, 130, 147
	Pilaster(s) 105, 118, 133, 150
Pagan 133, 138	Pindar 60
Palaces 78, 81, 103, 119, 122	Plan(s) 23–24, 81–82, 109–112, 120, 125,
Palaestra(s) 121, 149	147
Panel(s) 38–39, 41, 53, 95, 100–101, 105,	Plaster 24–25, 103, 138, 143
107, 130, 149	Plataea 5
Panhellenic 5, 32, 149, 151	Platform 24, 105, 150
Pantheon 113–116, 120, 140	Playwrights 84
Panthers 28	Pliny 56–57, 73–74, 76, 141
Paris 1	Plutarch 56, 58, 139

Pluto 75 Red-figure 47-55, 150 Relief Podium 110-112, 150 definition of 150 Pointing 142 on Argos stele 19 Polis, 4-5, 24, 32, 59-60, 89, 149-151 Reliefs, Greek Polygnotos 52-54, 56-57, 76, 147 on temples 27-28, 32-36 Polykleitos 18, 37, 57, 62-64, 91-92, 143, on metopes 32-36 on friezes 35-36, 68-69 Pompeii (Pompeian) 17, 65, 73, 78, 101-107, 114, 117, 128, 140 Reliefs, Roman historical 93-98 Porch(es), of a temple 23, 33, III-II3, on sarcophagi 98-100 149, 150 Prima Porta, Augustus of 91-92, 94, provincial 132-137 112-113, 143 Renaissance, 63-64, 72, 80, 99, 138 Portrait 90-95, 97-98, 130, 140, 143 Republic 89 Revival 61-62, 78, 138 Portraiture 80, 90, 100 Revolt 5, 132 Poseidon 15, 31-32 Rhetoric 90 Post-and-lintel 24, 150 Rhodes 147 Pot 39, 41, 44 Riot (in the amphitheatre) 102, 117 Potters 43, 150 River gods 30-32, 37, 80 Pottery 4, 38-42, 72, 151 Roman emperors see Emperors Pozzolana 115, 150 Romania 134 Pozzuoli 150 Rubens 75 Praeneste 87-88, 110, 115 Praxiteles 62-64, 70 Precinct(s) 87, 112, 126 Sabina 92-93 Salamis 5 Priam 28, 51 Sanctuary of Fortuna at Praeneste 87, Priene 81, 84 110, 115 Priests 95 Sanctuaries 24, 62, 85-88, 112 Procession 35-36, 94-95, 133 panhellenic 5, 32, 149 Pronaos 23, 150 Proportion(s) 7, 10, 12, 24-26, 96 Sand 115 Sarcophagus 98-99, 126, 128, 140, 150 Propylaea 58, 86 Sardis 131-132, 149 Proskenion 84–85, 150 Scaenae frons 116, 124, 150 Prototypes 90, 95, 105, 143, 144 Province(s) 3, 122, 133 Scaenarum frontes 116-117, 150 Provincial 101, 103, 125 Scenery 78 Ptolemies 60 Scholars 57, 80, 90, 103, 141, 143 Pumice 115 Sculptors, named 57-58 Sculpture Punjab 60 Greek 6-22, 61-71, 141-142 Pyramids 122 provincial 132-137 Roman 90-100, 141-142 Quintilian 144 Scythians 67 Second Style 103-105, 107 Raphael 63 Sects 133 Realism 10, 38, 60, 96, 117 Rebellion 5, 60, 132 Seer 30

Sacaria vas	Territoriose
Segovia 122	Tepidarium 120, 126, 151
Seleucids 60	Terracotta 38, 149
Self-supporting 115	Tessellated mosaic 149
Seven-branched lamp holder (menorah)	Theatres
95, 131–133	Greek 82–85,
Shading 55, 130, 149	Roman 116–118, 123–125, 149, 150
Shaft (of a column) 25–27, 146–148,	Theatron 83
150	Thebes 59
Shrines 86–87, 105	Thermae 119–122, 125–126, 146, 148,
Sicily 4, 89, 150	149, 151
Sicyonian treasury 33	Third Style 105–107
Sicyonians 32, 35	Thracian(s) 53, 54
Signatures 43, 150	Three-dimensional 24, 50, 54–55, 103,
Silhouette 41, 43–45, 51, 146	107, 130, 149
Single-point perspective 80	Tiber 2
Shapes of Greek vases 42–43	Tin 13
Skopas 62, 69	Tipasa 128
Skyphos 42, 150	Titus 92, 95–96, 117
Socrates 133	Toga 92
Sosos 77–78, 82	Tombstone 133
Sources of information	Torso, 8, 16, 18–19, 63–64, 91–92,
on Greek art 56–58, 76	151
literary 56–58, 72, 76, 139, 141	Trajan 96–98, 103, 117, 134, 136
Spain 122	Trajan's Column 96–97, 140
Sparta 1, 4, 5, 59	Treasury(ies) 32–33, 35, 151
Spear-bearer 18–20, 22, 37, 57, 63–64,	Tree-trunk 17, 143–144
66, 91–92, 143–144	Trier 125–126
Stage (sets) 29, 56, 74, 78, 83–85, 144,	Triglyph 25–26, 148–149, 151
145, 150	Trojan 1–3, 28, 67, 99
Stele 41, 150	Troy 1, 28, 51, 67, 99, 127
Still-life 76, 80	Trumpeters 127–128, 134–137
Stoa(s) 85, 150	Tunisia 126
Struts 143–144	Turkey 126, 129, 132
Stylobate 24–27, 150	
Superstructure 147	Unbaked bricks 81
Supports for marble statues 17, 64,	Underworld 53, 75, 80
143–144	75. 77.
Swimming pool 120, 122	Vandalism, 138
Synagogue 131–133	Vanishing point, 56
, 00 , ,,	Variation(s) 64, 68, 70, 90
Tablinum 109–110, 151	Vase painting 39–56, 100, 146,
Temple(s)	150–151
Greek 23–36, 61, 86–87, 149	Vault(s), vaulting 114–116, 121, 147
at Jerusalem 95, 132	Venus 144
Roman 110–116, 146, 150	de Milo 70
Tensile strength 13, 143	Genetrix 21, 92–93
G 7777	

Vergina 75–76
Vesuvius 56, 101, 140
Vettii (House of the) 106–108
Victory
image of 69, 97
of Alexander over Darius 73
of Greeks over Persians 6
of Pergamenes over Gauls 66
of Spartans over Athenians 6
Villa of the Mysteries 104–105
Vitruvius 56, 144–145
Volutes 26, 147, 151
Voussoir(s) 115, 151

Wax 13, 147
White-ground 42, 55, 151
Wine 4I-42, 149
Wood 23-25, 39, 115, 130, 147
Workshops 143
Worship 23
York 61
Zeugma 129
Zeus 15-16, 18, 28-30, 32, 52, 57-58,

68-70, 140, 147

Zeuxis 55